AN ANTHOLOGY OF BLACKNESS

AN ANTHOLOGY OF BLACKNESS

THE STATE OF BLACK DESIGN

edited by Terresa Moses and Omari Souza

foreword by Elizabeth (Dori) Tunstall

The MIT Press
Cambridge, Massachusetts
London, England

The MIT Press would like to thank the anonymous peer reviewers who provided comments on drafts of this book. The generous work of academic experts is essential for establishing the authority and quality of our publications. We acknowledge with gratitude the contributions of these otherwise uncredited readers.

This book was set in Gotham by Terresa Moses. Printed and bound in Canada.

Library of Congress Cataloging-in-Publication Data

Names: Moses, Terresa, editor. | Souza, Omari, editor. | Tunstall, Elizabeth, writer of foreword.
Title: An anthology of Blackness : the state of Black design / edited by Terresa Moses and Omari Souza ; foreword by Elizabeth (Dori) Tunstall.
Description: Cambridge, Massachusetts : The MIT Press, [2023] | Includes bibliographical references and index.
Identifiers: LCCN 2022061537 (print) | LCCN 2022061538 (ebook) | ISBN 9780262048668 (hardcover) | ISBN 9780262377256 (epub) | ISBN 9780262377249 (pdf)
Subjects: LCSH: Graphic arts—Social aspects—United States. | Commercial art—Social aspects—United States. | African American graphic artists. | White privilege (Social structure—United States.
Classification: LCC NC998.5.A1 A73 2023 (print) | LCC NC998.5.A1 (ebook) | DDC 744.089/96073—dc23/eng/20230612
LC record available at https://lccn.loc.gov/2022061537
LC ebook record available at https://lccn.loc.gov/2022061538

10 9 8 7 6 5 4 3 2 1

CONTENTS

1. Black Design Industry + Organizations

2. Black Design Pedagogy

3. Black Design Activism

WE,
CON' BE
ALRIGHT

FOREWORD
Dori Tunstall

Design and the Alchemy of Black Pain

Black folks possess the ability to transmute pain into joy. It is 2022, two years after the global protests of the murder of George Floyd by Minnesota police officer Derek Chauvin. We are experiencing another Black creative renaissance, in which previously horded resources have flowed into Black communities, and we have additional means to imaginatively express our anger, our sorrow, and our resilience in the face of consistent white-on-Black state-sanctioned violence. Through creative acts, we alchemize feelings of anger and sorrow into the joy of our community, our ancestors, and the ones who will come afterward. We alchemize feelings of resilience into the joy of being alive. Due to four hundred years of the ancestors' sacrifices and our own self-advocacy, we have free minds to creatively express our feelings. We have free bodies to give those expressions tangible form. Our souls have always been our own.

Like movements in the past, this current Black creative renaissance follows incidents of intensified and bold white-on-Black violence. The Black arts movement of the 1960s and 1970s transubstantiated into Black self-love, with the preceding white-on-Black violence culminating in the assassination of Malcolm X in 1965. The Harlem Renaissance of the 1920s and 1930s metabolized a "New Negro" in response to the "Red Summer" of 1919, in which thirty-eight separate racial riots against Black people took place, including thirteen days of rioting in Chicago and four days in Washington, DC. We can continue to travel back through time and across the globe to find Black folks in Africa, the Caribbean, South America, and Europe as well as North America turning white supremacists' base thoughts and behaviors into expressive gold and prolonged life for our communities. It speaks to the great souls of Black folks that when white supremacists double down on their hatred of us, we double up on the love for ourselves, our families, and our communities.

Life is not a circle but rather a spiral. And although it might sometimes feel like we have been here before in another cycle of white-on-Black violence and Black creative renaissance, each cycle brings us to a new and different level. I remind myself that two hundred years ago in this body, I would have been enslaved. Progress has been made. In An Anthology of Blackness: The State of Black Design, editors Terresa Moses and Omari Souza have assembled polyvocal statements from Black authors of our continuous movement through that spiral.

"Black Design Industry + Organizations" features eight works that speak to the painful material deprivations caused by the nearly 150 years of the structural exclusion of Black people in the "modern" design field. They reference Cheryl Miller's 1987 foundational print essay "Black Designers Missing in Action," when professional African American designers numbered only 1 percent of the field. They critique the fact that even after Maurice Cherry's 2015 essay "Where Are the Black Designers?" and the 2020 Where Are the Black Designers? conference, the number has only increased to 3 percent. The authors transmute their anger with the field's exclusion of Black people into programs that open up possibilities for more Black people to become designers, including youth design initiatives such as designExplorr and Creative Reaction Lab, using video games to attract Black youths to design and technology, and providing expert advice on how to hire Black designers, not just ask for a list. Yet authors also ask, What kinds of community accountability are we building for Black designers in the field? If, to paraphrase Audre Lorde, "the master's tools won't dismantle the master's house," Black folks must ensure that our joining the design professions does not further reproduce systems of commercial exploitation. We should join the design industry to care for ourselves and our communities by creating new conditions of possibility of a world for us and by us.

"Black Design Pedagogy" features six contributions that speak to the existence of hurtful and Black-excluding design curricula in academia. The story of design as something that happened in Europe in the 1800s excludes centuries of highly skilled making by Africans and the African diaspora. The authors make it clear that Black students feel aliened from design because they do not see themselves, their values, and their communities reflected in the curriculum, faculty body, and intimidation of the building. The authors, faculty in design programs ranging from those in historically Black colleges and universities to those in predominately white universities, focus their attention on projects that seek to disinfect design pedagogy from the disease of white supremacy. They offer courses and design briefs that ask students to be inspired by African histories of making, address issues important to the Black community, and question the white supremacy of design histories and discourses. Black-centered curriculum taught by Black faculty is being reinforced by Black cluster hires in North America and Europe, which is accelerating changes in the design education field and preparing the next generation of Black designers and design educators.

"Black Design Activism" features seven contributions that speak to the social and political systems that disenfranchise Black folks. The authors amplify their works and that of other Black designers who are purging discrimination and

corruption from those systems to achieve Black liberation. With a twin focus on the 2020 Black Lives Matter protests and US political efforts to suppress Black voters, the authors demonstrate the continuity of Black protest design from the 1920s, 1960s, and today. The authors look at a variety of tactics from placards and T-shirt designs at protests to voter information posters that show past Black voter suppression efforts. They engage us in the politics of Black self-care and the beauty of our textured hair. They remind us that intersectionally, all Black lives matters, including queer and neurodiverse lives.

As Black peoples, it would be preferred that we did not have to suffer so much pain. The ability to transmute pain to joy is a four-hundred-years-old survival mechanism, and thus reflective of the great depth of oppression, discrimination, and dehumanization we Black folks have experienced under systems of white supremacy. Design as a profession is implicated in the harm to Black communities and individuals. Yet design is not a master's tool. As the authors show, design has been continuously part of Black self-expression and collective values given form, even before enslavement. We are driven by the sacred duty to reduce the pain for the next generations that come after us. These works demonstrate that these efforts are healing ourselves, the ancestors, and the those who come after. Like the state of the Black community itself, the state of Black design is, in the immortal words of Kendrick Lamar, "gon' be alright."

Biography

Dori Tunstall is a public intellectual, organizational change agent, and design advocate. Author of Decolonizing Design: A Cultural Justice Guidebook, Tunstall works at the intersections of culture, design, and critical theory. She is a leading figure in decolonizing design through her work as dean of design at OCAD University in Toronto, Canada, where she was the first Black and Black female dean of a faculty of design anywhere.

INTRODUCTION

Terresa Moses and Omari Souza

On May 25, 2020, George Floyd was murdered at the hands of Minneapolis police officer Derek Chauvin. For nearly nine minutes, Chauvin mercilessly planted his knee on the father of five who called for his mother and his right to life—to breathe. The viral nature of the account recorded by several bystanders rivaled the contagious nature of the COVID-19 pandemic that concurrently ravaged the nation. The subsequent protests that ignited across the globe showed humanity's frustration, sadness, anger, and rage as we added yet another name to the list of Black lives stolen by institutionally sanctioned violence.

Militarized police officers and service members filled the air with tear gas and rained down rubber bullets on the bodies of peaceful protesters. Black people were labeled domestic terrorists, uncivil, and disrespectful in our attempts to seek justice for Black life. In the United States, white people have managed to normalize an ingrained ideology that Black people just cannot seem to do *it* right: be born right, live right, be educated right, work right, protest right and die right. And as the nation's polarization over the Black Lives Matter movement grew wider that summer, we grieved, and we organized.

As Black authors, organizers, educators, entrepreneurs, creatives, and designers, we understand the power our words possess to craft stories, create culture, shape narratives, influence policy, and impact our communities. Much like the historical Black thought leaders of twentieth century, we understand the importance of Black critical thought, and how our written and verbal contributions to society help shape our world and communities. The power in our language carries messages of nuance as we add to our vocabulary, establish euphemisms, and create art and design to tell *our* stories. The resilience and creativity of our ancestors enable us to acquire and utilize imaginative abilities to not only speak our narratives but write, visualize, and design them too.

And so we imagined the State of Black Design, a panel that took place online in September 2020. We designed this intentional collaborative space for Black voices to be heard, feelings to be expressed, and ideas to be visioned. There, we found not only a space to connect but also to begin collecting visual and researched work that would speak to three areas of Black design: Black design industry and organizations, Black design pedagogy, and Black design activism. This anthology is a manifestation of those collected writings and creative works by Black innovators and visionaries.

Throughout these pages, you will find the contributions of a variety of Black identities being represented through nuanced Black voices, Black writing styles, and Black design research approaches. While quantitative data exist within this work to support how racism has affected our communities through representation and voter suppression, we place substantial emphasis on the validity of autobiography, autoethnography, and counter-storytelling as qualitative methods of data gathering and scholarship. These applied research contributions have proven to establish positively impactful outcomes when utilized to create pro-Black, anti-racist, and intersectional design approaches. Together, quantitative data on the current state of Black representation and qualitative research contributions provide intellectual commentary on and real-life design approaches to the state of Black design. The subtlety of our research equates to that of the Black experience as we investigate how design practice, organizations, pedagogy, and activism are influenced by our unique understanding of systemic racism and intersectional oppression. Many of the contributing authors analyze their particular areas of expertise within an intersectional lens on race, class, gender, sexuality, ability, and the like. We approached this project with the full, *very* Black truth and identity in mind. Unapologetically.

Each of the three collectively organized themes offers an introduction to the contributions coauthored by the editors. The themes function as a continuation of community concerns and intellectual criticism on the state of design—in areas that can separate practitioners, educators, and activists, but may often blur across segments for stronger impact and advocacy. We organized the anthology in this way to be sure we considered the full range of Black designers' experiences and how other communities might contribute to the inclusion of Blackness in design.

"Black Design Industry + Organizations" explores the impact of design practice and community-coordinated institutions on the success, retention, and advancement of Black designers. This theme sheds light on the importance of Black-centered community spaces, liberal platitudes, the harm of a homogeneous design industry, critiques of racialized design, and approaches that can tackle many problematic actions that result from racialized ideologies. To change these areas requires commitment to trauma-informed and Black-centered design by the design industry as a whole.

"Black Design Pedagogy" centers on Black design student matriculation and Black-centered curricular approaches that disrupt colonial and white Eurocentric educational canons. It is no secret that there is a huge disparity in the representation of Black students and faculty on the campuses of institutions of higher learning. These anti-Black outcomes are examined under this theme, and the contributors offer approaches to Black-centered curriculum and inclusionary practices—approaches that every design educator and institution can take.

"Black Design Activism" focuses on historical and present-day designers and design that further racial justice, anti-racism, and Black liberation. The unique understanding of oppression and ways to advocate for freedom are carefully considered. As Black designers, we are activated by our need to not only live but also thrive in a world where Black people can freely seek healing, connection, and protection. It is this nuanced and intersectional lens that should be present in every discussion to craft policies and shift societal practices centered in collective Black liberation.

Through these themes, contributors look at how Blackness has shaped design and how design has shaped their experience. In our discourse with contributors, we asked them to consider subject matters related to anti-Black racism in branding, decolonization in design practice and education, dismantling the hegemony in the industry and academy, the Black aesthetic in design, the recent momentum surrounding issues of anti-Blackness, the canon of design, and how we and other communities can engage in design that positively impacts Black communities. Through the contributions of the authors, we have come to find that the resiliency of the Black experience is intrinsically linked to the way in which we engage in design and change the broader social, technological, economic, environmental, and political circumstances. Featured works take the form of research contributions, opinionated commentary, case studies, visual narratives, and frameworks. Each contribution investigates a unique window of time and subject matter that intersects, unapologetically, with the Black experience. Intersections of design in theories of Blackness, Black history, Black-centered curricular approaches, Black advocacy, and calls to action that support Black lives are thoroughly discussed.

An Anthology of Blackness: The State of Black Design is just one of many representations of the Black design experience. We are exploring Black intellectual and research-supported thought to better understand and facilitate the landscape of design as well as how Black designers can thrive in the intersection of identity and practice—the state of Black design. This anthology addresses cultural colonialism and systemic oppression not only through the contributions throughout this book but by the mere presence of Blackness in design too. Resistance is found in our very existence, and we use this work to pay homage to the unique ways in which we contribute to the field of design. This work reveals the influence, relevancy, and priority of centering Blackness and Black liberation as designers work collectively to fight systemic racism, racial capitalism, and patriarchy. This work makes it impossible to ignore the failures and exclusionary practices that make up the culture of design. The contributors illuminate new ways of thinking and doing to tackle our society's ingrained, systemic, and intersectional oppression.

This collection of perspectives was visioned and birthed from a diverse Black design community, and should be held in the beauty of its nuanced opinions, worldviews, and contributing writing styles—both academic and cocurricular.

It is our valuing of these unique experiences that will contribute to the fight for Black lives. This work exists to tell Black stories while intentionally furthering the accessibility of Black voices in homogeneous design spaces. The voices between these lines of texts are valuable and should be treated as such. And we call you, the reader, to action—not only by listening to, but following the leads of Black designers. There is opportunity right here to engage in ideologies that shift exclusionary design practices.

We worked closely with our publisher to maintain a strong editorial oversight to ensure the narratives of Black creatives stay unaltered in the representation of Black stories to support the overarching argument driven by a strong and cohesive vision of Black liberatory thought. In our best efforts to include a wide-reaching range of Black contributors, we will *always* fall short in the attempt to represent the full and beautiful spectrum of Blackness. *We are not a monolith*. The words written are only a few of the voices that need to be represented in design spaces worldwide.

Just as our culture shifts, time moves forward, and our knowledge increases for the betterment of humanity, inevitably so will the uses of language that may, in the future, affect the meaning of words throughout this book. We do not fear this change, however we would be remiss in not calling attention to it because we know that progress includes retiring antiquated language and adopting anew. That nuance is a welcomed part of the discourse centering Black liberation. Throughout the text, when we refer to Black people, Black communities, or African Americans, we mean those who are direct descendants of the enslaved Africans brought to the United States during the transatlantic slave trade. We also use an initial capital on *Black* as a means to honor Black individuals whose ethnicity and culture are also tied strongly with the social construct of race in the United States. With that said, we understand that the reference to *Black* also means race, but the word will remain capitalized and include other ethnicities if applicable in the surrounding context.

Editor Biographies

Terresa Moses is a Black queer woman dedicated to the liberation of Black and brown people through art and design. She is the creative director at Blackbird Revolt as well as an assistant professor of graphic design and the director of Design Justice at the University of Minnesota. As a community-engaged scholar, she created Project Naptural and cocreated Racism Untaught. Moses is currently a PhD candidate in social justice education at the University of Toronto exploring how Black liberation can serve as the foundation for design education.

Omari Souza is an assistant professor in the communication design program at the University of North Texas. He is the organizer of the State of Black Design Conference (online, April 2021). Souza is a first-generation American of Jamaican descent, raised in the Bronx, New York. He has gained work experience with companies and institutions such as Capital One, VIBE magazine, the Buffalo News, and Case Western Reserve University. Souza earned a BFA in digital media from the Cleveland Institute of Art and an MFA in design from Kent State University. His research explores the idea of perceptions and how visual narratives influence culture.

1

BLACK DESIGN

INDUSTRY + ORGANIZATIONS

An Introduction to Black Design Industry + Organizations

Terresa Moses and Omari Souza

To understand the intentionally designed world around us, it is important to continually recognize that all design outcomes are crafted within the dynamics of social power and ideologies of oppression. As a society, we can be conscious of things around us only insofar as we have ideas about them, the language to name them and thereby perceive them closely. Representation theory maintains the idea of a mediated world, where our relationships with everything we experience are continually mediated by perception and representation. So, for example, a symbol functions as a substitute for an external thing and thus our knowledge of that object is implied by the mediated lens of one's cultural frame. Centuries of imperial and commercial empires, however, have cemented a scope that almost exclusively narrates through the Eurocentric gaze.

Shaping perceptions, crafting symbols, or curating human experiences is an act of power, especially if we consider the reach of our designed products, ads, and narratives across global markets. Despite the reality of a global marketplace, the industry fails to reflect its consumer base, perpetuating harmful practices rooted in bias, bigotry, misogyny, and other forms of oppression. This is sadly due to a widespread and widely practiced culture of racism, anti-Blackness, and capitalism. So we pose the question, If culture influences what we make and how we perceive the world around us, how then can we separate the ideologies of a racist past in today's society? And second, how do we design spaces in which Black people might be safe to express their creativity, write their own narratives, and access opportunities in an industry that continues to reflect and adhere to the racist and oppressive culture?

"Black Design Industry + Organizations" aims to examine the intersection of Black identity with design practice and culture. We introduce and further explore the need for representation, creation and sustainability of intentionally pro-Black spaces, harmful practices of anti-Blackness, and access to mentorship opportunities for Black communities. Contributors investigate precisely why the design field has failed to attract Black professionals, how white Eurocentric hegemony impacts Black communities, and the potential methods and design approaches for creating an anti-racist and pro-Black design industry.

Black design and the Black aesthetic are hard to deny when we investigate the influence of Blackness and Black culture on the broader society. What exactly makes design "Black" is explored by author S. Alfonso Williams, who theorizes what Black design means and how the socio-political construct of race influences our design outcomes. We open with this contribution to reflect how we enter into this conversation and our own work, constantly in question of our own identity in a field that neither supports nor recognizes our contributions to it. Terrence Moline, the founder of African American Graphic Designers, follows this analysis with an introspective story looking at the impact of southern Black communal spaces, and how traditional principles could be utilized to establish sustainable and growth-cultivating spaces for Black designers. His exploration is a call to action for designers to craft the communities they want to see. Antionette D. Carroll echoes complementary ideas of community and the impact of collective power between the practicing and everyday designers. She provides design approaches to assist in dismantling the design of white supremacy culture and its remarkable hold on the design industry.

The design industry and design organizations work together to uphold the status quo, all while claiming their need for racially diverse and Black representation. It is a diversity problem that Jacinda N. Walker later describes as a complex, wicked problem "due to underlying problems that occur simultaneously as well as on both ends of the career path." She emphasizes the importance of

starting early with Black community members as they consider and find a place in the design industry. Similarly, Melanie Walby shares personal accounts of cultural taxation and the need for more equitable solutions to increase Black representation in the industry and organizations alike. Her stories are real-life examples of how racial diversity cannot be created without a sustained commitment to living an anti-racist lifestyle.

Omari Souza further dissects the outcomes of inequity that happen without a commitment to anti-racism. He delves into the societal branding and appropriation of Black women that perpetuate harmful stereotypes about Black identity. Jules Porter then focuses on what design outcomes could look like when crafted with Black identities in mind and at the forefront of creation in the video game design industry. What we find intriguing about these outcomes is that when Blackness is considered in all aspects of the design process, design equity can be had for all.

John Brown VI bookends this section by asserting that the future for Black designers begins through recognizing our visual predecessors in the Black Power, tribal chic, and New New Negro movements. He details how a continuation of these movements and attempts to connect to our previous design aesthetics and ideals can create liberatory futures for Black design.

We start this anthology with "Black Design Industry + Organizations" to shed light on the current, outward-facing state of Black design through the work of practitioners and the spaces that support them.

The Ontology of Black Design

S. Alfonso Williams

To understand what Black design means, it is necessary to examine the nature of design. Design takes on various roles depending on the applied context, yet its principal role is establishing the preexistence of an abstract or concrete object. A qualifier such as *Black* then adds body to the object's existence by blending subjective perception with a system of networked concepts. Not all concepts are created equal, though, as previously used concepts such as *race* and *ethnicity* were shown to possess no scientific legitimacy, despite common, everyday usage. The lesson learned is that the capacity to design concepts does not necessarily correlate with their applied usage.

Micah Bowers emphasizes the difference between art and design when he states, "Design is an art form, a method of human expression that follows a system of highly developed procedures in order to imbue objects, performances, and experiences with significance. Like all art forms, design has the potential to solve problems, but there is no guarantee that it will."[1] This definition can be modified to describe a relationship between design and ontology by restating it as such: ontology is an art form, a method of metaphysical expression that follows a system of highly developed procedures in order to imbue objects, performances, and experiences with significance. In other words, design on a universal scale has the power to shape perception and function depending on the designer.

If one takes for granted that to enter the world means to physiologically develop from dividing cell sets that come to encompass a being whose knowledge must develop over time, it is easy to see how assuming knowledge's innateness can be problematic, particularly toward the concreteness of ethnicity and race.[2] Does an infant know its racial and ethnic heritage on exiting the womb and entering the world? The answer is obvious and scientifically falsifiable in itself. The greater point, however, is that to know one's ethnicity and race ahead of one's existence would make humanity's obsession with compartmentalizing all facets of life more comprehensible—yet we know this is not the case and still persist in it.

What does it mean to be Black by design? Posing the question implies that individuals exist in a prelife waiting area. Preexistences are part of some socio-religious beliefs and mythologies.[3] Taking it to its logical end, though, implies a predeterministic problem: Given all potential outcome states, was cultural Blackness destined to be negatively perceived? Quantitatively, the answer is incalculable. Qualitatively, however, it raises some interesting questions. Here, Blackness functions in quantitative and qualitative capacities. Simultaneously, the subject reserves rights to personalize Blackness uniquely. Blackness is both universal and particular. The mathematical equivalent is a Klein bottle topology, a two-dimensional mathematical object where its exterior and interior are the same, uninterrupted surface. Yet Klein bottles do not make judgments on other objects. It is exactly Blackness's singular indefinability that allows its endless redefinition to weaken and limit its usage. Blackness's threshold—its event horizon—is the problem in question when embedded within systems of meaning.

The previous logic exercise partially demonstrates that even if race and ethnicity were a fixed and designated design element, absurdities would abound. Imagine more intense and worse off versions of contemporary socio-cultural conflicts—except that ethics is powerless to support justice. Studies such as the one conducted by the National Human Genome Research Institute in the article "The Use of Racial, Ethnic, and Ancestral Categories in Human Genetics Research" corroborate the invalidities of using racial concepts to

ground scientific phenomena and literature.[4] Yet the concepts persist in popular culture and contemporary mythologies like a chronic rash. Meaning, making is an essential part of existence. Human beings and nearly every other phenomenon in the universe cannot function without partaking in some semiotic function. Semiotics is branded as the science of meaning assignment, but its roots dig much deeper.[5] Even without the formal domain called semiotics, organic and inorganic processes alike cannot work properly if both the elements and mechanisms in play are incomprehensible and unrecognizable to one another. For example, if the nucleotide elements constructing DNA double helices are unintelligible to one another, how can genetic processes encode, decode, and pass down instructions to construct organic beings? The intelligibility and precision of DNA encoding is a testament to human(like) brains not being a requirement for semiotic functioning, formally falling under the domain of biosemiotics.

The curious question arises, then, that if neither biology nor ontology need racial and ethnic concepts, and if these concepts are human conveniences for categorizing, why obsess on maintaining them? The answer is not straightforward in any sense, and in the author's opinion, requires the transdisciplinary bridging of various domains such as semiotics, philosophy, media ecology, evolutionary anthropology, (neuro)psychology, the complexity and systems sciences, and other affiliates. Philosopher Gilles Deleuze and psychoanalyst Félix Guattari in their seminal book *A Thousand Plateaus: Capitalism and Schizophrenia* speak of how the essence of a face is overcoded onto the head's physiology, saying, "The head, even the human head, is not necessarily a face. The face is produced only when the head ceases to be a part of the body … when the body, head included, has been decoded and has to be overcoded by something we shall call the Face."[6] Their argument reasons that the concept of a face is artificially imposed onto the body and not inherent to human physiology's organizational process. The face is a sense-making tool to understand what the body does not overtly explain. The face *mediates* the subject's perception of biological design. Canadian media ecologist Marshall McLuhan in *Understanding Media: The Extensions of Man* powerfully wrote, "All media are active metaphors in their power to translate experience into new forms... . [T]hey are a technology of explicitness. By means of translation of immediate sense experience into vocal symbols the entire world can be evoked and retrieved at any instant."[7] The crux of Deleuze, Guattari, and McLuhan's arguments in relation to semiotics and design stress the human's necessity to manipulate perceptual meanings to make design comprehensible.

Black design can be interpreted, then, to be a human attempt to make sense of an environment that perceives it as hostile and threatening. This environmental feedback helps flesh out the form Blackness takes in specific individuals and groups to create a diverse network of subjects who collectively expand the definition of Blackness. The important takeaway is that each subject must design Blackness for themselves since is not

predetermined. Their design will continually evolve with their experiences and environment, resisting any static definition. With enough care and understanding, designing Blackness this way can be holistically beneficial instead of being a response to an impending threat, a protagonist to an antagonist, and vice versa. The difficult work begins with humbling oneself and understanding the role of design in human choices and experiences.

Biography

S. Alfonso Williams is a respiratory therapist in training and an interlocutor engaged with various scholastic domains, such as philosophy, psychoanalysis, psychology, media ecology, semiotics, science, and clinical medicine. He has a special interest in subjectivity, particularly toward behavioral systems and emergent behavior. Apart from scholastics, Williams deeply enjoys drawing, film and cinema, staying healthy, and finding new questions to engage the world with. He graduated from Case Western Reserve University in his hometown of Cleveland, Ohio, with a bachelor's in art history and sociology, and will complete his associate's in respiratory care at Cuyahoga Community College in spring 2024.

Acknowledgments

I would like to give a tremendous thank you to all who have supported my career and presented opportunities through this point, including Nicol A. Barria Asenjo, Slavoj Žižek, Carl Abrahamsson and Vanessa Sinclair, Robert Beshara, *Stillpoint* magazine, Clint Burnham, Blake Light, James W. Williams, Ed Heilman, Hafidha Saadiqah, the Cleveland Museum of Art, Case Western Reserve University, Cuyahoga Community College, and Phi Theta Kappa.

Stewardship and the Survival of Black Design Communities

Terrence Moline

Racial segregation was surely hateful, but let me tell you, friend, that if I knew that its return would restore our Black communities to what they were before desegregation, I would think such a trade entitled to serious thought. —Geneva Crenshaw, the fictional heroine of *And We Are Not Saved: The Elusive Quest for Racial Justice*[8]

This is a warning.

I'm writing this because I feel that we abandoned Black culture and institutions after integration. I do not know if we hold ourselves accountable for that outcome. Some of us blame racism for our shortcomings, leaving little room for honest self-evaluation and community assessment. Those two choices make the critique of our cultural shortcomings challenging. They cause a lack of discernment that inhibit growth. Critique is necessary to the function of any human system. To break the cycle of abandoning our Blackness, we need to design better systems of critique, feedback, and stewardship for the survival of the Black community. Over the fifteen years of running a national online family of African American / Black (AA/Blk) graphic designers, African American Graphic Designers (AAGD), I have observed that we spend much time focusing on how other people and institutional systems hinder our growth. I have also noticed the unmeasurable amount of energy, talent, and intellect our tribe has. I often wonder, If we focused on our strengths and designed better ways to sustain the community, what could we accomplish? From listening to our congregation, spending weekends on research, and having conversations with elders, I have concluded that we need active design solutions to aid in the survival of Black creative, safe spaces. The three areas we need to concentrate on are saving strong community traditions, embracing accountability, and understanding our roles in the lineage of Black survival to help the next generation succeed.

The Fading Art of Stewardship in Our Community

On any given Wednesday back in the 1980s and 1990s, my parents welcomed almost anyone into our well-lived-in house. Sandra and Marcel hosted home meetings, which were an extension of our church. Our place was not huge. It was a little over a thousand square feet. We always *always* had food ready—red beans, fried chicken, pound cakes, and punch bowls; that level of hospitality was part and parcel of being a New Orleanian. Our living room, at its finest, was adorned with plastic-covered, faux-velvet, yellow couches that had emerald-green trim. We had a walnut-brown piano on pecan-colored covered wood floors that I waxed—on hands and knees—to prepare our house for guests. Though I sometimes despised the rituals and getting ready for these events, the reward was always worth it. We were part of a small community of beloved individuals who were play cousins, aunties, uncles, and mentors. We built trust and commitment to each other as we worked toward our common cause of strengthening ties.

I don't know if AAGD would exist without my upbringing.[9] Those rituals planted the seed of community and stewardship. These are the ways the community meetings made a difference in my life:

- I learned to appreciate the labor of carefully preparing for guests
- I watched my parents model generosity by willingly giving whatever we had
- I saw the ability to craft our own culture
- I felt the warm reception of my contributions to our gatherings
- I understood the implications of preparing enough food for people to take home extra plates

To this day, if I receive an invitation to speak at an event, I always offer to help the conference hosts clean up or stack chairs. You would be surprised at how many people take me up on this offer. At the last conference I attended, I helped them roll up the backdrop. I pretty much did it with a drink in my hand, but offering to do something sometimes means a lot. Nowadays, online social activity replaces meeting in person, hanging out at a mall, or preparing a place for visitors. Still, I want to make a pact—yes, you and me— to consciously preserve and honor the spirit of the Black church, family barbecues, and small satellite gatherings like the ones curated by my mom and dad. These traditions are worth preserving. They can keep our identity solidified and our culture nurtured as we travel through digital spaces.

Accountability Is the Heart of Community

To practice being a better steward, I am also part of a few groups I would love to mention: #AllBlackCreatives, African-American Marketing Association, Black Marketers Association of America, and Black Copywriters Association. In our talks, we discuss our shared challenges, and across the board, the core

challenge is accountability. The Black people in our creative circle are some of the most outstanding minds I have ever encountered. I do not doubt we have already come up with the solution to bridging our talents to solve real-world and industry issues. If we do not show up and follow through, however, all the talk is a waste of time.

Our problem: we need to put a higher value on accountability to make any imaginable world tangible.

I believe accountability has the strength of watered-down drinks at outdoor festivals. Everybody needs an accountability partner, and it is often the first conversation I have with other creatives. Yet we rarely define what it means for each of us. Our group, AAGD, has been through several prototypes of accountability programs. Unfortunately they have failed, but we learn through each iteration and realize we cannot have accountability initiatives without addressing or defining accountability. I thought I understood what accountability meant until I started researching it and realized how subjective it is. That is why we need to set the rules for each other. Below I break down and reframe what it means to be held accountable.

Account
What is in your account is the résumé of your deeds. The worth of your account is measured by how you choose to spend your time, a record of what you create, a history of how you make your money, a track record of who you work with, a ledger of how frequently you give and pay credit, a chart of how often you keep your word, and a report of how you show up. It is everything. It is an index of who you are and how you build your brand. What is in your account is a form of social wealth. It is an antidote that helps cure imposter syndrome because despite the voices in your head, you know your record of accomplishment. It is an internal and external practice that is more powerful than any résumé. It is building equity in community trust at its most basic form. Once you have done the internal work and possess the skill of monitoring the wealth of your deeds, that is when you pair this strength with your abilities.

Ability
Ability is the manifestation of skill. You now know how to manage your account. You have done the internal work. You have practiced holding yourself accountable. Ability is also a choice. How you use the agency of your account is a matter of curation. You create your opportunities. As a creative, you have the privilege of communicating messages that help connect ideas to identities. You can use your skills for commerce and help our communities survive.

Accountability
These two concepts mesh together when we invest the wealth of our accounts into each other and use our abilities to encourage each other to reach greater

heights. In the online discussion Consent Is Accountability, Stas Schmiedt explores this concept further, stating,

> We think of accountability as holding someone else accountable, but I feel like it really starts with holding yourself accountable. ... It's really about thinking about your choices, thinking about the options that you have, your desires and your drives, your values, and being aware of your agency within those different competing things. Recognizing your ability to make choices that align or having made choices that didn't align with your values and figuring out what it takes to address any impact on yourself or on others based on those choices.[10]

We cannot expect the hopes and dreams of our community to manifest if we do not make an effort to define accountability and act on that definition. We have to practice accountability too. Accountability is a muscle. It can atrophy, and you will have nothing in your account worth sharing with the community. We need to develop more programs that produce accountable athletes. Through more thoughtfully designed regiments, our community will stand a better chance of shaping creatives with stronger shoulders to sustain future generations.

Becoming Giants

Old sayings need contemporary perspectives. We state that we are standing on the shoulders of giants. While this saying gives credit to our ancestors for their sacrifices and work, it does not speak to how we contribute to this lineage. We need to examine our roles and review our intentions. We also need to analyze our actions in preserving Blackness based on what we can learn from our historical leaders to progress as a people.

I have noticed an explosion of efforts to build personal brands and inclusive communities. I had a conversation with the design oracle Cheryl D. Miller. She noted, "We're getting wider, we're covering more breadth, but where's the depth?"

I believe the depth happens when we become more accountable to each other and assume the role of helping people become giants by being a bridge between generations. In terms of bridging generations, our elders have no interest in the realities of working in a creative field. Instead, they would rather disdain our conditions and criticize us for "kowtowing" to technology without realizing our reality is automation and outsourced design. Some younger members seem to grasp the personal benefits of the power of organizations. Still, they are stuck in the illusion of individual celebrity and branding.[11] And it is difficult for them to hear the voices of our elders because in many ways, they speak different languages.

We have to see past our differences. Call our communication coaches and soldiers to act as bridges; use empathy to hear and collect our stories; and

use media to preserve our powerful lineage. We become giants by reverently respecting and researching our past. We become giants by being present enough to see our future. We become giants by embracing all shades and microslivers of Blackness to glean insight from diverse perspectives. The United States' future may be good or bad. We have to design solutions together because without each other, we will not survive.

Conclusion

I called my parents the other day to ask them how they felt about accountability in the Black community. Through their leadership in religious communities, they have seen changes in the ability to keep congregations strong. My dad said, "Yeah, I'm eighty and still picking up chairs, and if the younger people see me picking up chairs, they assume it's my job. No one lifts a finger to help out." I talked to some members of our community, and Emelia Hollis observed, "Accountability to me is being honest with myself and those around me and owning my own contributions to a situation. My parents taught me accountability." As much as I want to talk about the nuances of being a great commercial artist, I have known that designing for capital has never been my reason for being. W. E. B. Du Bois stated,

> Thus all art is propaganda and ever must be, despite the wailing of the purists. I stand in utter shamelessness and say that whatever art I have for writing has been used always for propaganda for gaining the right of black folk to love and enjoy. I do not care a damn for any art that is not used for propaganda. But I do care when propaganda is confined to one side while the other is stripped and silent.[12]

I do not give a damn about design awards, being patted on the back by "time-honored" organizations, or the commingling of traditional design agencies. I hold myself accountable for the advancement of Black creatives, the Black community, and Black identity. I use design thinking as a lens to look at our current issues and work through our community to solve the United States' wicked problem: *racism*. I have chosen to be the bridge between what my parents cherish and what the next generation needs to know to survive. I have pledged to use my abilities to rage against anti-Blackness, antiotherness, and those who fight for the myth of white supremacy. There is an apparent urgency as the United States further divides and—honestly—continues to use the media to disseminate lies.

My message to fellow creatives is: before it is too late, we need to review our responsibility to the community and each other. We cannot continue to make the same mistakes. We can continue the great work of our giants and play our role in uplifting the existence of Black life. And these acts will make it easier for AA/Blk designers to gain more ground in the world of creativity for community change.

Biography

Terrence Moline lives by design. He resides at the corner of marketing and art by utilizing his skills to create identities, communities, and communication. With over twenty-five years of industry dedication, his illustration, strategy, and design have helped raise the profile of community causes and educational organizations. Moline is also the founder of and head listener at African American Graphic Designers (AAGD.co), the largest collective of AA/Blk designers who collaborate while growing as a family.

Acknowledgments

I would like to thank my parents, the giants in my life. My sisters, Tiffany and Robyn, who kept me in check. The people who help me maintain AAGD: Richard Manigult, who has been an amazing steward of our community since day one; and Ron Tinsley, Denishia Macon, Jakia Fuller, Lafe Taylor, Monna Morton, Juan Roberts, Nigeria Riggins, Camille Fletcher, Gabi Zungia, and the AAGD core, Dave McClinton, Nakita Pope, Russell Toynes, Jordon Moses, Terresa Moses, and Chiara Bartlett, for helping to keep our community and agency a safe haven for AA/Blk creative genius. #ItTakesAVillage.

Shattering Spaces of Othering: Building a Creative Culture of Creativity, Blackness and Brown Power

Antionette D. Carroll, supported by Maya Aduba Williams

White supremacy culture, ableism, devaluing, and othering is everywhere and within everyone. Whether creating a policy or designing a curriculum, the culture in which we have been socialized shows up within every one of our words, thoughts, and actions—whether intended or not. The work of unpacking and unlearning harmful practices, and the realities we define as "normal" or "common sense," are constant, difficult, and messy.

What Is Design?

Reflecting on my self-identities of being a Black, African American woman, living in the United States, and growing up economically underinvested, I realized that my mindset and perspectives were not my own. My perspectives, like everyone else, have been shaped by my environment, education—especially as a first-generation college student, with neither parent graduating from high school—the media, and my family, friends, and culture.[13] My background and personal experiences contributing to a poverty of mind and spirit began to permeate into my professional worth, and thus the industries and companies in which I forfeited my power to fit in. My industry of design and communications taught me that we were visualizers, strategizers, and so-called empathizers of society. I was taught that you "cannot NOT communicate," a quote from David Carson, and that everything was by design.[14] I was also made aware that in the 1960s, IBM defined design as the intent behind an outcome, and that outcomes are everywhere.[15] To this day, I still believe both of these mindsets to be true, albeit my company, Creative Reaction Lab, has expanded IBM's definition of design to include the impact behind an outcome being just as important as the intent.

It Is by Design

Designers are more than our craft. We are makers and navigators of ambiguity and complexity. If and when we challenge negative or bad designs, however, we primarily focus on superficial issues such as horrible kerning, lack of alignment, or not connecting with the right audience—the audience primarily defined by the client and not the community impacted by issues that truly matter. The critical analysis of systemic design along with the outcomes of oppressive policies, programs, businesses, learning experiences, and organizational cultures are absent—or worse, erased when historically underrepresented and underinvested community members speak of exclusion, lack of belonging, and systemic inequities.

The act of designing by nature is to hold power. And yet the powers that we center are namely white cisgendered men from privileged backgrounds.

For example, even though Black women are said to be the most educated group of people within the United States, we occupy some of the fewest seats in design spaces or within executive leadership positions. Additionally, according to the 2019 Design Census, an annual study of the industry cocreated by myself, Jacinda N. Walker, and Google, Indigenous designers were the only group represented even less than Black women within the design field.[16] Oftentimes, for Black and Indigenous creatives and creatives of color to be seen, heard, and recognized, they must intentionally create spaces for themselves to thrive in design and creative thinking spaces. Due to the lack of sustained resources and social capital, which is diluted by stereotypes and power hoarding, this also puts Black people, Indigenous people, and people

of color at risk of having their ideas and content stolen, further perpetuating their traumatic experiences. And unfortunately, this is a reality I have known all too well.

The world we navigate has been by the design of people who have been in historically centralized positions of power through the intersectionality of many lenses such as race, ethnicity, ability status, religion, gender identity, sexual orientation, and residential status. Black and brown people, both historically and currently, are largely excluded from traditional design spaces. Their contributions to the industry have been either disregarded or stolen. Historically, inventions that were created by enslaved African people belonged to their masters, and were inaccurately credited to their slave owners with no intellectual acknowledgment or financial compensation. We can see this cycle being repeated by organizations with more historic power and the privileged creators that leverage their socially assigned credibility for personal gain and benefit. One example is the decentering of Black creators and their contributions on TikTok. Joanne (@leafjooce) on Twitter emphasizes this ideology when they state,

> White colonizers have looted and exploited indigenous/poc lands, bodies, and cultures for centuries for their own gain under the guise of religious virtue and manifest destiny. It comes as no surprise as design agencies replicate this extraction and universalizing, reinforcing white cultural hegemony and stealing from the work and lived experiences of black intellectuals to virtue signal, all without attribution. #CiteBlackWomen[17]

Most executive positions, particularly in the design industry, continue to be occupied by fewer Black, Indigenous, and people of color, perpetuating the "only one" narrative that continues to create skewed power dynamics within classrooms and work spaces. Unfortunately, the few designers of color who are in primarily white spaces experience issues such as tokenism, microaggressions, isolation, and compounded trauma. Yet oftentimes we are taught to fight for a seat at the table, or to pull up a chair if no seat is available.

We Need to Build

I question why we are so focused on just a table. What about owning the room, building, or neighborhood? While newly wealthy white male bitcoin founders are looking to create their own cities, Black, Indigenous, and people of color are primarily taught to fight for the table located in one building in one of their cities. This is a successful design of generational devaluing that furthers the racial wealth gap and cements the ideology that makes everyone nervous: *white supremacy*.

Kenneth Jones and Tema Okun define white supremacy in their "Dismantling Racism Works Web Workbook" as the ideology in which white people and the ideas, thoughts, beliefs, and actions of white people are positioned as superior to people of color and their ideas, thoughts, beliefs, and actions.[18] Beyond ideology, white supremacy culture manifests interpersonally and structurally. White supremacy culture upholds that we should be emotionally objective, and promotes a belief that emotions are destructive and irrational. Employees and students who speak out are frequently silenced or gaslit in the name of the institution's traditional right to comfort and power.[19] It is unclear that these workplaces know that these actions are all symptoms of white supremacy culture because it is hard to see white supremacy culture when it is so embedded.

White supremacy culture is so prevalent that it is even embedded in design frameworks such as the design thinking process that has been prioritized and centered in the industry as the *right way* to solve problems. When compared to the characteristics of white supremacy culture, design thinking models perpetuate these same tenets as defined by Jones and Okun: power hoarding, fear of open conflict, right to comfort, individualism, progress is bigger (more), objectivity, one right answer, either-or thinking, perfectionism, sense of urgency, defensiveness, quantity over quality, worship the written word, and paternalism.[20]

To avoid perpetuating white supremacy culture, it is important to consider the sources and impacts of exclusion and inequities. Who defines design and the ever-expanding process of design thinking? Although women and people of color have created and led creative problem-solving processes for centuries—you can't tell me that Harriet Tubman was not a design thinker and trailblazer—the individuals credited as the creators and expanders of design thinking have historically been white men (i.e., Tim Brown, David and Tom Kelley, Richard Buchanan, Victor Papanek, Herbert Simon, Buckminster Fuller, and the like).[21] This is not surprising, especially with over 70 percent of the design industry being white. When it comes to shaping the system, white people hold most of the power as well as benefit from narratives that center them and their comfort levels. How is it, then, that we might build a collective culture of creativity centering Black and brown identities?

Damn the chair, I want to own the building.

Creative Reaction Lab

I founded Creative Reaction Lab in 2014 as a response to the Ferguson uprising, sparked by the murder of Michael Brown by police. As a former Ferguson resident in Saint Louis, Missouri, I needed to create a space of community ownership, creative exploration, and action. Concurrently, I was just named the chair of the inaugural Diversity and Inclusion Task Force of AIGA—the

professional association of design. The task force was in its third iteration of a community-led attempt to use AIGA as a vehicle for systemic change in the creative industry. This was a huge undertaking as I attempted these two prototypes toward inclusion and equity while building my own acumen as an intrapreneur through AIGA and entrepreneur through Creative Reaction Lab.

When designing spaces of inclusion, belonging, equity, and liberation, it is important to understand the power, risks, and emotional labor that this work entails. Through the building up of my own understanding in this work, I have learned valuable lessons through my failures. These include:

- Challenging the idea that being "human centered" is enough.
- Acknowledging that diversity and equality efforts are just unsustainable window dressings without the individualized and community-centered outcomes of inclusion and equity.
- Understanding that biases and the ability to hold and wield power are inherent in *everyone*.
- Recognizing that an equitable design does not exist without community ownership, the centering of lived expertise, and the allocation of resources.
- Prioritizing language setting as the first step in any equity-centered and community-based work. Shared language must continually be referenced and addressed throughout the design process. If we cannot clarify and cocreate language together, how are we going to cocreate interventions addressing systemic oppression together?

We are all designers with the power to affect outcomes. Given this, we have to hold ourselves accountable to the responsibility we bear to improve outcomes for the betterment of our communities. Accountability is key in healing work, especially when dismantling oppressive systems and addressing inequities. Jennifer Joy Butler emphasizes this point in her article "How Accountability Will Lead You to Heal and Move On" when she states, "When we choose to be accountable, we become willing to take an honest look at how we have contributed or co-created the situations in our own life."[22] As designers, we have to acknowledge that our contributions—our designs—impact the lives of others every day. Our practice affects people's perceptions about themselves and others in relation to life expectancies and quality of life. Our designs influence systems and people, not computer screens and sheets of paper.

Creative Reaction Lab is one of my designs that is actively working to produce equity and liberation for Black and brown communities. We are not just focused on visual representation but also amplifying living expertise. Creative Reaction Lab is a social enterprise working to educate, train, and challenge Black and Latinx youths to become leaders, designing healthy and racially equitable communities in Saint Louis and throughout the United States. We are globally working with institutions and employees alike to

build and shift their diversity awareness to action for equity, because it is not only the responsibility of the living experts in historically underinvested communities to address the designed systems of oppression, inequality, and inequity. It is about individuals and institutions alike building their personal and organizational humility and empathy while leveraging their power and access on behalf of the living experts.

These living experts are not just passive people who understand the impact of day-to-day oppression. They are a new type of civic leader that we need in our communities—our Redesigners for Justice™.[23] We are building a movement of Redesigners for Justice™ to imagine and cocreate a new world with people and equity at the center while amplifying the cultural assets already working within our communities. Building on resilience and organizing models already embedded within our communities and creative problem-solving spaces, we cocreated an evolved approach to addressing inequities that we call Equity-Centered Community Design (ECCD).

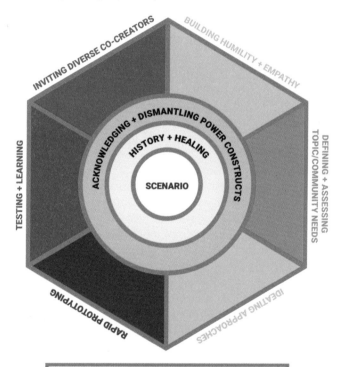

Equity-Centered Community Design (ECCD). Graphic design by Creative Reaction Lab. crxlab.org/our-approach.

ECCD is a unique creative problem-solving process based on equity, humility building, integrating history and healing practices, addressing power dynamics, and cocreating with the community. This design process revolves around a community's culture and needs so that it can gain tools to dismantle systemic oppression and create a future with equity for all. Creative Reaction Lab's goal is to share ECCD to achieve sustained community health, economic opportunities, and social and cultural solidarity for all. Through ECCD, we are building and supporting an emerging movement of Redesigners for Justice™ that takes on systems with self and systemic awareness of oppression, creativity, and action. The movement is made up of designers, students, activists, organizers, educators, government staff, hospital workers, technologists, and beyond who seek to disrupt and dismantle these challenges in, with, and by their communities.

Currently being utilized across the globe, ECCD was recognized as a Fast Company World Changing Idea finalist. And while awards in the design industry are credibility signalers, the most powerful but forgotten part of ECCD is that it was cocreated by women and nonbinary people of color (myself, Erika, and students Amelia, Eva, and Jewel). ECCD was made for the benefit of people historically underinvested but beautifully resilient and joyful.

Challenging Social Norms

Building an organization and movement that challenges generational trauma, othering, the sustainability of inequities, internalized oppression, harmful power dynamics, and the tenets of white supremacy is complex, messy, and hard. Failure is daily because there is no preestablished road map to equity. We are challenging centuries of oppression that has masked itself as *societal norms*. Additionally, unpacking biases, privileges, unseen areas, and power alongside working to redesign a system of liberation and justice that only lives in our imagination requires social and financial capital that has yet to be acquired by any equity practitioner, practicing designer, or community organizer. Therefore collective power between practicing *and* everyday designers is required to actively redesign our classroom, workplace, and societal cultures of belonging. We cannot claim to design *for* or *with* others without keeping them at the center of the design process. Those who are closest to the challenge know more about how and what to change. Jacinda N. Walker, founder of designExplorr and my AIGA Diversity and Inclusion Task Force chair successor, believes that "we no longer should have to work, study, and live in spaces in which we are the *only*."[24] I agree. I want to contribute to designing a system in which supremacy and othering of any type does not exist, but instead collective liberation becomes *common sense* and the *norm*.

Cathedral Building Activity at the Winter Wellness Retreat. Photography by Antionette Carroll, 2021.

Antionette D. Carroll is an African American, Saint Louis native who is the founder, president, and CEO of Creative Reaction Lab. Carroll is an equity, diversity, and inclusion specialist, designer, and trailblazer of the ECCD framework and Redesigners for Justice™ leadership model. Within her almost ten years of volunteer leadership, Carroll was named the founding chair of the Diversity and Inclusion Task Force of AIGA—the professional association of design. She's a former AIGA national board director, and currently an Aspen Institute Civil Society Fellow, TED Fellow, and GDUSA Person to Watch.

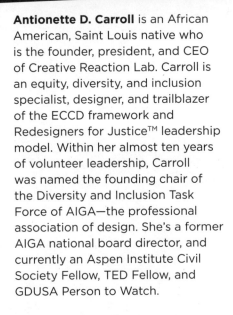

Maya Aduba Williams is a Nigerian American, Texas native who serves as the people engagement and impact director at Creative Reaction Lab. She is a diversity, equity, and inclusion practitioner, evaluations consultant, and educator. Williams is passionate about using data to support and improve the experience of Black people, Indigenous people, and people of color, and has developed her professional career to understand survey design and data analysis. Her research interests include intersectionality, health equity, anti-racist pedagogical strategies, education policy, and organizational strategic planning.

So, You Want to Solve the Diversity Problem in Design

Jacinda N. Walker

The lack of Black representation in the field of design unfolded during the beginning of John F. Kennedy's presidency. After years of segregation and investigations about racial inequities, US president Kennedy started having conversations with many national leaders and officials to get input and support for a civil rights bill. The opportunity to move this conversation to the forefront of our nation presented itself on June 11, 1963. The then governor of Alabama, George Wallace, attempted to uphold his campaign promise of "segregation now, segregation tomorrow, segregation forever" by refusing to allow two Black residents to register for classes at the University of Alabama.[25] This confrontation of state and federal authority to block segregation is now known as "the Stand in the Schoolhouse Door."[26]

Although Wallace's efforts to protect the nation's last all-white state university were thwarted, it did provide President Kennedy with the perfect occasion to appeal to the nation with his first speech on civil rights about the "moral crisis" and introduce his thoughts on the necessity of a civil rights bill. During his speech, Kennedy called on Congress "to make a commitment it has not fully made in this century to the proposition that race has no place in American life or law," and guarantee that the United States is the "land of the free" for all citizens.[27] After the address, he spent months going back and forth with the House and Congress. Then finally in October, the House Judiciary Committee passed the bill. Four weeks later, Kennedy was assassinated.

In an attempt to see Kennedy's bill through, his predecessor, Lyndon B. Johnson, spent eight months working to release the stalled legislation. Then on July 2, 1964, the Civil Rights Act was signed into legislation, outlawing discrimination based on race, color, religion, sex, or national origin. Many citizens thought that the hard work was done. Unbeknownst to these citizens, the hard work was only just beginning. In fact, the very next day, companies, organizations, and several institutions started silently opposing the new law by creating policies to block the access of those who had just received their civil liberties. Today, this practice is defined as *institutionalized racism*. It consists of the structures, policies, practices, and norms resulting in differential access to the goods, services, and opportunities of society by "race."

In June 1968, following the collision of institutionalized racism within education, public housing, and architecture, the first historical reference to the lack of racial diversity in design and social responsibility was publicly mentioned by Whitney Young Jr., the executive director of the National Urban League.[28] Young was invited to address the attendees at the American Institute of Architects convention in Portland, Oregon, about the urban environment and what the American Institute of Architects could be doing to better advance the cause of civil rights in communities, neighborhoods, and cities. As he stood onstage, looking into the all-white male audience, he said, "You are not a profession that has distinguished itself by your social and civic contributions to the cause of civil rights. ... You are most distinguished by your thunderous silence."[29] His words struck the convention goers deeply, prompting their first strategic initiative, the Minority-Disadvantaged Scholarship. Although the name of the scholarship was quite oppressive, the scholarship aimed to help students studying to be architects, designers, and educators teaching architecture as well as aid those working on their certification.

The ramifications of the Civil Rights Act, institutionalized racism, and mass incarceration are still being seen throughout the design profession in the form of detrimental attitudes in education, discriminatory hiring practices, cultural insensitivities, and minimal diversity-building initiatives. Increasing racial diversity in design is important because—when cultivated and sustainably retained—it generates more ideas, better solutions, and increased innovation.

Diverse representation creates opportunities for racially underrepresented populations, and most important, it will provide characteristics to viable solutions to increase Black representation and contributions in design.

Understanding the Problem

In order to better understand the dilemma that a young Black person faces when they are interested in a creative career, designers must address the scarcity of Black designers and magnitude of problems simply trying to exist within the field. Limited access to education and knowledge of career planning, an absence of design role models, a lack of career preparedness, nonexistent workforce growth opportunities, and poor resources to stay abreast of changes within the profession are just to name a few. Access to education deeply affects career opportunities and career choices, particularly among the most vulnerable populations—those people deal with various personal, social, and economic obstacles that already impact their career choices.[30] Poor educational funding along with systemic disregard for overwhelmingly Black and brown school systems impact the quality of instruction and course offerings at underresourced institutions. This underlying inequity in educational programming across US institutions has far-reaching societal implications (salary gaps, career trajectories, etc.), which solidify racial and class divides.

The process of closing the racial equity gap in design is especially complex due to underlying problems that occur simultaneously as well as on both ends of the career path. Problems on one end of the career path relate to access and exposure, which impacts course offerings and instruction for Black youths in their local community schools. The problems on the other end relate to the opportunities provided to Black professionals, which are limited due to systemic prejudices, especially among those who monitor the distribution and application of funding for education. But for the traveler on their career path, the problem is related to where they are on the journey. Together these factors create the current problem of ethnic and racial homogeneity within the design profession.

A complex problem is typically characterized by a system of causal relationships wherein the effect of a change in one part of the system may have long-term and difficult-to-predict consequences.[31] The term *wicked problem* was first coined in 1973 by design theorists Horst Rittel and Melvin Webber.[32] A wicked problem is a social or cultural problem that's difficult or impossible to solve because of its complex and interconnected nature. The phrase was also used in the context of social planning; the term *wicked problems* had been popularized in the 1992 article "Wicked Problems in Design Thinking" by Richard Buchanan.[33] Wicked problems lack clarity in both their aims and solutions, and are subject to real-world constraints that hinder risk-free attempts to find a solution. Rittel and Webber describe the characteristics of

wicked problems.[34] The three characteristics that are pertinent when exploring the lack of racial diversity in design are:

- Solutions to wicked problems are not true or false (right or wrong); they can only be good or bad.
- Every solution to a wicked problem is a "one-shot operation" because there is no opportunity to learn by trial and error; every attempt counts significantly.
- Wicked problems do not have a set number of potential solutions.

The lack of Black representation in design is a complex wicked problem that has multiple layers connected to numerous societal circumstances that happen throughout the design journey. This problem should be considered in the context of particular communities, which adds more nuance when considering the treatments, strategies, or interventions. In a context, the way to address the problem becomes clearer—creating personalized impact for those affected. Tackling wicked problems means believing every attempt counts, which in turn equates to multiple solutions. The five steps in tackling wicked problems are: break down information into nodes and links, visualize the information, collaborate and include stakeholders in the process, release solutions quickly and gather continuous feedback, and carry out multiple iterations.

The journey to becoming a designer has not been visualized, particularly considering the unique journey for Black youths. If designers, educational institutions, and organizations are able to agree on the important milestones that mark progress from one stage of a career to the next, it will be easier to communicate the objectives to students and parents. This increased transparency about a design career could illuminate paths to opportunity and better equip travelers to face challenges along the way to a design career. In my solutions-based thesis, I created the Design Journey Map (DJM) framework, fifteen strategic ideas, design principles to measure strategic solutions, and designExplorr, which does the day-to-day work to increase representation within the design profession and demonstrates how these tools can be used to close the racial diversity gap.

About designExplorr

DesignExplorr is a social impact organization and enterprise whose mission aims to racially diversify the design profession by increasing access within education and corporate organizations. We do this through collaborations that develop youth programs, coordinate diversity-building initiatives, and connect stakeholders to resources. The number one design goal is to empower today's youths with real-world skills, connections, and opportunities so that tomorrow's design profession has all the best people leading the way. Since its brief inception, designExplorr has reached more than fifty-five hundred youths. We have been commissioned to execute the Design Diversity Index,

work to diversify the Amazon Design internship pipeline, develop mentorship programs at Target, coordinate youth activities with Cooper Hewitt, Smithsonian Design Museum, and present this important research work to several organizations.

The DJM

The primary tool used at designExplorr to address the lack of racial representation is called the DJM. This framework is a visualization used to help students, parents, and educators chart young people on a course to a design career from grade school to a seasoned professional. This tool offers a simplified, long-term view of the steps that a person travels on their design journey. The map is divided into four color-coded bends labeled "passages," which are overlapped with "career competency" components. The passages are:

- Foundations, which include public school systems and extracurricular activities such as after-school programs or community activities akin to summer camps, recreational events, and museum programs.
- Proficiency, including higher education (in a degreed vocational, college, or university program), internships, and graduate education.
- Workforce, which includes freelance work, institutional employment, and entrepreneurship.
- Influence, representing policy makers and influential individuals such as faculty educators, managers, chief creative officers, and retirees.

Career competency components have been added due to the necessity for individuals to develop and cultivate soft skills simultaneously with the hard skills they learn throughout their journeys. Each passage identifies the recommended steps that a designer should travel throughout the design journey. The gray triangles on the inner circle of the passages on the map illustrate the gaps where transitional leaks or stops occur while a designer is traveling from one passage to another on their journey. Although it is possible for a traveler to jump passages, it is not advised because each passage on the DJM is specifically crafted to provide unique opportunities and professional competencies.[35]

Design Principles

The second tool I use involves four design principles. These principles measure strategic solutions directed to close the racial diversity gap within the design profession and increase representation for marginalized youths interested in creative careers. The principles are broken down into four categories—comprehensive, collaborative, local, and scholastic—and are based on real-life experiences. They break down the barriers that prevent entry into education, success, and careers for Black and brown communities.

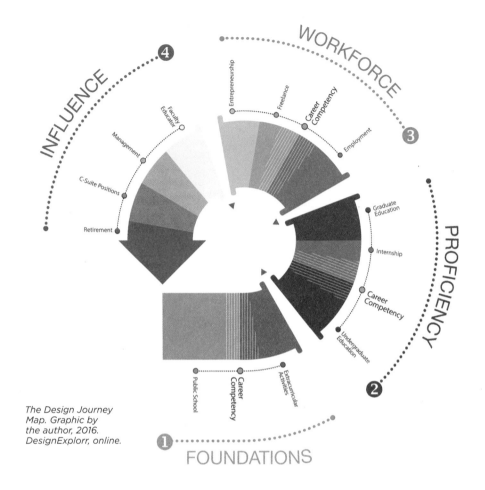

The following labels appear around the Design Journey Map diagram:

WORKFORCE

INFLUENCE

PROFICIENCY

FOUNDATIONS

① ② ③ ④

Entrepreneurship
Freelance
Career Competency
Employment
Faculty Educator
Management
Graduate Education
C-Suite Positions
Internship
Retirement
Career Competency
Undergraduate Education
Public School
Career Competency
Extracurricular Activities

The Design Journey Map. Graphic by the author, 2016. DesignExplorr, online.

Principle 1: Comprehensive
In order to be effective, the strategic solution must first address multiple passages along the design journey. A solution that meets multiple passages on the DJM has a far greater chance of assisting the greatest possible number of individual stakeholders including students, parents, educators, guidance counselors, administrators, and schools. Such a solution may help to address any transitional leaks relating to access, exposure, opportunity, and value. Moreover, meeting multiple passages ensures greater possibilities for implementing multiple strategic ideas.

Principle 2: Collaborative
Closing the racial diversity gap in design disciplines is a complex problem. Complex problems are best solved through cooperation by a diverse body of individuals, stakeholders, businesses, and organizations. This means that organizations such as AIGA—the professional association of design—and the

Industrial Designers Society of America should be working together to create common practices that will address diversity problems across the discipline. By the same token, professional designers will need to work together with educators in order to work toward this common cause of promoting racial diversity in design. Fashion designers must work with architects, parents must work with designers, and administrators must work with businesses.

Principle 3: Local
The strategic solution should meet students in their own communities and local schools. Although there are many opportunities for students to encounter design outside their local communities, bringing design opportunities and experiences to students eases the burden on parents by meeting students in environments where they are already learning. Taking the solution to the students is also a great way for the design disciplines to become more engaged with and visible in local communities. Moreover, this principle will encourage more collaboration within the group of stakeholders.

Principle 4: Scholastic
The strategic solution must have an academic and/or college and career readiness component. If design programs and initiatives committed to exposing Black youths to design disciplines do not include academic components, their efforts will be minimally impactful in the long-term. Indeed, long-term career success ultimately depends on educational attainment. Students who do not meet public school graduation requirements for English, geometry, or foreign language competency have a lower chance of graduating high school and attending higher education institutions where they will be able to pursue their interests in design. And when design programs and initiatives work in conjunction with academics, students are exposed to greater career opportunities.[36]

These two tools are used every day in tandem at designExplorr to create and measure all of our initiatives, programs, and activities. Applying the DJM and design principles results in six impact modules (doorways to independent units), which create seven youth programs, a nine-week curriculum accompanied by a six-hour training for educators, and several experiential learning opportunities for youths eighteen to twenty-four years of age. Another approach that contributes to designExplorr's success is a service subsidization business model. A service subsidization business model is used by social enterprises to sell products or services to an external market and uses the income it generates to fund its social programs. Currently, designExplorr's six revenue streams include creative services, public speaking, diversity, equity, and inclusion training, educational materials for students and educators, classroom curriculum, and youth programs and activities. Our future goals are to open an experiential learning center, then develop a precollege residency program, and continue our research work to execute a design forecast that reports on the data of the current status of the design profession.

How designExplorr Addresses the Problem

In 2015, I began implementing the solutions-based methodologies outlined in my master's thesis, "Design Journeys: Strategies for Increasing Diversity in Design Disciplines." Seven years and over fifty-five hundred students later, our work does more than change the face of design; it transforms communities. Youths who attend our workshops and participate in our experiential learning opportunities express their creativity and explore the power of design. They also gain creative confidence, artistic exploration, critical thinking, problem-solving skills, self-regulation, and interpersonal communication while developing real-world skills, connections, and opportunities to sustain themselves now and in the future. Our signature youth programs intervene for creative youths on the pathway to a creative career by being comprehensive, collaborative, local, and scholastic. These programs and activities include:

Design learning challenges: This interactive workshop expands students' imagination as they learn to think like a designer, practice empathy, self-regulate through artistic exploration. During the workshop, students produce a physical (or digital) prototype using a six-step design thinking process.

Takeover curriculum and education training: These in-classroom learning sessions take over the classroom by introducing students to the design ideation process through a design challenge and artistic prototyping activity. Students have fun while gaining creative confidence and developing critical thinking as well as communication skills as they bring their design ideas to life.

Design club: This after-school and summer interactive, multiple-session program introduces students to the power of design by supercharging their creativity with activities that look at design thinking, problem-solving, creative exploration, and artistic prototyping. Students learn conceptual design techniques through daily design challenges and visualizing their ideas, gain creative confidence, and develop critical thinking skills.

Think like a designer workshop: Students are immersed in the world of design with a one-day, interactive pop-up workshop that allows them to explore design in three easy steps. Attendees receive a kit that contains art supplies, user cards, and an activity worksheet that provides students with the tools to guide them through solving a design learning challenge at home.

Creative career conversations: Students discuss the power of creative careers in this in-depth workshop that teaches students about the design journey and what it takes to become a designer, including the necessary skills, salary opportunities, and day-to-day work tasks. Students review the six entryways into a creative career, create a vision board to identify their interests, and learn how to set specific, measurable, achievable, relevant, and time-bound (SMART) goals to achieve a successful creative career.[37]

Digital design workshops: Students discover the amazing world of digital design through a single or multiday activity where they learn digital prototyping with an online design software app. Attendees learn about designing posters, social media graphics, slideshows, and videos.

Power posters workshop: In this two-day workshop, youth attendees learn how to design meaningful messages by using digital prototyping software. Students develop meaningful messages, discover the three things that make posters powerful, and learn how to create posters that work.

Metrics of Our Students by the Numbers

- 49 percent were more interested in learning about where they can study design after high school
- 84 percent were more interested in design after the workshop
- 35 percent would like to hear from more designers about how they became a designer
- 57 percent of youth attendees are African American / Black
- 12 percent of youth attendees are Latinx
- 37 percent of our youth attendees self-identified as being female
- 50 percent of our youth attendees self-identified as being male

Get Involved, Be Counted, and Share Your Voice

Due to the lack of consistent strategic solutions along with the limited role of professional associations, organizations, and businesses, I propose the following recommendations to begin addressing the complex problem of the lack of Black representation in design.

1. Stabilize the problems on both ends of the journey by simultaneously increasing access and opportunity with tools and resources such as the DJM and design principles.
2. Take stock of the current people power in the design profession, and then encourage businesses, organizations, and professional associations to create many more diversity-building initiatives. These initiatives provide the opportunity for a much-needed intervention on the design journey.
3. Emphasize from the beginning of the design journey that aspiring designers should enter the profession with a mindset that when they reach a position of influence, they will reach back to impart their knowledge and insight to the next generation.

Although I believe the ability to think critically and solve problems makes designers the most equipped to tackle the complexities of the lack of Black representation in design, solving it does not solely sit on the shoulders of Black designers. It is foolish to think that the issue of diversity is a problem

only to the communities that encounter the magnitude of the injustices. Our profession will only be what we all make of it. I look forward to working with you.

Biography

Jacinda N. Walker is renowned for her work in design, diversity, research, and strategy. She is the founder and creative director of designExplorr, a social impact organization whose mission addresses the diversity gap within the design profession. Her research on "Design Journeys: Strategies for Increasing Diversity in Design Disciplines" has been hailed as breakthrough work. This solutions-based thesis explores diversity in design disciplines and investigates effective strategies to expose Black and Latino youths to design careers. Walker's future goals are to help scale diversity in design initiatives within education institutions, corporations, organizations, and museums. For more on designExplorr, see designExplorr.com.

Why Asking for a List Won't Solve Racial Disparities

Melanie Walby

A different approach to design is required to decenter harmful, oppressive systems of power. That includes not only how we hire but how we ask for referrals too. I am a designer and illustrator who believes art has the power to move people toward social change. In my creative director role at Pollen, a media arts nonprofit that harnesses the power of narrative change to build toward a society that is free, just, and loving, I see every single day how our creative team is tasked with not only imagining a better future but also helping other people see what it looks like. We challenge conventional ideas about designing for justice. We believe that fashion-magazine-style photography, illustration, and design—often reserved for celebrities and big brands—should be applied to the social sector, a community of change makers who are making the world better. Our visual storytelling is rooted in understanding the end goal: making people feel something that moves them into action to get us closer to the world we want.

Each project we work with at Pollen is made up of a different creative team, the majority of which consists of women, trans and nonbinary folks, Black people, Indigenous people, and people of color. We take that power seriously at Pollen, regularly educating ourselves in harmful hiring practices, researching online to connect with designers, illustrators, and photographers, and being active community members to ensure that we are constantly making.new connections with creatives, not just hiring within our existing networks and circles.

Before working at Pollen, I was the communications manager at Juxtaposition Arts (JXTA), a teen-staffed art and design education center, gallery, retail shop, and artists' studio space in North Minneapolis. It was in leaving for-profit agencies to go work in spaces like JXTA and Pollen that I realized just how much the rest of the design industry could learn from what artist and organizer spaces were already getting right. My old coworker Bobby Rogers once said,

> I only truly grasped the myth of diversity and inclusion during my time working for Juxtaposition Arts in North Minneapolis. Agencies preached of their efforts to do better while year after year nothing changed. All the while, Juxtaposition Arts employed a staff and student cohort of 116 people with over 80 percent of them being people of color. That's over 92 artists of color in one company with the majority being Black. Yet when we look at the million-dollar organizations around the city, you'll notice many struggled to even hire more than 1 or 2 Black people at most—a primary excuse being that Black artists/designers are hard to find and/or don't exist.

Black Designers Do Not Exist

The *don't exist* narrative is one I know all too well. I worked in various roles at different ad agencies and design firms across the Minneapolis–Saint Paul metro area for about seven years. From 2010—2017, I also volunteered with AIGA Minnesota as the chair of the Sustainable Design Committee and later as a board member with voting power for our chapter. I witnessed the Minnesota chapter struggle over the years with the disconnect between who is in its community compared to who is in our city. Throughout the last decade, I have confronted a lot of harm in our industry, but have seen little change. I have created work to confront harmful platitudes like "Well it *is* Minnesota" and "I just hire based on talent" that never get us any closer to our goals of inclusion or answers as to why their spaces do not reflect the demographics of our city. The more overtly racist responses such as "Well are 'those' people really interested in design?" or "Are 'they' any good?" was what brought me to my end. I was tired after almost a decade of free labor and endless teaching so I left advertising and AIGA in 2017. Since then, I have found spaces that center Black people, Indigenous people, and people of color where it is no longer my job to teach white folks what they simply do not want to learn.[38] The cycle of

repeating what I presented on stages or communicated in board meetings became an ineffective use of my energy once I started to see how fast it gets accomplished when done on purpose. We were already represented and did not have to talk about how to find us; our dreams, goals, freedom, and passions were the new conversation.

People in the spaces I left began to notice and started to reach out to me for referrals. Despite my many efforts to respond to people's questions about hiring more Black people, Indigenous people, and people of color, I kept running into the same disappointing response from those who claimed to be invested in diversity and inclusion, but were disinterested in authentic relationship building or any changes to their personal routine. And that response was six little words that I have grown to loathe: "Can you send me a list?"

For almost five years, I did. I made lists and sent lists. I tried that method for half a decade and this is all that I learned: people do not pay for and do not use them. You can do an event series that features over sixty-two Black people, Indigenous people, and people of color, which I did in Minnesota, and the next design event in town will still be an all-white lineup for a majority-white audience. These people do not actually hire Black artists, Indigenous artists, and artists of color despite the referrals they claim to need; they are always able to justify why it was a white person who was more qualified, a better culture fit, or had a closer design aesthetic to what they think is "good" design. They do not book the speakers we suggest because they will always want a bigger name without ever questioning if recognition is actually merited or just repetitive. And when it is all over, they will always come back years later with the same questions and opinions we thought were addressed in previous conversations.

Melanie Walby in Front of the Design Impact Series Backdrop. Photograph by AIGA, 2017. Design Impact Series, online.

Reimagine Public Safety Series. Graphic by Pollen Midwest, 2020. Pollen Midwest, online.

Let me be clear: I think people who are willing to pay are trying to do the right thing. I am just tired of seeing the conversation always revolve around how to get people of color into white spaces without any sort of requirement for those white people to go to Black and brown spaces. I will admit that even I am in need of referrals at times, but it feels different when someone who is not willing to show up in the community suddenly requests a simple solution sent to them via email so they are not burdened with having to go anywhere. When I ask for referrals, I am not asking someone to help me skip the work of going into different spaces to make friendships with Black people, Indigenous people, and people of color. When people who only have relationships with white folks want a list, that is exactly what they are doing. Asking for a list is asking for a shortcut, and the consequences are far too harmful to allow that to continue to be the path forward.

Inclusion Requires Real Change

Many agency owners in Minneapolis have seen me speak about this over the years, yet the staff page on their company website remains full of all-white headshots. Their homogeneous network is visible in years' worth of majority-

white group photos on their personal social media, but pointing that out is only ever met with defensiveness; they cannot see the correlation between their friendships and their hiring practices. I have put it into writing, and while people like it on social media, they respond to my posts about *not* asking for a list with a request *for* a list in my direct messages as if they only like the photo but did not read the caption. And although I helped book speakers and featured artists for AIGA Minnesota events between 2010 and 2017, I still receive requests from new volunteers who present "representation" to me as *their* new idea and ask me for free labor that I already did for almost a decade. I remember who was interrupting me in board meetings when I spoke ten years ago about booking speakers and uplifting Black people, Indigenous people, and people of color who have contributed to the design field throughout history for the Minnesota chapter of AIGA. Their response was always, "What we really need to do is mentor youths," which is true, but the issue is not just the pipeline. There are a lot of talented people in our industry who are already mentoring youths to bring more young Black people, Indigenous people, and people of color into the field, but solely focusing on that narrative allows people in power to ignore the necessary internal work that they have not and will not do to examine why they cannot retain those youths or hire any senior-level talent. The same people who used to fight me on this now

sation
tion

outside of your
ar routine to make
ew connections.

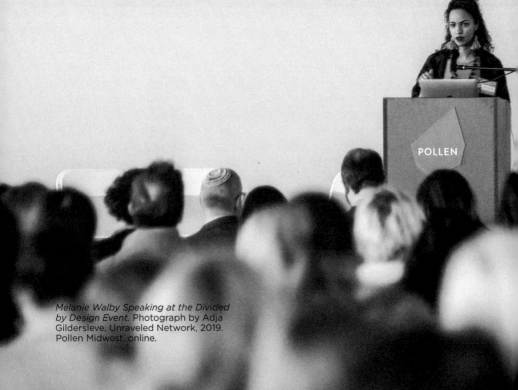

Melanie Walby Speaking at the Divided by Design Event. Photograph by Adja Gildersleve, Unraveled Network, 2019. Pollen Midwest, online.

get recognition for their work in making the AIGA Minnesota chapter more diverse, but it was not them. It was me, Terresa Moses, Marla Bonner, Garrio Harrison, and Austin Nash, all the artists who showcased their work in our 2016 Design Impact Series, and the people who were around for decades prior like Luis Fitch and Miko Simmons. People who copied our ideas after years of preventing progress even have the audacity to monetize it for their recruiting businesses while still expecting Black people, Indigenous people, and people of color to help curate their lists for free. What they do not promote is how soon and how often those new hires leave for a different opportunity because they were so badly harmed in spaces that did not know how to make someone who is not white feel welcome, valued, respected, or safe.

Perpetuating the idea that referring someone is all it takes for inclusion ignores what it is like for us in those spaces after we are hired. That is why I say no to these list requests. I am not interested in centering the conversation around what white folks are doing to "help" us as opposed to what we are doing to make the design industry better. Our lived experiences give us expertise that can prevent harm in storytelling. Our perspectives bring liberation, possibility, logic, and healing to conversations that when left in the hands of white-led narratives, leave people overwhelmed and hopeless with no energy or motivation left to put toward meaningful action. Or it is action without impact—social mimicry that does not lead to systemic change. What the design industry has to gain from Black people, Indigenous people, and people of color gets reduced to "They feel left out so let's let them come here to witness our greatness—so long as they keep us comfortable," instead of what it should be, "We do not know how to do this so we are going to sit down and let experts lead."

People hate hearing no so I am always fearful of burning a bridge, but to what extent do I need to keep doing something that does not feel right to me to avoid the backlash of white fragility? To hear so many stories of so much harm happening in spaces that boast about diversity and inclusion makes it feel quite conflicting to send Black people, Indigenous people, and people of color their way in any form of list or directory that does not first hold white spaces accountable to learning how to keep people safe once they get there. In defying the demand for list requests, I am showing that I care deeply about our creative community, and believe that if people knew they were harmful, they would stop. So I made a new list. A list of why asking for a list will not solve racial disparities.

We Already Have Lists

Our community has already been making lists. People need to research before they ask.

I am not against lists; there are great resources out there that I think should be utilized. What I am against is being asked to do other people's work for them. When I get a list request, it is pretty obvious that person does not care enough to look it up, and that they have not paid attention to any of the work that has already been done or they would not need me to tell them who is out here. This is not work that has to be done but rather work that has been ignored. During my time on the board of AIGA Minnesota, a group of us put on poster shows, lectures, and panels featuring over sixty-two designers, illustrators, and photographers who identified as people of color. In 2017, I had two different people from AIGA email me for suggested speakers for Design Camp—one of the largest regional design conferences in the country—a few months later, as if I had not just provided more than enough names to fill the entire lineup of the conference. Most of the creatives I know have an online presence. Many of our portfolios and Instagram profiles are full of photos of Black artists, Indigenous artists, and artists of color. And while many white designers like those posts, when I go to see who they are following it is only other white designers.

The organization I work for, Pollen, has a contributor page, and we also have a job board where people can pay to post opportunities that will be seen in front of hundreds of Black artists, Indigenous artists, and artists of color. For far too many folks, posting to our job board is too much work. I respond to list requests offering that as a solution and they usually decline. I have started to say, "If you Google 'Black designers,' we come up. People make lists of us." It was through simple searches and minimal effort that I was able to find resources like Revision Path—a podcast that interviews Black designers and has featured hundreds of people since Maurice Cherry started it in 2013. AIGA Design Journeys, blackswho.design, latinxwho.design, and 28blacks. com are similar examples of where and how this work already exists. The lack of recognition of these resources is how so many people are still out here thinking we "don't exist." We have been here. We have just gone unrecognized for a really long time.

A List Does Not Ensure Retention

If the goal is to have someone join a community or workplace, then the reality of what it takes to make them stay cannot be ignored. While people may have success in hiring from a referral list, if they do not create an inclusive space for that new hire, it results in expecting the whole staff to fit within a culture of whiteness. I know that because the informational interviews I do are often listening to people cry about how white people treated them at work. In their book *Hiring Revolution*, Trina Olson and Alfonso Wenker break down how racial disparities create different needs within benefit packages and salaries as well.[39] The consequences of white spaces being oblivious to their impact on everyone else can be traumatic for anyone considered "other." Those barriers do not get solved if people continue to think that a referral list will make

everything all better. Keeping different types of people on staff requires a genuine interest in what it is like to be those people and humility that people in power do not know because they are not them.

First, Show Up
Why would anyone go to your stuff if you're not going to their stuff?

I recently attended a *Five Heartbeats* screening featuring actor Robert Townsend at SPNN, a community media and technology center. I am a huge Townsend fan and hung on his every word about being Black in Hollywood, finding so many similarities to my own experiences in design. My favorite thing that he said was, "If you don't move, you can't stumble." This is applicable here if you think about who it is that asks for these lists. Most people higher up at agencies only go to diversity and inclusion events when they are the ones speaking. That means that they have only heard white-led narratives about what companies are doing to try to attract Black and brown people rather than hearing from a Black or brown person about why they quit. Going to a space where we are the ones speaking will not just teach people our names but our perspectives as well. And when folks do not show up, we notice and take that as a sign of disinterest in who we are as people. If someone does not care about what we are doing in the community and just wants us to show up to their events for diversity points, then they will get no list from me. People need to show up for us before asking us to show up for them.

I have spent years encouraging people who lead creative agencies to require their entire staff to regularly attend events outside AIGA, AdFed, and MIMA (or whatever predominantly white professional development organization exists in your city). There are multiple creative communities in Minneapolis and Saint Paul; requiring staff to follow JXTA, Pollen, Black Table Arts, Public Functionary, and Art in Many Forms on social media would make a huge difference. I have been saying this for so long now that each new list request is another painful reminder that I have been silenced and ignored by my own peers. No matter how direct I am, people change the narrative to a more elementary-level sanitized version that requires less effort from people in power. Changing this mindset starts with people learning that there is much to gain from Black and brown spaces, but history and media has taught the majority culture the opposite. It is really heartbreaking when we look at it that way: that they do not actually think they need to learn about us; they just want us to learn about them.

Defining Diversity
The language of *diversity* in most list requests deters people who do not like that word.

An old coworker of mine once said, "It's weird when you realize you're someone else's idea of diversity." The emails I get often use diversity as synonymous with Black and brown, like it does not also apply to many other types of people. The definition of the word *diversity* is "variety," meaning it cannot be used to describe one person. Folks seem to use it as if it were a less taboo replacement for ethnicity and the deeper message behind that implies whiteness as the norm. It was my friend and talented artist Bayou Thomas who I first heard explain how using diverse to describe people perpetuates white supremacy by insinuating that white is the default and everything else is "diverse/different." It can be used to talk about groups (diverse teams or diverse communities), but *not* for individuals (diverse talent or diverse candidate). I encounter folks who are not offended by the word. But when emailing for a "diverse list," people have no way of knowing if the person on the other end has already told over a dozen people what I just described above. My issue is not the word itself; it is the implications when it gets used as code speech for "not white." The difference is understanding the definition as variety, not "people of color." I get pushback on this opinion, mostly from white folks who want a list, but my friends and I frequently vent about how tired we are of being called that word and how sick to our stomachs it makes us when "I am looking for diverse talent" emails hit our inbox. If the end goal really is to attract us to their spaces, people need to be willing to hear from different perspectives within our community and not assume that one size fits all.

Social Capital Is Not Free

There is a monetary value on the relationships that we build. That is why recruiting agencies charge a fee. I have invested almost ten years into showing up in spaces that the majority of white creative professionals in the Twin Cities have never and will never be in. Compared to how much money recruiting agencies get paid for the same work, I view list requests as another extractive way that society asks Black, Indigenous, and people of color for free labor.

Asking us for a list undermines the existing friendships and trust we have built with Black people, Indigenous people, and people of color.

Where I work, we talk about this a lot. Long before I joined the team, Pollen worked to ensure that the people photographing, illustrating, designing, and writing have shared lived experiences as the stories being told. When predominantly white organizations come to us to work with artists of color, we are hyperaware of the vulnerable position we are putting artists of color in. It is our responsibility and role to make sure that they are not taken advantage of, tokenized, asked to do something against their morals, or asked to perpetuate harmful stereotypes, and that their creative recommendation is heard and respected. I do not trust people emailing me for a list to advocate for my friends in that way because I highly doubt they have the cultural competency

to even know that is part of the job. You have to have relationships to know that; people who ask for a list do not or otherwise they would not be asking.

Is That All There Is?

Giving people a short list of people of color allows them to assume that list is all there is.

Those of us who are invested in creating representation need to resist the pressures from what white folks think we need to do for them. A list is a band-aid solution. It is not good enough, and unless we want to be stuck in this conversation for the rest of our careers, I say we take alternative approaches that will resolve this problem as soon as possible. My work is never about starting a conversation; I have heard it enough and am trying to get the nonsense to stop. I want every person who says "Well it *is* Minnesota" to experience what it is like to be the only white body at an event so they understand the reality and possibilities of our amazing, talented, and brilliant community. I want them to hear my friends speak about justice and liberation, and recognize us for our expertise, not reduce us down to "diversity and inclusion" as if that is all we are. In order for that to happen, we have to stop enabling white folks by handing over Black people, Indigenous people, and people of color directories that allow them to stay in their same routine, and instead force them to actually move around the city and experience something new to them. When I look at the demographic maps of the Twin Cities, I notice the predominantly white areas are also the neighborhoods where most ad agencies and design firms are, and where professional development organizations host events.[40] White folks do not have to leave predominantly white neighborhoods for anything else if they do not want to. Their grocery store, bank, yoga studio, and breweries are all right there for them. Representation must sound ridiculous to someone whose perception of our city is white, just like predominantly white spaces sound ridiculous to those of us who know it is not. A directory alone is not going to fix that. Forcing people into a new routine is a long-term solution; emailing a list perpetuates the problem.

We Deserve More

It is time for folks to dig deep and ask why they need a list of Black people, Indigenous people, and people of color when there are so many of us here, working in every single field. In a time when inclusion is suddenly on everyone's mind and it is not just being talked about in spaces where the people who have always done this work have been saying the same thing for decades, I encourage everyone to pause before asking for a list. A lot of people are late to this conversation and repeating the same harmful patterns we have been trying to dismantle—and it is not just white folks. I see communities of color doing this too. It takes care, intentionality, and work to cultivate new relationships. Rather than asking someone to help us do it for free, we all

have to commit to a life of going outside our regular routines to make new connections. If we are willing, we will acknowledge we already know how. People have been telling us for years.

Biography

Melanie Walby is the creative director at Pollen, a media arts nonprofit that harnesses the power of narrative change to build toward a society that is free, just, and loving. Before Pollen, she worked at various ad agencies in Minneapolis for six years and was the communications manager at JXTA, a teen-staffed art and design center, gallery, retail shop, and artist studio space in North Minneapolis. She's a former board member of AIGA Minnesota, was recently named one of AdFed's "32 Under 32," and has been featured in *Communication Arts* as well as on Wisconsin Public Radio, blackswho.design, and Adobe Creative Jam. For more details, see melaniewalby.com.

Acknowledgments

This piece was originally published in part on Pollen, pollenmidwest. org, and considerably expanded for this publication.

Ain't I a Woman

Omari Souza

I entered the E train as a new man. Zuri, the Bajan goddess I had been crushing on since ninth grade, had agreed to be my girlfriend. My very first girlfriend. We had officially become a couple that day, sharing our big news with our close friends at school. It was a major milestone for me, a studious, introverted kid who lacked the street cred and popularity that attracted girls.

Zuri and I found seats on the crowded train. And I was beaming, still relishing in my accomplishment, when I heard my name, followed by an eruption of laughter that rose above the clamor of the train.

Zuri and I were both sophomores at the High School of Art and Design. And we were on the train that took us and other students, who lived in Queens, to and from the prestigious school in Midtown Manhattan. As usual, the train was packed with our classmates. The laughter got even louder and bolder.

"Look at Omari and his new girl!" my friend David said, pointing at me and Zuri.

He stood across from us with other friends, and they all chuckled while hanging onto the train straps and jerking with the rumble of the train. I had told David earlier that day Zuri and I were official. He cackled then too. And I was as baffled then as I was on the train.

"Damn, Omari! Your girl is so Black and ugly!" Lamont added.

"What? She is not ugly! You don't even have a girl, so be quiet!" I shouted back, as I felt a puff of steam fill my collar.

My heart raced and rage coursed through my body. And I remained baffled. But Zuri stared ahead, unfazed by the downpour of insults. She was truly striking. Her melanin-rich skin conjured images of Yoruba and Fante beauties. It appeared remarkably untouched by the forced miscegenation from rape during slavery. I could not take my eyes off Zuri. And neither could my friends.

"Yo, Omari is the ugly intaker!"

I balled my fist and tried to stand, but Zuri stopped me.

"Don't," she ordered, while maintaining her cool composure.

"What? You hear what they're saying about you?"

"It doesn't matter. I deal with this all the time. Even if they stop today, somebody will do it tomorrow."

My heart broke but I understood. Tackling my friends would have been useless. Zuri and I were up against a more formidable opponent: history. It is a history that implored Sojourner Truth in 1851 to ask "Ain't I a Woman?" in her famous speech:

> That man over there says that women need to be helped into carriages, and lifted over ditches, and to have the best place everywhere. Nobody ever helps me into carriages, or over mud-puddles, or gives me any best place! And ain't I a woman? Look at me! Look at my arm! I have plowed and planted, and gathered into barns, and no man could head me! And ain't I a woman? I could work as much and eat as much as a man—when I could get it—and bear the lash as well! And ain't I a woman? I have borne thirteen children, and seen most all sold off to slavery, and when I cried out with my mother's grief, none but Jesus heard me! And ain't I a woman?[41]

History would answer no because for centuries, the original woman has been hypersexualized, stereotyped, and masculinized, stripping her of beauty and softness. Instead, she is perpetuated through media, myth, and symbolism, as Jezebels, mammies, and sapphires. The damage of this historical stereotyping has not only denied the Black woman her femininity but has also eroded her humanity.

In 1810, Saartjie Baartman, a young South African woman, was taken to Europe and exhibited as a freak show act due to the size of her buttocks and parts of her genitalia compared to European norms. Baartman was advertised as "the missing link between man and beast." In 1845, Dr. James Marion Simms, dubbed the "Father of Modern Gynecology," began conducting surgical experiments on enslaved Black women without anesthesia. In his autobiography, he wrote, "There was never a time that I could not, at any day, have had a subject for operation."

The long history of maligning Black women is fraught with stereotypes. In 1889, a pancake brand was named "Aunt Jemima" and the caricature of a "mammy," a submissive enslaved woman, was put on the box. For 130 years, until 2021, that disparaging image and the name would remain on the popular breakfast brand.

Baartman. Digital illustration by Neville Al Harvey, June 2021.

Branding Black Women as Sexual Deviants

From fall 1810 until April 1811, twenty-one-year-old Baartman, a Khoekhoe woman from the Cape Colony, appeared onstage in London. Descriptions of the Khoekhoe woman's sexual organs' perceived unusualness emerged in visitors' travel writings to the Cape Colony. Before the nineteenth century, these claims existed primarily in travelers' and missionaries' accounts as expressions of curiosity, rather than assertions of physical, moral, and racial assumptions. In particular, the women were said to have elongated labia minora (Hottentot apron), enlarged buttocks (termed *steatopygia*), and swaying breasts. A Dutch physician employed by the Dutch East Indian Company provides one of the earliest accounts of the "Hottentot apron": "The Women are distinguished from the Men by their Deformity ... and have this peculiar, among all other Nations, that out of their Privities, you see two Labels hanging down as part of a Man's Yard (as now and then some of our European Women are subject to the relaxation)."[42]

Revolutions in the biological and human sciences led to new hypotheses about the nature and significance of race. For the first time in history, scientists mounted investigations into the physical characteristics of different racial groups, ascribing physical and behavioral importance to racial designations. Thus the doctrine of scientific racism took shape, expressed through techniques that documented, classified, and codified racial inferiority and superiority.

Investigations were premised on the hypothesis that race was the conclusive and definite marker of human difference. The apparent anatomical distinction piqued European curiosity, leading to Baartman's body being exhibited as a freak show attraction. For two shillings, people gained entry to the show. There, they watched Baartman walk onto a stage, sing a song, and spin for her audience. She was displayed as a primitive and extraordinary phenomenon of nature,exhibited half naked. For most Europeans who viewed her, Baartman existed only as a collection of sexual parts. The European history of exhibiting conquered subjects dates back at least as far as Christopher Columbus.[43] In the nineteenth century, however, as imperialism grew more expansive, live displays of colonized peoples in Europe's capitals reached their peak, capitalizing on the curiosity of metropolitan publics.

Europe's imperial aspirations also encouraged new ideological divergences in the study of race. From the nineteenth century onward, concomitant with the emergence of modern science, comparative anatomy gradually replaced metaphysical explanations in academic understandings of human difference.[44] After Baartman's death in 1816, Georges Cuvier, a renowned zoologist working within the French academy, performed a postmortem on her. The dissection of Baartman's body helped frame European science investigation—examinations that use the size of Baartman's sexual organs as distinctive signs of African women's sexual primitiveness. As a method to pacify those who mistreated women of color, these theories were used to convince the public that Black

women were excluded from the possibility of rape. How could one rape a woman who by her very biology was always in heat and unable to see beyond their impulses?

Baartman's genitals and buttocks—which remained on display until 2022—summarized her essence for these nineteenth-century observers. Following the election of Nelson Mandela as president in South Africa, her remains were repatriated to her motherland in the Gamtoos Valley. She was buried on August 9, 2002, over two hundred years after her birth.

The notoriety of the Hottentot Venus's presentation gave rise to copious cartoons featuring Baartman's prominent posterior, exaggerated for comical effect. The lessons that London and Paris learned from attending these shows were not only that Baartman's body was freakish but also that this "deformity" was considered beautiful in Africa. Baartman functions as the supreme example of racial and sexual otherness. This was emphasized in the broadsides and advertisements for the show.[45]

A striking example of the conventions of human diversity captured in the iconography of the nineteenth century is the linkage of two seemingly independent female images: the icon of the Hottentot female and that of the prostitute. Comparatively, both are social outsiders bearing the assumed signs of sexual deviation. The intersection of both identities has been expressed in multiple mediums, including but not limited to in Édouard Manet's 1862 *Olympia*.

The negative perception of Black women and prostitutes is dependent on the inherent fear of "the other." Additionally, it is rooted in the fear of losing control over women in general. Manet's *Olympia*, painted in 1862–1863, was first shown in the Paris Salon of 1865, and presented a merger of female sexuality and sexual communication by association.[46] The salon, originating in 1667, was arguably the most notable annual or biennial art experience in Western society. The portrait displayed in the 1865 salon of a reclining nude with a Black maid standing behind her raised questions about art and decency. The general understanding concerning Manet's painting states that the model, Victorine Meurend, was naked rather than nude, which was more traditional. Manet was fascinated by Titian's works, so this iconic painting's composition takes inspiration from *Venus* of Urbino, painted in 1538.

The works differ in the models' gestures. Titian's *Venus* is a woman of mythological stature who conservatively covers what my sons would call her privacy. In comparison, Manet's *Olympia* unashamedly does it to boldly underline her sexual and economic independence.[47] There is also a difference in the animals present. Instead of a dog accompanying *Venus*, Manet painted a black cat, a traditional symbol for women and sex workers. Moreover, the nude's eyes, which directly confronted the viewer, were a distinct difference

from the work of *Venus*, whose gaze was slightly averted. *Olympia*'s defiant gaze inferred a woman whose sexuality and naked body needed no apologies.

The Black female attendant, a servant bringing flowers, has been seen as both a reflection of the well-known Black servant figure present in the visual arts of the eighteenth century and a representation of poet Charles-Pierre Baudelaire's *Vénus Noire*. The stereotype of Black sexuality is viewed as both unquenchable as well as antithetical to European sexual morals. The prostitute in the nineteenth century representing the sexualized woman in general becomes the subject of detailed investigation. After *Olympia*'s exhibition, Manet became known as the painter of a scandalous woman with a black cat. The main subject in the painting would have been understood by Manet's contemporaries as a courtesan, according to critic Jules Claretic.

Most of the reviewers dispatched the painting with a sneering sentence or two, marking the work as a visual prank. The jury accepted the picture as a method to teach Manet humility, assured that its offensive subject matter and poor craft would finally silence the fiery dialogue encircling the painter, whose reputation had grown since exhibiting his painting *The Luncheon on the Grass*, another composition based on indecency behavior. By the late twentieth century, the maid's presence became the focus of further investigation of this painting. The painting was crafted fifteen years after France's abolition of slavery. *Olympia* and her maid existed when the terms of race, sexuality, and racial violence were contested and particular.[48] Political and economic arguments about the slave trade and abolition situate the passive gesture of *Olympia*'s maid in a tangible context that gives greater insight into the social perspective of the time.

The painting primarily focuses on *Olympia*'s gaze, her ownership of her sexuality and profession. Manet uses several icons such as her bracelet, pearl earrings, and the oriental shawl on which she lies to communicate the idea of wealth and sensuality. His *Olympia* has been used as an essential reference in the context of the white male gaze proposed by both the feminist and postcolonial movements. *Olympia*'s offhand rejection of the servant's offerings raises questions about race, sexuality, and hierarchy in nineteenth-century Europe.[49] In this broader context, we must situate *Olympia* as an image around which myriad issues about the autonomy of the body, sexuality, racial hierarchy, and licentiousness meet.[50]

The argument can be made that Manet did not include the maid's figure for the artistic convention but instead to further articulate Olympia's sexual deviancy. Since the sexuality of Black women was believed to be deviant and somehow more "primitive," then the maid's presence also functions as a symbol for physical indecency, especially when juxtaposed by a white woman who was seldom painted in this manner. This juxtaposition transfers the association of sexual availability to a white body. The desire for intimacy, however, is no

longer primitive because while the Black body is considered to be governed by instinct and biology, the white body is governed by intent and reason.

In the late 1990s, New York City–based artist and critic Lorraine O'Grady wrote a vital essay titled "Olympia's Maid: Reclaiming Black Female Subjectivity," where she expressed that "like all other "peripheral Negroes," Olympia's maid is a robot conveniently made to disappear into the background drapery."[51]

Branded by the Color of Her Skin: Appropriated Otherness

In November 2014, *Paper* magazine launched a "break the internet" campaign on social media with the printing of nude and seminude images of the US media personality, socialite, model, businessperson, and actress Kim Kardashian. Kardashian first gained public notoriety as the friend and stylist of media personality Paris Hilton, and she later became known for her participation in a 2002 sex tape. The 2014 magazine focused on Kardashian's derriere, both naked and with a champagne glass resting precariously on it. The published images continued the commodification of the "derriere" as a hypersalable object of desire and gaze. The curvature of Kardashian's body were used to highlight her beauty and sexual appeal when those very same curves were used as a symbol of Baartman's primitive disposition.

Although the printing of the Kardashian cover then seemed revolutionary, it is a re-creation. French photographer Jean-Paule Goude recycled the shot from an original. The original image was shot thirty-two years prior for a book titled *Jungle Fever*.[52] The initial photograph was of a nude unknown Black woman standing in front of a blue wall, popping open a bottle of champagne into a glass propped on her butt.

The image that appears on the cover of Goude's book with that title depicts Jamaican-born model Grace Jones naked, in a cage, surrounded by raw meat. Atop of the cage, a sign that reads "DO NOT FEED THE ANIMAL." Goude served as an art director for *Esquire* during the 1970s and later shot images himself. As a photographer, he produced colorful images that flirted with the boundary between fine art and advertising.

According to a *People* magazine article written in 1979, "Jean-Paul has been fascinated with women like Grace (Jones) since his youth," the 1979 article reads. "The son of a French engineer and an American-born dancer, he grew up in a Paris suburb. From the moment he saw *West Side Story* and the Alvin Ailey dance troupe, he found himself captivated by 'ethnic minorities—black girls. I had jungle fever.' He now says, 'Blacks are the premise of my work.'"[53]

As writer Blue Telusma states in her 2014 article for *TheGrio* magazine, "This idea that "black equals erotic" is fetishism in its purest form; it mocks

Glorification. Digital illustration by Neville Al Harvey, June 2021.

"otherness" while pretending to celebrate it and defines human beings by their genitals instead of seeing them as whole people."[54]

Due to the fetishism of her rear end, the dominant culture has come to celebrate Kardashian's behind. Her paper cover proclaims her curves as a part of her attraction and exoticism, while those same curves have been used for centuries to exclude Black women from categories of beauty. Propelled by the powers of mass production, her participation in the magazine spread continued the violence enacted on bodies of Black women motivated by racial fetishism—the dehumanization of Black and brown women over the centuries. The perceived authenticity of Black sexuality assures that the body of Black women cannot be both outwardly Black and beautiful. White women can commodify the body for their own advancement that has othered women of

Don't Feed the Animal. Digital illustration by Neville Al Harvey, June 2021.

color. By adopting aspects of Black culture or paralleling Black anatomy, a white woman can enhance her aesthetic.

August 25, 2013, in New York City, Miley Cyrus made news with her stage performance at the MTV Video Music Awards. Her performance included, but was not limited to, life-size teddy bears, flesh-colored underwear, the appropriation of a sexualized Black dance, and Black background dancers. The appeal of the dancers happened to be their behinds, similar to that of Baartman. Like Manet's *Olympia*, the Black women's figures were used in the background to mark the presence of illicit sexual activity. Whether conscious or unconscious, her performance engages in women's politics of sexuality, choice, and agency. What makes her performance problematic is the fact that she appropriates Black racialized motifs to do so. If the stereotype of Black sexuality is both unquenchable and antithetical to European sexual morals, then the Cyrus performance attempts to transfer the appearance of unquenchable sexuality to a white body. Shedding the innocence of pop singer Hannah Montana, Cyrus announces her womanhood and sexual autonomy.

Kardashian, Goude, and Cyrus each have leveraged print publications in addition to the aspects of the branded myth of Black female sexuality in order to gain social adornment and commercial success. Designer Hank Willis Thomas explores the connection between modern brands and the genesis of the concept in his series *Branded*. He connects the original meaning of branding (to burn signs of ownership onto the flesh of livestock), the history of slavery, and the relationship of product branding to Black culture. In the

modern context, this forced branding of human beings has been meaningfully done away with.

Voluntary branding, however, has replaced it as a way for individuals to lower the social hierarchy to show their loyalty to those above them. This new form of branding does not demonstrate ownership; rather, it is used as a form of social mobility for those on the bottom of the hierarchy. Branding more than the act of promoting goods is also a mode of everyday communication. Within the context of advertising, the concern is whether the industry contributes to either reinforcing or challenging the social hierarchy. Those with the ability to exercise influence continuously over time are able to shape culture and solidify ideas of hierarchy. Promotional industries utilize design to communicate expectations about race and ethnicity, just as they do about cars, clothing, or coffee shops. Moreover, they can influence how the diverse communities that make up the world perceive one another. So what if the brand that is being proposed through these pieces of work is that wide hips, full lips, and a full behind is only acceptable when placed on a white woman?

Conclusion

Just as a language communicates through structured sentences, visual languages depend on essential elements and the rules for combining them in order to communicate. Author Roland Barthes used a system of the signifier (word/image/object) and signified (meaning) as the two elements of this language.[55] For example, in his book *Mythologies*, Barthes dissects the structure of nightly news. He describes the use of typography and constructed sets with which the news is broadcasted as being mediated signs employed to give the perception of professional, objective, and unmediated reality.

We are inevitably shaped by the language of visual symbols presented by those who wish to change or maintain those rituals and structures.[56] Our society is steeped in visual narratives, often utilized by journalists, politicians, and other opinion leaders to perpetuate cultural "myths" about the products they offer and the consumers who "need" them. In this consumer-based society, designers play a vital role in crafting visual narratives, giving designers a vital role in determining how individuals view the world through the kaleidoscopic lens of the visual symbols of advertisement. These narratives are used to illustrate the dynamics of social power and ideology we use to create meaning.

Western Eurocentrism has made it difficult for Black women to exist in a professional or social setting without adapting a Western aesthetic. If a nose is too broad or too flat, if your lips are too big, then the more your appearance becomes the antithesis of the accepted European standard. When the colonies became the United States, the primary campaign to "uglify" African slaves became more intense, pervasive, and codified. The characteristics and symbols historically used to represent Black people in advertising have forged

permanent images into the US psyche. Design is intended to be consumed by an audience, but is the audience limited to the consumer? Should the scope of the audience include a more fluid margin in order to better actualize a universal base? As humans, we are made human through the craft of making. The ability to make is both an expressive power and authority. It gives the builder the power to envision stories or choose who has access to the tool to be crafted.

Design guides culture, shaping the human experience. Leaving the general populace to adapt to which creations. In this sense the designer functions, expanding territory through commercial goods, forcing the user's adaptation to the curated experience versus the other way around. While the devaluing of Black women has been the work of the West, the messages have reverberated and permeated the African diaspora, resulting in the practice of white supremacy by-products, like colorism. And its women like Zuri, possessing aboriginal West African features, are rejected, defeminized, hypersexualized by their own.

I think back to that day when Zuri and I sat on the train, stoic as the insults rained down on us. More of my friends joined in, and then an impromptu song developed.

"Omari is the ugly intaker!"

"Omari is the ugly intaker!"

In the 1994 sci-fi cult classic film *The Crow*, Brandon Lee articulated to a drug-addicted woman that he believed Mother is the name of god on the lips and hearts of all children. Staring into the mirror with this woman, he revealed the tracks on her arm. Tilting the arm so her drug of choice can pour out of her veins, he healed her of her addiction. He points out to this woman that the drug she has used is bad for her and that her daughter awaits her return. Similarly, I believe as visual communicators and content generators that we owe it to Black women and future generations to pour out the poison (myths, stereotypes, and colorism) that continue to cause harm. It is up to us to do what prior generations have failed to do and attempt to heal past traumas reuniting the divine to their disciples. We owe it to Black women to no longer leave them to question their beauty or permit them to feel less desired.

Using Video Games to Champion Justice and Expand Imaginations of Superheroes

Jules Porter

While approximately 80 percent of Black American youths play video games (well above the 65 percent for white American youths), less than 3 percent of video game characters are Black.57 Black characters in video games are designed in such a way that they reinforce harmful stereotypes. This negatively impacts the way Black children see themselves and their futures as well as the way children of other races view Black people. Such negative and disparate representation is caused in part by the reality that less than 1 percent of video game programmers are Black. Additionally, less than 3 percent of the entire workforce in the video game industry consists of Black people. I, a Black woman technology and civil rights attorney, recently founded a console video game development company in Minnesota. My games are designed to show Black, Indigenous, and people of color as heroes as well as complex, multifaceted beings with relatable lives. I was struck by a statement of the officer who killed Mike Brown in Ferguson, Missouri. The officer described this teenager as looking "like a demon" before they shot him.58 The statement revealed that social justice and equity work had a different starting point than I had initially believed. While a focus on accountability along with more effective policies and procedures is vital in the push for justice and equal rights, the United States is still not yet at a place where all believe in practice that all people are human beings worthy of dignity and respect. By designing and displaying more realistic and positive portrayals of Black, Indigenous, and people of color in video gaming, I hope to build empathy and nuanced multicultural understanding, and expand the collective view of who a hero is and who we can all be. My work features my art and shows how I embrace Afrofuturism, real-world heroes, folklore, poetry, history, and cultural mythology to use video games to champion justice and expand imaginations.

This Is Our Time

My art revolves around daring to be epic. When I think of Afrofuturism and superheroes, I think of having the boldness and freedom to fully be ourselves and create who we want to be in the future. My art is a celebration of not just our melanin and kinship to our life experiences but also the intellect and ingenuity we have shown since the dawn of human history.

In the ever-constant fight for justice and equality, Black and Indigenous communities must seize the media narrative, using it to challenge stereotypes and reinforce our humanity, invaluable contributions to society, and heroic stories. Media plays a vital role in how we come to perceive ourselves and each other. This is as true in video gaming—interactive media—as it has been in theater, film, television, and other forms of media throughout history. Globally, the video game industry is larger than sports, film, and television, with a worth that exceeds $180 billion.[59] Over 2.5 billion people play video games, and more people watch esports than any other sport.[60] Video games have also become sixty- to one-hundred-hours-long photorealistic interactive movies compared to other forms of media and entertainment, which generally last between thirty minutes and three hours. This means that the player is immersed in this world or minimetaverse for over twenty times longer than they are in other forms of media. Video games offer the closest opportunity we have to stepping into the shoes of another person and experiencing the world from a vantage point vastly different than our own.

For the past fifty years, the fully immersive experiences that video games provide have been created nearly exclusively by a non-Black creative and executive workforce. Less than 3 percent of the entire industry workforce is Black or Indigenous. This corresponds to less than 3 percent of the total playable characters (outside sports games) being Black or Indigenous. Additionally, when a Black character is included, the character is depicted from the vantage point of folks outside our community. Black characters in video games are designed and portrayed as gangsters, mobsters, drug dealers, thugs, and prostitutes. Even Black heroes in gaming are depicted as antiheroes; we are always given one or more moral deficiencies. Black heroes in gaming are rarely able to be the *pure* hero who slays the monster and saves the villagers. This means the 80 percent of Black youths who play video games can go their entire childhood without playing a single video game where the hero looks like them by design.

The infamous "doll test" of the 1940s tested Black children aged about ten years.[61] The children were given two dolls—one Black doll and one white doll. They were then asked which doll was the smart doll, pretty doll, and good doll? Overwhelmingly, the children selected the white doll in response. When asked which doll was the dumb doll, ugly doll, and bad doll, the children selected the Black doll. This test was repeated in 2015 with children of all different ethnicities. The results were nearly exactly the same as they were

in the 1940s. In the 2015 test, the Black children were asked which doll they believed they looked like. Some of those children began to cry when pointing to the Black doll.

We, all of us, must take intentional steps to change the demonizing messages society is sending about people with darker skin. These images not only affect the self-esteem and feelings of self-worth of the Black community but also impact the way people outside Black communities come to perceive us, fear us, and mentally limit our roles in society at an early age. Video games reach children, youths, and adults of all ethnicities, and capture their imaginations for the equivalent of two or more workweeks. The video game industry provides an opportunity for Black creatives to take ownership of our narratives, sharing our experiences, imaginations, fantasies, stories, and heroes in our own words, colors, movements, and images.[62] Doing so builds empathy while reminding others of our shared humanity and ranges of emotions, personality, depth, ambitions, and wonder.

Juan-Ukuu Edinkira Amina Okandi, the Infinite Tree

> When I die I'm sure I will have a Big Funeral [with] … Curiosity seekers … coming to see if I am really Dead … or just trying to make Trouble.
>
> —Mari E. Evans, "The Rebel"

Juan-Ukuu Edinkira Amina Okandi is an Ethiopian superhero created with love and infused with the spirit of my beloved godmother. My godmother was the tree who nurtured, sustained, strengthened, and shielded me. She lived her life as a standing stone of steadfast faith, prayer, and belief in God and others. She was a prayer warrior who sowed seeds within all who knew her. These seeds blossomed into richer lives and the courage to live boldly in truth. Likewise, Juan-Ukuu does not die. She lives wherever her seeds take root. Her roots are connected to all other trees. When her people need her, she rises to sustain and shield them. I believe we all have a person in our life like Juan-Ukuu who sustains, shields, and empowers us when we need it most. This common experience transcends time and crosses oceans. It is what makes Juan-Ukuu an infinite superhero. While my godmother was of short stature, her spirit is a titan. With this in mind, Juan-Ukuu is the tallest person in the known universe.

In this imaginative work, a seed of Juan-Ukuu reached a distant planet. There, Juan-Ukuu grew and became revered in that distant society. A colossal building of Juan-Ukuu was erected to tower above the clouds. Through her seeds, Juan-Ukuu has lived for thousands of years across many places. At times, she sits so still for hundreds of years that she becomes a tree waiting to be awakened when she is needed.

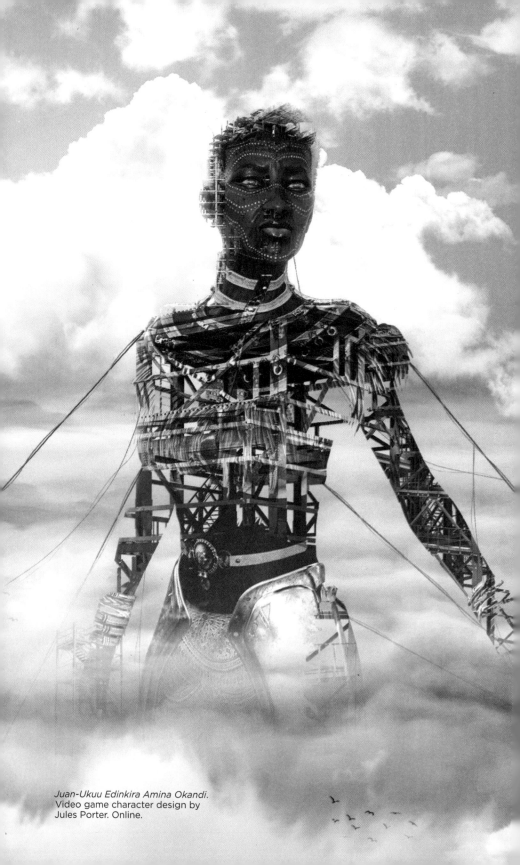

Juan-Ukuu Edinkira Amina Okandi.
Video game character design by
Jules Porter. Online.

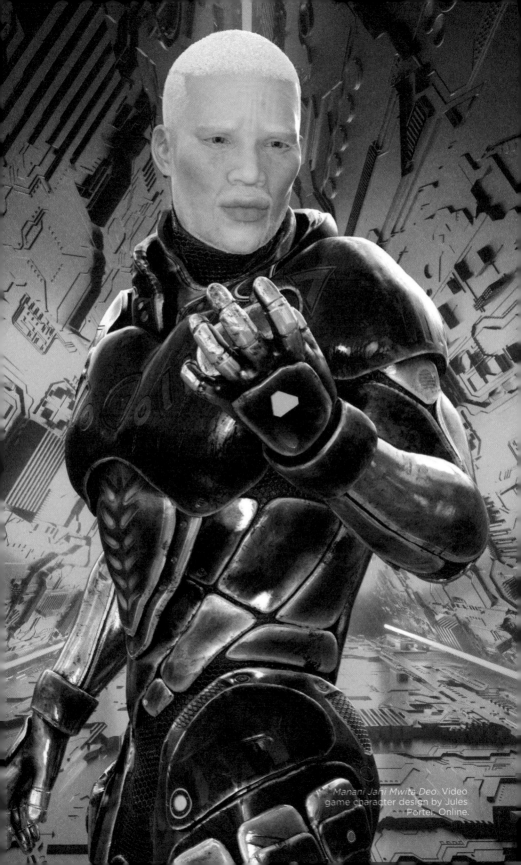

Manani Jani Mwita Deo. Video
game character design by Jules
Porter. Online.

Manani Jahi Mwita Deo, the Keeper of the Serengeti, Manzili, and Black Moon

> The man's soul, the complexion of his life. The menace of its greyness. The fire, throbs, the sea moves. Birds shoot from the dark. The edge of waters lit darkly for the moon.
> —Amiri Baraka, "The Invention of Comics"

Manani Jahi Mwita Deo, "Manny," is a superhero with albinism from the Serengeti. While the African continent—especially the countries of Fiji, Tanzania, and Kenya—hosts the highest rates of people with albinism, people with albinism are rarely featured in Afrofuturistic art. Additionally, during a review of superhero universes, I could not find a single albino superhero, although villainous depictions were plentiful. This means there are a wealth of stories that have not been told and perspectives that have not been shared. Consider for a moment the complexity of being an African man with pale white skin. We can choose any moment in human history, and a person with albinism lives a complex life and forced experience in society. They are often feared and even hunted for their lack of melanin. With Manny, I seek to provide one voice for people with albinism that I hope will be followed by many other voices seeking to share their unique experiences.

Manny, the keeper of the Serengeti, was born on the night a volcano erupted. The eruption saved his life as the falling ash was taken by the people as a supernatural hailing of his birth. The albino child was then declared a prophet or "Manzili" and was allowed to be hidden away in the Serengeti by his parents. Like many people with albinism, Manny is legally blind. At night, Manny gains a colorful night vision where he can see a person's aura. Having to learn to fight in order to survive, Manny is the best martial artist in the world. He can learn the fighting style of his opponent during the heat of the fight.

This Afrofuturistic works depicts a younger Manny during a covert operation mission. Having trained himself to the peak of human strength and durability, he enjoys challenging his opponents to land a single blow on him without using their superpowers. Manny is legally blind by day and has an aversion to sunlight. His superpowers reach their highest peak at night, when he also gains superhuman vision. Manny is the master of numerous African fighting styles that include Dambe, Donga, Evala, Laamb wrestling, and Nguni. He is a master tactician, renown painter, and sculptor too. Manny has had many superhero names, with his favorites being the Black Moon, Manzili, and Almighty Ghost.

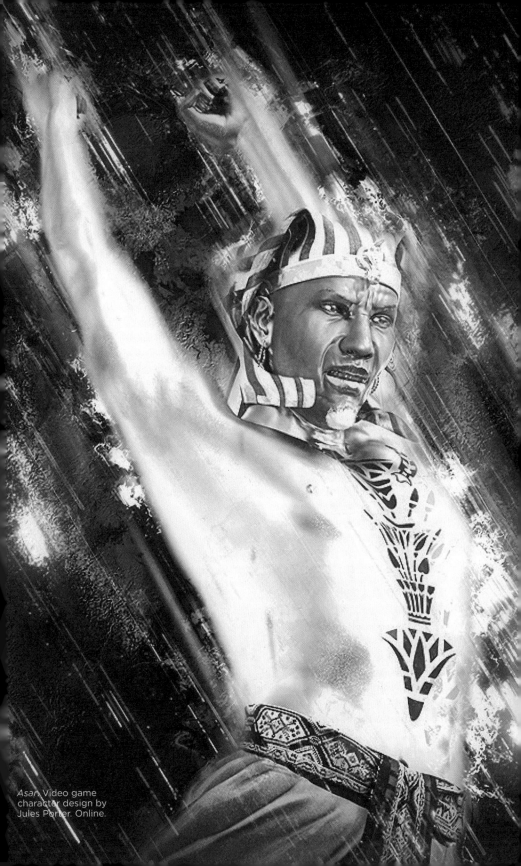

Asar, the Golden Man

I have just seen a beautiful thing Slim and still, Against a gold, gold sky, A strait cypress, Sensitive, Exquisite, A black finger Pointing upwards. Why, beautiful, still finger are you black? And why are you pointing upwards?
—Angela W. Grimke, "The Black Finger"

Asar, the Golden Man, was created during a time when others doubted my ability to create and found a video game company. Despite all of my education and past success in overcoming challenges, some people openly discouraged me. They could not fathom a Black woman making significant progress as a tech founder. My detractors also heavily criticized my goal of more positive Black representation in gaming. They counseled me to stick to a woman empowerment angle and ignore my own Blackness. My response was Asar, the Golden Man. I gave him hardened skin so that the attacks of his enemies would bounce off him without causing harm. I infused him with the power of flight and ability to survive in outer space so that he could literally fly above the foolishness. Finally, I made him a caring person who had a heart for those down on their luck. Asar is the defiance in me that will not allow others to limit my journey, dreams, and impact.

Growing up, my grandfather would always tell me that whatever man could conceive, I could achieve. He taught me to be fearless in learning, and put in the time and work necessary to excel. The fact that I was a woman, and that others had self-imposed limitations they wanted to place on me, must not hinder God's calling for my life as well as my boundless curiosity and dreams. In homage to my grandfather, Asar was designed to resemble a man my grandfather admired most: his father, the patriarch of our family.

This work depicts Asar's solar flare power from the perspective of his legally blind fellow character, Manny. Asar and Manny make up the superhero duo Jua na Mwezi (Sun and Moon), offering two contrasting views of African men. Asar, the Golden Man, is the dark-skinned Egyptian who is powered by the sun and claims to be the son of Osiris—the God of the Underworld. Manny, discussed previously, was born with no melanin in his skin to animal caretakers and hidden away in the Serengeti to save his life.

Over the years, Asar has been called the "Golden Man, "Soul of the Sun," "Sun King," and "Sun Maker." Despite these titles, Asar prefers to simply be called by his name, Asar. In addition to his many sun-related powers, Asar's skin turns into a golden metallike substance making him impervious to damage and highly reflective. Asar also has a naturally warmer body temperature that prevents frostbite and hypothermia. He often visits encampments in the winter to keep them warm and entertained with his stories.

Biography

Jules Porter uses video games and technology to advance social justice and bring more joy to science, technology, engineering, arts, and math education for diverse students. A lawyer, technopreneur, and edupreneur, Jules is the founder of Seraph 7 Studios. Seraph 7 develops games with Black and brown heroes and story lines, and has a tuition-free STEAM (science, technology, engineering, art and math) program for underestimated students. Jules works to create a world where all gamers can see themselves as heroes in games, lives, and dreams. Jules is a US Marine Corps veteran and licensed attorney in the state of Minnesota, with a JD, MBA, and BS in aeronautics, and seminary theology degree.

Acknowledgments

Dr. Mae Jemison ignited my interest in science and outer space. Judge Pamela Alexander showed me that Black women could be prosecutors and judges. Mayor Sharon Sayles-Belton modeled how to be an impactful civil leader. Amiri Baraka, Waring Cuney, and Audre Lorde showed me how to use words to paint the soul. Thank you.

Designing a Black Future

John Brown VI

The purpose of this contribution is to critically explain the need for radically changing the methods by which we attempt to racially diversify the field of design. Many will ask, "Why is this necessary?" or "How will this help the field? Why is this so important?" In its article "The Black Experience in Graphic Design: 1968 and 2020," Letterform Archive compared Dorothy Jackson's interview regarding the Black designer's experience in 1968 to responses from contemporary Black designers fifty years later. Unsurprisingly, the article cites a 1 percent increase in Black designers in a forty-year period. Unequivocally, the fault for this continuation of the status quo lies with the field of design itself. As a result of our field's current methods, Black designers have seen little growth in population and are often alienated, existing in pockets of space, leading Maurice Cherry to ask the question during his SXSW presentation on March 14, 2015, "Where are the Black designers?" In addition to limiting the Black design population, maintaining the status quo has limited the field of design, leaving it with fewer participants and contributors. Opposed to simply hiring those within the small pool of Black designers, I propose drafting new designers into the field by exposing Black community members to the field and providing access to design tools, softwares, and methodologies. How this can be implemented will be determined through interviews, secondary research, and other design tools. Like any other problem, this can be reframed as a design problem in analyzing assumptions. If the necessary change is not practiced, the Black population will continue to see minuscule increments of growth within design. If this issue continues to be ignored, we cannot ensure accessibility and welcome others into a truly human-centered design practice.

We have always lived in a world where as Black people, regardless of profession or background, we are acknowledged or made visible only after massive, overwhelming amounts of success. This results in two phenomena: one, the belief that Black people as a whole have "made it" and thus there is enough representation, and two, invisibility. Only those who appear "mainstream" or "marketable" are remembered and recognized while everyone else remains invisible. Time and time again examples of Black people, typically male, are used to justify these concepts and argue against the need for more inclusion. Think of former president Barack Obama or fashion designer Virgil Abloh. While the issue of recognition permeates through every level of society, it is especially present in the creative fields of art and design.

In the wake of articles like "The Black Experience in Graphic Design: 1968 and 2020" and *Fast Company*'s "Where Are All the Black Designers?," written by Lily Smith, many inside and outside the industry have begun to question how they can be more inclusive. How can we find and hire more Black talent? How do we create more Black designers? How does the classroom exclude Black and nonwhite designers alike? While these are great questions to ask initially, they fall short as they fail to address the larger problem of exclusion. In order to thoughtfully answer these questions, we must first understand the issue at hand: the exclusion of Black designers and thought.

Black Exclusion

The act of exclusion is by no means a new issue, and it happens across education and professional practices. Before I was a budding design educator, I had my own isolating experiences in academia. As a student studying painting and drawing, much of my work incorporated topics of race and nontraditional art styles. For my thesis, I utilized collage to compare bullfighting to the plight of Black people, examining how the bull and Black person were forced into a new hostile environment where the rules served to incapacitate them. I was met with overwhelming resistance. "Are you sure it's really like that?" "Do you study this?" "Why don't you do more? If this is such a big part of your life, maybe you should do more." Despite a standout show, the feedback from my peers effectively ended my ambitions of becoming a studio artist. Black students in design experience similar yet different problems. In his post "Dismantling White Supremacy in Design Classrooms: My Conversation with Design Guru Cheryl D. Miller," Eugene Korsunskiy recalls how his own classroom habits may have perpetuated ideas of white supremacy. Korsunskiy's habits are the same as many other design educators and practitioners: the prioritization of the Helvetica typeface and Eurocentric grid alignments.[63] This subconscious and overt obsession with Swiss design elevates the white and European style and obscures any others.

Some may say, "I know Black designers, so how have they been excluded from the field of graphic design in professional practice?" Traditionally, Black people have been excluded from certain occupations simply because of their race. The color of our skin has implied that we are not good or smart enough to handle and solve complex problems. As a result, we are left with smaller jobs for which we are usually underpaid and overqualified. As Alex Walker recalls in PRINT magazine's initial version of "The Black Experience in Graphic Design: 1968,"

> Unusually long periods of employment at one job tend to hamper one's creative process. Most white designers who eventually become award-winning art directors or make lots of money spent short periods of time in various studios and agencies. With each move, their knowledge, contacts, and usually their income increased. This is one modus operandi that has left the black designer in the dust.[64]

The author, Jackson, notes that in an attempt to stay gainfully employed in an unforgiving profession, Black designers become stuck and isolated. As a result of this struggle, the field of design is less attractive to Black people as they pursue financial security and stability.

In 1968, 1 percent of designers were Black. In 2021, that number has risen to 3 percent.[65] Over the span of almost fifty years, the field of design has seen an uninspiring 2 percent increase in the number of Black people employed. In 1985, Miller observed in her thesis that the majority of Black college students attended historically Black institutions, where they received an education that left them ill prepared for a job in graphic design.[66] Today in 2021, 87 percent of Black students attend private white institutions, but we must ask what is waiting for them in the classroom. As previously noted, the classroom must become a space where educators share various design styles and techniques. This will encourage students in attendance to share and develop their own styles instead of performing whiteness.

In her essay "Searching for a Black Aesthetic in American Graphic Design," Sylvia Harris recognizes designers from the New Negro movement, commercial arts, aesthetics of Black Power, tribal chic, and the New New Negro movement as forces who are "continuing black visual traditions."[67] In order to design a Black future, we must recognize modern design as a continuation of these movements and attempt to connect to our previous design aesthetics and ideals.

Biography

John Brown VI is a graduate student at Kent State University pursuing an MFA in visual communication design with a minor in user experience design. Brown is passionate about generating new experiences and fostering connections, with a great interest in user experience, design thinking and research, community, and design as a means of engagement. Currently, Brown works as a publication designer at the Cleveland Museum of Art creating books, exhibition ephemera, and other printed works. Outside design, he enjoys his loving family, friends, and soccer.

BLACK DESIGN

PEDAGOGY

An Introduction to Black Design Pedagogy

Terresa Moses and Omari Souza

Just as the design industry does not intentionally cultivate opportunities for Black representation and contribution, that practice is further reflected in the culture and systemic nature of secondary and higher education. Since desegregation laws took place after the US Supreme Court's decision in *Brown v. Board of Education*, we have yet to see a real and substantial increase in the representation of Black students, faculty, and/or upper-level administration that accurately represent our nation's racial makeup. This lack of representation not only affects the opportunities available to Black communities in higher education but also solidifies the exclusion of Black history and voices in the academy.

Before the existence of formal educational institutions, Black communities were already creating innovative ways to carry and archive our history via oral storytelling practices and artistry. Many of our educational practices were hands-on, building on kinesthetic traditions passed down through our generations. These practices remain in our communities as we continue to face threats of cultural erasure and whitewashing within the US educational system by right-wing white supremacists. Unfortunately, it has always been up to Black communities to fill the gap in Black historical knowledge that the system of education has intentionally designed to leave out. This reality is unacceptable, and academic change and progress can only be achieved through cross-disciplinary as well as cross-racial collaboration.

"Black Design Pedagogy" contributors are Black educators, historians, and creatives who use academia as an avenue to disseminate Black liberatory pedagogy and curriculum. As such, they recognize and express in their contributions the potential of learning environments and opportunities to be spaces of radical thought, anti-racist practice, and liberatory action. We should have a thriving system of education that values the lives and contributions of Black students, staff, and faculty. We understand just how easy it is to create intentional projects that explore identity and create room for critical dialogue that can lead to more inclusive, anti-racist, pro-Black, and progressive frames of thought. And although it seems simple to us, until these practices and pedagogical approaches are normalized in classrooms where the faculty member is not Black, decolonization and anti-racism in education simply *cannot* happen.

Decolonization is a cultural shift in practice that leads to the decentralization of white supremacy and inclusion of Black liberation. This culture shift recognizes student experiences as not only equal but a valued part of the course curriculum too. These positive cultural shifts must constantly challenge tradition in the institutions of higher learning that have been designed to thrive off its historical elitism, exclusion, and anti-Black racism. For Black liberation to be fully realized in design education means an intentional effort must be taken to remove cultural taxation from Black individuals and provide nontraditional approaches to center Black narratives and represent the Black experience in institutional leadership. In this way, education has the opportunity to examine positionalities in the design educational discourse to positively impact student contributions to the broader society.

Black liberation in education is a culture shift that is unafraid to talk about race in the classroom and its racist exclusionary practices. In fact, institutions of higher learning should attempt to understand why their faculty shudder at just the thought of mentioning racism. We have found that this effort can take place if we center the Black student experience. In Lesley-Ann Noel's contribution, she attempts to understand why Black students were not enrolling in design electives. She details her intentional outreach efforts to gain feedback from

Black students on recommendations, and their understanding of design and design thinking. Pierce Otlhogile-Gordon matches some of the Black students' recommendations by further analyzing how design has failed our communities, and offers pedagogical directives that provide space to transform and reimagine the historical injuries of design. He suggests antisupremacist design interventions as a means to support practical, liberatory alternatives for possibility and stewardship.

Building on these recommendations, Jillian M. Harris discusses the antithesis of the notion of *no existence preslavery*. She explores Africa along with her diaspora's cultural history and our contributions to the history of design, which if added to design pedagogy, can directly benefit the broader design community. We intentionally follow up this contribution with a visual narrative titled #BlackHistoryMatters by Stacey Robinson. The illustration includes the Sankofa bird, which means "go back and fetch it," referring to a retrieval of our stolen past to proceed to a Black liberated future.

Lastly, we give a detailed account of three design exhibition projects used to look at Black experiences, participate in political engagement, and examine civic participation. Because it is not enough to just mention racism in the classroom; faculty have a duty to creatively challenge it, purposefully, in their pedagogical approaches. Terresa Moses looks at what it means to truly center Blackness in every aspect of a design project, focusing not only on Black history but also Black contributions in the field of design as well as the local Black community. The connection of Black design and community impact is undeniable in this project as well as the following project, which focuses on community engagement. Anne H. Berry and Kelly Walters look closely at the exhibitions *Ongoing Matter: Democracy, Design, and the Mueller Report* and *With a Cast of Colored Stars*, which highlight how political engagement, active learning, and civic participation in contemporary contexts can be facilitated in graphic design environments. Each design project leaves room for critical analysis of representation in media and cultural bias.

"Black Design Pedagogy" should be a valued contribution to the academy, and the contributions we have selected actively prove this to be true. The value of the Black experience in curriculum and pedagogy must be intentionally added to deepen our understanding of the field of design, this nation, and our own understandings of who we are—all of us.

Black Student Perceptions of Design Courses at an Elite Private University

Lesley-Ann Noel

Administrators at a university in California were attempting to understand why students of color were not enrolling in the highly desirable design electives. As a response, outreach efforts were scheduled with the on-campus Black and Latinx student groups to understand their perspectives and invite them to the school. This case study documents the feedback received from one of two focus groups with Black students to understand their perceptions of design thinking. The focus group also explores their recommendations for improving the classroom environment in a way that would increase the enrollment of Black students and other students of color.

While these sessions centered specifically on the experiences of Black students, the recommendations are useful to all design educators seeking to attract and retain more diverse student groups by demonstrating how to create welcoming and inclusive learning environments for design thinking education.

Where Are the Black Students?

In spring 2019, long after Maurice Cherry's "Where Are the Black Designers?" presentation in 2015, and long before the mammoth Where Are the Black Designers? conference in summer 2020, the question that I heard often was "Where are the Black design students?" and "Why do so few Black students enroll in our prestigious classes?"

The setting was a design school at an elite private university in Northern California. The design courses were available to almost any student on campus as electives, yet Black students did not enroll. In spring 2019, out of a total student population of over seventeen thousand, only about seven hundred were Black according to various websites.[1] Therefore the question "Where are the Black students in our programs?" should have been part of a larger discussion about where were the Black students at this university, and conversations about meritocracy and inequity at private universities in the United States.

Background

At the time of this study, Donald Trump was still president. The college admissions scandal had just taken place. Robin DiAngelo's *White Fragility* had been released a year earlier and was already popular. Ijeoma Oluo's *So You Want to Talk about Race* was less well-known at the time but was also popular. President Trump was advocating for a border wall between the United States and Mexico. Democratic candidates like Pete Buttigieg, Cory Booker, Elizabeth Warren, Kamala Harris, and Joe Biden were announcing their intentions to run for office. Lori Lightfoot became the first Black woman and openly gay mayor of Chicago. For the first time in US history the winners of the Miss America, Miss Teen USA, and Miss USA beauty contests were all Black women. Against this backdrop, at our school in Northern California, we had many discussions about equity. This climate may have been part of the impetus to increase the enrollment of Black students in the courses.

For most of that academic year, I was the only Black member of the staff. A Black faculty member from a neighboring school was a regular collaborator at the design school and would often join us for lunch. A Black student employee was also hired later on in the academic year. There were several diversity, equity, and inclusion initiatives during the year that I was at this school. These were "opt-in" sessions, where we discussed microaggressions and intent versus impact, and codesigned a diversity manifesto.[2] There were always questions about why Black students did not enroll in our courses. At least two of my white colleagues engaged me directly in these conversations throughout the year. We strategized about what could be done to address the absence of Black students at the school.

I am a Black woman from the Caribbean. I was an outsider on so many levels at that school in Northern California. I was not American. I was not white. I was middle class in my home country, but living in California brought me closer to the poverty line than I had ever been in my life. I had not gone to an elite school for any of my education. Far from this, I had attended public universities in Brazil, Trinidad, and North Carolina, where the universities' missions for equity and raising people out of poverty were clearer. I had taught design for many years in Trinidad and also for a short period as a teaching assistant in North Carolina. I was unfamiliar with spaces that had extreme wealth and little diversity. Perhaps I was naive, but my naivete and beginner's point of view empowered me to ask questions. One of these obvious questions was, "If we want to know why Black students will not participate in these classes, why don't we just ask them?"

I devised a plan to qualitatively understand the issues that were preventing Black students from enrolling in design classes. I reached out to my two white colleagues who were genuinely interested in increasing the number of Black students at our school. I shared the plans with them since—as longtime staff members—they would understand the university ecosystem much better than I would. With their support, I arranged two focus groups to understand student perceptions of the design school and its courses. In the first focus group, I intended to reach out to students who had never taken any courses at our school. In the second focus group, I intended to reach out to Black students who had taken classes at our school to understand their experience as students. The results of the first focus group are recorded below.

The Focus Group

To find these students, on the recommendation of one of my colleagues, I reached out to the student affinity group for Black students. Affinity groups are spaces for people of the same racial, ethnic, or sexual identity to find support and connection.[3] These groups support the identity development of their stakeholders in small groups independent of the dominant culture and larger communities. On this campus, there were many affinity groups for students who identified as Black, Latinx, Asian, Native American, and LGBTQ+. Interestingly, the headquarters for the affinity group for Black students was located only about two blocks away from our school. I made an appointment with the coordinator, and she helped me organize the first focus group. After consultation with her, the main questions that I intended to ask were simple: "Why do you not take courses at this school?" "What kind of courses would you be interested in taking?" and finally, "What could the school do to attract more students of color?" Our meeting took place in April 2019.

I went to the meeting with a Latinx colleague so that he could possibly replicate or adapt the meeting structure with Latinx students in the future. We made a short presentation about our school and its courses, and then we

opened the floor for open-ended discussion. The students regarded us with some suspicion and took their time to warm up to us.

What Do You Know about Us?

The question "What do you know about us?" could be asked in both directions. What did the students know about the school, and what did the school know about them? Some of the students vaguely knew about the design school. They identified it as one of "those engineering buildings." They said they had little idea what actually went on inside. From the outside, the building seemed uninviting. Some of them had friends who had taken classes there. One student said she got the impression that the design school was too "career focused and oriented around money," and that rubbed her the wrong way. From the outside looking in, they felt the space felt exclusive. Another student said, "The courses seem targeted at white students." She asked, "How are they going to even get us into the door, so we can understand what they are about?" Yet another student found that the worldview that was generally presented by the school seemed overly optimistic, nonrealistic, and noncritical. She said, "It's just too California for me."

The few students who knew about the school and design thinking were critical about the approaches. They felt that the school seemed too far removed from the university and its requirements. They said, "We are just trying to navigate the system," sharing that while some of their white colleagues may have extra credits through high school advanced placement programs that gave them more freedom in choosing electives, they were often trying to meet their core credit requirements and could not then do additional courses for credit at the design school. They demonstrated how enrollment inequity actually starts before attending a university.

Student Recommendations to Increase the Enrollment of Students from Diverse Backgrounds

At the meeting, the students were eager to provide suggestions on what might encourage them to register for design classes.

Align Design School Courses with Mandatory Registration Requirements

They recommended that the design school align its offerings with required courses. Students were required to take courses in ethnic reasoning, creative writing, aesthetic inquiry series, or scientific methods analysis. They wondered if any of the design school electives could be listed as equivalent to any of these courses.

Conduct Open Houses for Student Groups That the School Would Like to Attract

The students indicated that from the outside, it was impossible to discern what went on in the design school. They mistook it for another one of the engineering buildings. They felt open houses and tours would be a good way to get students of color and first-generation, low-income students into the building.

Promote the Social Capital of the Program

Students were unaware of the opportunities to expand their network and make real-world connections in the design classes. These opportunities were derived from the interdisciplinary nature of the classes and the many contacts with industry partners. They felt that "people who knew, knew," and that the school could promote these opportunities to students who were unfamiliar with the field of design.

Create More Classes around the Interests of Black, Indigenous, and Students of Color

The students indicated that they sometimes felt that the courses that were advertised did not cater to the interests of students of color. They suggested that the school be more intentional about targeting students of color in general and Black students in particular, and proposed several ways of creating classes that align with their interests such as:

- Offer more courses targeted to Black students, like collaborations with people in Oakland.
- Develop more classes about racial inclusion.
- Offer more classes with a social justice, abolition, or liberation focus, although these classes should not be created through a white lens.
- Supply a clearer identification of majors for which the courses might be relevant so that the students would know if the courses align with their interests or not.
- Provide more consultations with Black, Indigenous, and students of color to find out their interests and "who they desire in leadership roles."

Create More Partnerships with People of Color

The biggest issue for the students was the absence of people who looked like them at the school. They made many suggestions on the types of productive partnerships that could happen between the school and people of color at the university and in the wider community:

- Partner with more faculty of color from outside the design school, especially with professors who are "doing the work" to make students feel more welcome, and professors who are popular with students. They named specific professors from the School of Education and Department of African American Studies that they would like to see in collaboration with the design school.

- Set up partnerships and classes as well as cross-listing courses with the design school and programs where Black students could be found, such as African American Studies.
- Develop "culturally informed design thinking" to partner with different ethnicity-specific affinity groups.
- Partner with folks who have influence in Black communities, such as professors, activists, and community partners.

"If This Is Fake, We Will Know!"

The students ended the focus group discussion with a warning for me, my Latinx colleague, and the school in general, saying, "If this is fake, we will know!" They questioned the authenticity of the interest in increasing the enrollment of Black students. The performative diversity, equity, and inclusion efforts of many companies in the weeks and months following the murder of George Floyd demonstrate that the students had every reason to be suspicious. In light this, the students continued to make suggestions on what the school could do to stay on track with its mission to attract and support a more diverse student body. Here are their suggestions:

- Create a racial equity class for white people affiliated with the school.
- Do an equity assessment to find out if your leadership matches the student and community demographics (at this point, the students asked how many Black faculty members were at the school, and I had to say that I was the only one).
- Create a task force of campus partners willing to support the school in dismantling white supremacy because the students did not trust the school to do enough on its own to dismantle white supremacy, although accountability to external partners would ensure that they stuck to their mission.
- Explicitly create spaces for Black and brown students.

Conclusion

I can look back and see the hubris in our approach. I can also see how the students *called us out*. Even as a Black woman, I had been drawn into the narrative of "How do we increase enrollment?" without looking at the bigger issues. We merely wanted more students of color and in particular Black students in the programs. We went to the meeting with a certain arrogance and assumption that we had something to save them from—typical design saviorism. The conversations with the students helped me to see the flaws in our approach. The enrollment of students was one issue, but possibly it was at the end of the chain of issues. The students were able to clearly identify issues around enrollment equity since some students gained extra credit in high school that gave them more freedom in their choice of electives. They showed how the content of the classes was not aligned with their interests. They gave

us concrete examples of how the content could be restructured, and how both the instruction and delivery methods could also reflect the diversity that we said we wanted to achieve. In their last recommendation about "creating spaces for Black and brown students," the students showed that this effort could not be about numbers. It had to be about creating new content, from different points of view, with different partners and different worldviews. They would not merely be tokens in a school and courses designed only for white students. If we wanted a more diverse student body, we had to be conscious of that diversity before the start of the classes, at enrollment, in planning the content, selecting the partners and instructors, and finally the delivery of the courses. The conversations reminded me of the beauty of codesign too. These students essentially helped us design programs for them.

I left the school before I could gauge the impact of the report that I presented to the school administration. I do know that my two white colleagues and the one Latinx colleague, who were committed to change, used some of the suggestions in the report in planning their future work, and continue their own paths in support of racial equity. Personally, I was surprised at the impact on me as an educator of both the meeting and the students' suggestions. A few years have passed since the meeting, yet I am still able to consult my notes and ask myself what would these students think about what I am doing. They have kept me accountable to Black and other students who do not identify with the dominant narrative, encouraging me to decenter white experiences and intentionally, not accidentally, create courses that welcome a plurality of experiences. I have changed my teaching practice. For that I am grateful.

Biography

Lesley-Ann Noel is an assistant professor at North Carolina State University. She practices design through emancipatory, critical, and antihegemonic lenses, focusing on equity, social justice, and the experiences of people who are often excluded from design education, research, and practice.

Acknowledgments

I would like to thank Dr. Brent Obleton, Christian Price, Hannah Joy Root, and Louie Montoya for their support and friendship. I would like to also warmly thank all the students who participated actively in the focus group.

Design's Ledger of White Supremacy: Constructing a Critical Race Pedagogy to Shape Design Futures

Pierce Otlhogile-Gordon

Peruvian sociologist and humanist thinker Anibal Quijano's influential work in critical theory and decolonial studies details how Spanish rule in Latin America originally constructed the concept of race as a social hierarchy.4 In this racial classification system, the rights one had as a citizen were determined by their bloodline: whether you were Españoles/Spaniard, Indios/Amerindians, or Negros/Africans. Such categories and their "intermediates," such as mestizo, castizo, mulatto, morizo, zambo, and pardo, became the primary dynamic for a new type of society, with each role offering different social hierarchies. It is important to note that the "innovation" from this structure, although ethnicity and skin color in society were noticed in the past, is how it was specifically used to organize forced behavior and production as labor control to produce commodities for the world market—more specifically to maximize profit for the Spanish in Europe.

In doing so, the world system is organized around a single locus—a universe—of hegemonic power and a periphery primarily designed to fuel culture. This core-periphery model, a core concept in world-systems theory, is perpetuated across multiple structures of human organization. This appears in the division of labor, political and economic institutional structures, and racial and gender hierarchies, to linguistic, epistemic, a pedagogical hierarchy, and more that collectively organize centrally produced knowledge over knowledge from the periphery.

As expected, the aesthetic and design communities followed this organizational structure. Design scholars who created "canon" texts used "periphery" craftspeople, as in those not from Western history, as a racist counterpoint to how and why "design" as a field held value. By delineating between designers and the "unselfconsious cultures," Christopher Alexander stated, "[these] cultures contain ... a certain built-in fixity—patterns of myth, tradition, and taboo which resist willful change. ... [W]e do not need to pretend that these craftsmen had special ability. ... Once presented with more complicated choices, their apparent mastery and judgment disappeared."[5] To them, only Western "designers" could engage in design work, while primitive people/cultures could only engage in the creation of "craft." This history is rarely recognized in today's design canon; over generations, Western-producing design communities willfully constructed artifacts, systems, and mythos that subjugate and exploit non-Western work in several ways. To co-opt the language of the cryptocurrency community, the ledger of design harms has been purposefully lost to history.

While there are design methods and communities used today to shape products, services, experiences, systems, and policies, the relationships between these artifacts and the transgression of the white supremacist world order are rarely systematically explored. Some artifacts such as Guinean slave ships were built specifically to perpetuate and house white supremacy, but others like Halloween costumes implicitly adopted a social channel for racism already prevalent in the culture.[6] Additionally, different design subdisciplines directly manifest or implicitly perpetuate systems of supremacy. Human-centered design, industrial design, graphic design, and many other design communities perpetuate a supremacist narrative by building a hierarchy of a single valuable method set over many others.[7] And countless design schools perpetuate this supremacy by teaching white design practitioners and practices over Indigenous, Global South, and culturally constructed design.

To rebuild systems of liberation and decoloniality along with the pedagogical capacity to critique and deconstruct, we offer this course structure. This course—Design's Ledger of White Supremacy—is a curriculum framework to unpack, connect, and surface the systemic and personal relationships between oppression and design. It rebuilds relationships between design and white supremacy. I will explore this through a historical and present-day lens

to build a space where design students can see and shape a more liberatory world. Toward this end, I will review valuable literature on recent critical design education work, outline the structure and purpose for such a course, and offer the next steps for expanding the course past the outlined curriculum.

Resources for Shaping a Liberatory World

Over the past decade, the global community has gone through a cultural reckoning of its multifaceted relationships with white supremacy. In doing so, many resources have been developed and spread across the world to support people looking to shift their relationship with hundreds of years of oppression. The design community is no different; certain resources outline human-made artifacts and their relationship with racism.

In "The Color of Supremacy," Zeus Leonardo states how "a critical look at white privilege, or the analysis of white racial hegemony, must be complemented by an equally rigorous examination of white supremacy, or the analysis of white racial domination."[8] Kyoko Kishimoto offers that effectively developing anti-racist pedagogy requires at least four core actions: the facility's critical reflection of its social position, anti-racist course content, an anti-racist approach to teaching, and anti-racist organizing for institutional change.[9] Lisa Mercer and Terresa Moses, the founders of Racism Untaught, offer a categorization of how racism manifests in society: through design artifacts, systems, and experiences.

There are multiple mainstream calls to decolonize syllabi, the core resource that undergirds pedagogical support from offering alternatives that inspire agency and social justice in the classroom, as a return to modes of thinking and knowledge that colonization aimed to destroy, and demand for the repatriation of Indigenous land and life.[10] Communities outside academia have presented ways to dismantle white supremist culture in schools, resources that interrogate racism, specific strategies for and practices that support anti-racist/decolonized teaching tools, and how teachers can encourage behavioral shifts toward anti-racism in their classrooms.[11] Additionally, internationally recognized universities offer codified resources to address white supremacy including Dartmouth's Becoming an Anti-Racist Educator tool, the Office of Pluralism and Leadership, and the Office of Institutional Diversity and Equity as well as Vanderbilt University's Teaching Race: Pedagogy and Practice.[12]

This cultural inflection point also offers multiple design educational resources available to the world that support personal education toward anti-racist topics. Though design thinking has engaged in many diverse critiques over its mainstream expansion, Darin Buzon unpacks how "Design Thinking Is a Rebrand for White Supremacy" by prioritizing, hierarchizing, and universalizing a single collection of methods and mindsets that shape a future, akin to modernism and other supremacist perspectives.[13] To this end, famed designer Cheryl D.

Miller speaks about how universal design represents an era that oppressed Black women designers aiming to carve out space in the design canon.[14]

To address these issues, multiple designers have developed tools to educate on critiques of oppression built for design practice and facilitation. Though there are too many to list here, a few must be stated for context. For instance, there's Lesley-Ann Noel's Critical Design Alphabet, a deck of cards built "to introduce designers and design students to critical theory and to help them reflect on their design process."[15] The Liberatory Design Cards, developed through a relationship between the National Equity Project, Beytna Design, Design School X, and operators of the Stanford d.school, offers processes, mindsets, and "do nows," purposed to "create opportunities for the human-centered designer to NOTICE + REFLECT on the identities, experiences, and biases they bring to a design opportunity."[16] Moreover, the With/Out Modernity Cards offer "questions and invitations related to affective and relational work 'within' and 'gesturing out of' (with/out) modernity."[17] Multiple resources also serve to amalgamate and make open-source design resources specifically to reimagine and address oppression, such as the "Decolonizing Design Reader," "Incomplete List of Resources for the Equity-Centered Designer," and "A Hundred Racist Designs."[18]

Researchers, practitioners, activists, and other multihyphenates also have begun to build assets available to all that offer tool kits, methods, spaces, and other resources that support design education against oppression. Equity Meets Design, for instance, develops online curricula specifically built to understand and address racism and inequity as products of design, including "Problem with Problems" and its Intro to EquityXDesign courses.[19] Polymode's BIPOC Design History offers a collection of courses through lectures, readings, and discussions that shed light on cultural figures and previously marginalized designers, particularly BIPOC and queer and trans people of color.[20] Racism Untaught offers a paid service that uses design research methods to support a systematic process of unlearning for academic and industry clients.[21] Dark Matter University offers a community that creates new forms of knowledge production, institutions, collectivity and practice, community and culture, and design toward radical antiracism.[22] And the Black School is an experimental art school that teaches radical Black history through building and maintaining a community center, facilitating workshops for community engagement and art, and maintaining a studio that uses apprenticeships to execute client work for third-party organizations.[23]

Course Structure

This framework is intended to support the education, guidance, and implementation of action-oriented white supremacist critique using methods and mindsets of design. To do so, the course offers four stages. First, the course builds theoretical grounding in tools that help critique design in the

past and present. Second, the course requires students to research harms close to their personal context that perpetuate white supremacy. Third, the course requires students to build creative spaces that offer methods to imagine and implement a future built on nonsupremacist politics, technologies, and relationships. Finally, the course requires the design students to reflect on the experience and their role in shaping a liberatory design alternative while building tools to sustain the intervention once the course is finished. Teachers are free to modify, evolve, expand, and build the structure as they see fit, as long as the changes continue to hold the critique and transformation of white supremacist artifacts at its core.

Phase 1: Surveying the Ground

Before we start to build anything, we must first scrutinize the ground we stand on—physically and conceptually, collectively and personally. The first phase of the course, intended for potentially the first four to six weeks of the semester, unpacks the philosophical foundation of the course as well as builds the unique intersection of design and oppression named through white supremacy. As a field centered on generating artifacts, policies, experiences, structures, and more, the first phase of the course outlines human creations that contribute to supremacist domination, authority, exploitation, manipulation, and control. The first part of the course offers resources to critique and reshape systems of oppression that manifest through our society. This involves methodological frames to understand supremacy, including but not limited to intersectionality, design justice, systems thinking, dominating power, bias, world-systems theory, and coloniality. These concepts offer ways to conceptualize intrapersonal, interpersonal, organizational, community, national, and global scopes on how white supremacy reveals itself through our lives. The course requires the students to answer these questions:

- What's the history of white supremacy in human life?
- How does supremacy manifest in our lives?
- How can we name and deconstruct its effects, today and through history?
- What examples exist where design, as a field, community, discipline, industry, practice, or outcomes, manifests white supremacy?
- What can design offer toward liberatory futures?
- What limits does the field have when trying to reach liberatory futures?

This phase supplies unique examples that reveal design supremacy manifested throughout history. This includes lists and instances of influential oppressive designs today and throughout history, interventions designed to be oppressive, and others that came to represent oppression over time along with oppression related to race, gender, ability, and other systematic identities of oppression. Some illustrations include, but are not limited to, slave ships, the craniometer, defensive architecture, redlining, and zoos.

The first part of the course provides opportunities to understand the capabilities and limits of these frameworks, explore how these designed interventions intersect and affect the lives of citizens, learn about how white supremacy manifests, evolves, and reproduces throughout society, and research and expand the collective knowledge of design's relationship with white supremacy. The experience will be effective if the students, individually and as a collective, can understand these examples, critique the world we live in, find additional instances not represented in the teaching materials, and develop a rigorous understanding of its relationship to white supremacy as a concept.

Phase 2: Tilling the Soil

The second phase of the course aims to outline local design contexts, systems, artifacts, and the like that manifest white supremacist consequences and histories. Here, the students have the opportunity to understand specific problem spaces that they have the capacity to reshape. This differs from other design courses that might name, build, and work on outlining issues of social change. Instead, this course does two things: speaks truth to power by specifically naming design's relationship to white supremacy and other oppressions, and aims to build solutions that destroy and re-create with liberation in mind. If the metaphoric priority of the previous phase is to envision the supremacist ecosystem, the second phase begins to prepare student designers to find where they will start to plant their roots. The course requires the students to answer these questions:

- What specific problem(s) do I want to address during the expanse of this course?
- What problem(s) do I have the capability of addressing?
- How was this problem historically created? How does this problem affect other actors in our world? What keeps this problem alive?
- How will I go about reshaping the problem that I intend to address during this time together?
- What do I need to know about the problem to ensure that I'm not reproducing supremacist design practices?

During this phase, the students will be tasked with finding their specific problem to address. To do so, the students will be offered personal design tools to shape their path including, but not limited to, paseo diagrams, power-mapping tools, participatory imelines, capability diagrams, community activist tactics, and culturally responsive evaluation methodologies. Additionally, this phase of the course offers spaces to intervene, such as topic areas, scopes, deep structures embedded within the system, and potential leverage points for the students. It requires the students to consider the specific contexts in which they operate (if this course is developed for a university, for instance, how the university designs white supremacy today and throughout history) and learn antisupremacist values of design practice. The students also will be

exposed to understanding how scope, time, and space affect their intended problem: how the problem was created through history, and how systems of colonialism, neoliberalism, politics, power, and more affect their problem.

The students will be successful if they can find and name the specific supremacist issue they want to work toward addressing through society, and its consequences both before and after history. Designers today have personal and institutionalized problems with understanding the context and consequences of working on social and political issues, and most designers make the same mistake. The students must also reliably unpack the connections between their chosen problem area and how they affect others: those who perpetrate it, benefit from it, or are harmed by it.

Phase 3: Planting the Seeds

The third phase of the course provides tools, methods, pathways, and cognitive space to ideate and implement anti-racist futures that can support the transformation of the students' problem spaces. The core focus of this phase is to offer students collective and independent spaces to ideate, implement, test, pivot, and learn about methods that intend to disrupt a white supremacist design context. This course is built around negotiating the difficult yet essential tension between imagining unforeseen futures and practically building solutions that affect them. In doing so, these students must balance on this tightrope, building practical steps to shift the systems they find on one side, and expanding their imaginations past logics of domination through products, services, and solutions on the other. It also offers spaces to imagine possibilities to design for restoration, collective building, healing, and activism, instead of harm, division, exploitation, and domination. The course requires the students to answer these questions:

- Which tools need to be wielded to shape this design intervention?
- How, who, and when do others participate?
- How does planning proceed when building the intervention? What are the large steps? The small ones?
- What are the consequences of wielding your chosen intervention on the issue? How does it affect your stakeholders? How does it affect society?
- How, and when, will you test and learn from wielding the intervention?

To do so, the students will be equipped with a collection of tasks to imagine, create, understand the consequences of, and iterate on their creations. This process includes, but is not limited to, methods of systems thinking, generative ideation, community research, and engagement, and supports methodologies, community critique opportunities, transdisciplinary collaboration, organizing and activism tactics, technological tools available to the community, and more. This phase of the course is about building spaces for creating artifacts

that open up room for learning, critique, building agency, and recognizing the consequences of their interventions.

Moreover, the students will be given specific case studies of liberatory designs that exist throughout history but are not as visible as normalized interventions. Examples of these interventions will be represented in such resources as Actipedia, an online resource that categorizes resistance tactics and stories, and KATA and Molly McCue's "Examples of Inclusive Design."[24] In doing so, the students will be exposed to how creating interventions affects others, how they unlock complexity in latent systems, the difficulty of navigating existing power structures, and what lessons we can learn when building and wielding our design interventions.

The students will be successful if they can actively build, understand, and learn from the interventions they construct along with their effects on stakeholders at different scopes. For students and facilitators, this phase of the class is when tension, friction, synthesis, and agitation is most likely to occur. Holding the tensions of creating and affecting change through white supremacy is an essential, consistent task of any teacher of this course, and ensuring students recognize the consequences of their creations is critical to a successful design experience.

Phase 4: Reflections and Connections

Finally, this course offers personal reflection on the past and future of their design context to ensure that the students understand how their journey incited change—in their chosen issue, their community, and themselves. By this time, students will have had in-depth experience naming and shaping liberatory interventions with their fellow students and colleagues, and it will be valuable to distance themselves from their projects to meditate on the influence of this course and the future. This phase of the course supplies space to understand how they have been changed and what other changes are possible after the course has been completed. To build on this understanding, the course requires the students to answer these questions:

- How has this experience and your project shaped you?
- How has your project shaped others during this course?
- How can this project evolve in the future?
- What needs to happen to ensure that the project continues to effect change?
- Why does your work in this course matter?
- With whom do you need to be in community with to continue this work?

This phase is intended not simply to reflect on transition but to celebrate and support the next steps in the designers' lives too. To do so, the students will be equipped with a collection of tools, methods, and resources specifically

focused on reflecting the experience. This includes, but is not limited to, meditation, one-on-one and collective sharing experiences, physical manifestation exercises through making and theater, and building community support plans for the projects. Doing so builds the importance of appreciating and holding sacred the liberatory work that each student designer embarked on, and how this reflection and celebration must continue in the future. Additionally, the students will be incentivized to actively design how their interventions should be sustained, whether that means building relationships, finding places to continue to learn, build, and grow, finding ways to build their skills and use the skills of others, and remembering humanity at every phase of the process.

Conclusion

This resource builds on generations of communities that critique, heal, imagine, and push against systemic oppression in all forms. Though the course can be applied toward transforming other systems of oppression including ableism, homophobia, sexism, nationalism, classism, and more, building a curriculum that first critiques the organizing structure of white supremacy is extremely grounding—both for other oppressions and designers looking to speak truth to power. A productive critical design course, in fact, would also investigate how these oppressions are designed to intersect.

This course offers the opportunity to build and evolve design artifacts that redesign white supremacy. While conducting the course, the lecturer and students are likely to come across events, methods, communities, artifacts, and other resources not originally available in their original curriculum. Fortunately, this adaptation is a designed benefit: by forming the topic, we intend to attract exponentially more knowledge resources that make practical liberation seem more likely. When these resources are found, the teacher can add these resources while the class is in operation and build the information into the next iteration of the course. As this course is administered over years, we hope multiple changes can be implemented and shared to build a better teaching experience.

The world that created white supremacy, though hundreds of years old, hasn't existed forever. Many people forget this fact. As Antionette D. Carroll, founder of Creative Reaction Lab states, "Systems of Oppression, Inequality, and Inequity are by design. Therefore, they can be redesigned."[25] People have survived, resisted, deconstructed, and designed outside its structures in ways that we can use as fuel to rebuild our society. Any productive redesign of white supremacy wields the language, disciplinary knowledge, and methodologies of design to rebuild connections between existing artifacts and oppressive interactions—to build a space to imagine and integrate the future. If we are to rebuild other worlds, we must build places that designate, dissect, and design anew.

Pierce Otlhogile-Gordon is an innovation catalyst, researcher, facilitator, and evaluator, impassioned by the space between transformation and liberation. Otlhogile-Gordon serves as a shepherd for equity innovation to shape our collective future. He's taught courses in design, evaluation, international development, and equity across four continents, codesigned partnerships, products, and services with local and international change makers to support social change, and researched the complexity, evaluation, and emergence of design and innovation across the world.

African Design: Origins and Migration

Jillian M. Harris

The term *graphic design* was first used in 1922 by book designer and calligrapher William Addison Dwiggins, however he was not the inventor of the craft. Graphic design as we know it today—the creation of an artifact utilizing image, text, or a combination of the two—has been used by humans since our beginning. The current design history archive attempts to provide the reader with a time line of the "notable stages and achievements in graphic design history" that lead to design as practiced today.[26] While aesthetics plays a significant role, other determinants for inclusion in design canons have been the effect on the viewer, the designer's principles, the work's impact on technology and the industry, and its resulting economic associations.

Like most of history, the lens through which design has been evaluated is admittedly Eurocentric. Yet if we were to widen that lens, we undoubtedly will find a more diverse landscape of design history that includes the contributions of Black, Indigenous, and people of color. Because these contributions were not perceived as affecting the evolution of European and US design, they did not meet the criteria set for inclusion in the canons. Nevertheless, these castaways of design history can often be found in anthropology's annals, and if we stitch the two together, an exciting narrative begins to unfold.

Except for the work done by Professors Ron Eglash and Audrey Bennett, most examiners of African art posit that any radical exhibitions of form, technique, or even math found in African art were intuition, and not the result of deliberate thought, action, or calculation. Bennett seeks to find a Black aesthetic whereby Black, Indigenous, and graphic designers of color can find belonging. For her, that aesthetic begins in understanding African mathematics as outlined in Eglash's work. Similarly, Sylvia Harris's essay "Searching for a Black Aesthetic in American Graphic Design Education" points readers to several resources from the 1920s to the essay's publishing in the 1990s that can be used to find some semblance of an aesthetic tradition. Harris's position is that

> [Black] students often exhibit insecurities that negatively affect their performance. In fact, they experience a problem common to many black design professionals: the feeling that they are not completely welcome in the profession. Lack of exposure to the prevailing aesthetic traditions also puts them (us) at a disadvantage. This outsider posture leads many black designers to compulsively imitate and assimilate mainstream aesthetic traditions to feel accepted and be successful. Often, black designers and students are trapped in a strategy of imitation rather than innovation.[27]

For me, this disparity goes even further back. Yes, I agree that Black art and design students need to see working professionals of color producing at the highest levels of the field. What they also need—or maybe I should say here, what I needed when I was a student—is to see their ancestors reflected in the foundations of civilization, art, and design history that they are studying. One root of the psychosis outlined in Harris's essay is the telling of a history that says to Black designers that they had, and extension, will continue to have, nothing to contribute. I hope that by providing examples of how Africans have contributed to the evolution of art and design history, it leads to a more inclusive telling of history.

Cave Painting

Art and design history frequently begin with cave paintings. In most design history texts, while the cave paintings from Africa are mentioned quite often, only the cave paintings from Europe are shown. "Early human markings found

in Africa are over two hundred thousand years old. From the early Paleolithic to the Neolithic period (35,000 to 4000 BCE), early Africans and Europeans left paintings in caves, including the Lascaux caves in southern France and Altamira in Spain."[28]

In reality, cave paintings have been found wherever Indigenous populations were seen worldwide. These first peoples documented their existence from Brazil to Indonesia, India, Romania, Australia, and Africa. While recent evidence points to discoveries in Indonesia that are now said to be the oldest, previous research had reserved that title for cave paintings found on the African continent. As described by the Bradshaw Foundation in "Where Is the Oldest Rock Art?,"

> The painted stones from Apollo 11 in Namibia date to roughly 27,500 years. The oldest dated rock art in Africa was discovered in the Apollo 11 Cave in the Huns Mountains in southwestern Namibia. Seven grey-brown quartzite slabs, each smaller than an adult hand, were found with images drawn in charcoal and ochre during excavations in the cave in 1969 by German archaeologist W. E. Wendt. ... Three samples of charcoal and ostrich eggshell found in the same layer were radiocarbon dated to between 27,500 and 25,500 years BP (Wendt 1976). More recent excavations have confirmed the dating of this layer and its Middle Stone Age associations.[29]

This is just one documented instance. Further research on the subject reveals that rock art has been found across the African continent, from the Atlas Mountains in the north to the Drakensberg in South Africa, with a scale and complexity of form and color that rival the paintings in Lascaux. Additionally, not all rock art found in Africa is prehistoric; the Dogon people of Mali are, in fact, still producing rock paintings today. While cave paintings have been documented in both art and design texts, they are not recorded as the beginning of the evolution of either craft but rather as an ancient mode of communication and storytelling that serves as a lead-in to the study of ancient civilizations and their alphabets and writing.

The First Civilizations

While the oldest-known human specimen has been recorded in present-day Ethiopia, archaeologists and anthropologists continue to argue over which civilization was the oldest. Early researchers believed it to be the early civilizations of the Mesopotamians and Sumerians.

Biblical theology supported colonialism and slavery, noting the story of Noah and his sons, Shem, Ham, and Japeth. In Genesis, it is written that Noah cursed his grandson (son of Ham) Canaan with Black skin. This led to scholars to believe that Ham and his offspring were cursed with Black skin and further

justified their enslavement. It was also noted that later, Western and Islamic traders and slave owners used the concept of the "Curse of Ham" to justify the enslaving of Africans. The Bradshaw Foundation explains that

> beginning in the 19th century, scholars generally classified the Hamitic race as a subgroup of the Caucasian race, alongside the Aryan race and the Semitic—thus grouping the non-Semitic populations native to North Africa and the Horn of Africa, including the Ancient Egyptians. According to the Hamitic theory, this "Hamitic race" was superior to or more advanced than the "Negroid" populations of Sub-Saharan Africa. In its most extreme form, in the writings of C. G. Seligman, this theory asserted that virtually all significant achievements in African history were the work of "Hamites."[30]

The telling of this history is essential because even though those theories have long been discredited and we no longer refer to Africans as Hamites, those theories have seeped into the overall retelling of history by which the achievements of the ancient Egyptians, Mesopotamians, and Sumerians are never told as the achievements of Africans. Similarly, the contributions of the people of sub-Saharan Africa are not often spoken about with the same regard as those northern Africa (ancient Egypt).

The Mesopotamians constituted a civilization that benefited from the genius of Sumerian immigration. Universally, historians have believed that the origin of the Sumerians remains a mystery. It's difficult to believe that it remains a mystery to this day. Yet evidence suggests that the Sumerians called themselves "the black-headed ones." Historians have theorized that black referred to the color of earth along the Nile. While the dirt along the Nile is black, a more logical explanation is that the reference to the head in relation to color relates to the color of their skin. As a result of the subgroupings outlined above, the level of advancement that these people brought to the region has made it difficult for researchers to accept them as Black or Negroid people. The Wikipedia entry for "Hamites" states,

> It is clear that the Sumerians were highly civilized when they entered Babylonia; they knew the arts of agriculture by 3500 BC; they would make beautiful objects of gold and silver, surpassing in craftsmanship and beauty anything found in Egypt until centuries later; they could write; they had invented the principle of the real arch and dome, and they had invented the use of the wheel and the chariots.[31]

By 3100 BC, we began to see entries of Egypt, specifically Egyptian hieroglyphics. "By the time King Menes unified the land of Egypt and formed the First Dynasty around 3100 BCE, a number of Sumerian inventions had reached Egypt."[32] In the telling of the story of King Menes, little is documented about Upper and Lower Egypt themselves, leading a nonquestioning student

to believe that nothing of note came out of these civilizations, or that they were not civilizations at all and that the writer is simply speaking about the unification of territory. The word unification, however, suggests that there may have been an ongoing conflict between the two unnamed groups of people. Chancellor Williams writes in *The Destruction of Black Civilization* that

> there were Blacks who neither fled before the Asian advance nor submitted to enslavement. These, also rejecting amalgamation as the process of transforming the race, stood their ground fighting back and were generally wiped out. In short, the Africans held Upper Egypt (South) while the Asiatics held Lower Egypt (North).[33]

Chancellor Williams goes on to observe that, "Finally, the great triumph came when African King Menes defeated the Asians decisively and united all of Egypt under African rule again, beginning the historic First Dynasty"[34]

It is important to note that while textbooks universally refer to this territory as Egypt, Egypt as a territory did not exist before the arrival of the Greeks. The unification of Upper and Lower Egypt resulted in the building of Memphis. Egypt was not a single civilization of Indigenous people but instead the culmination of years of immigration of different cultures and ethnicities from the Sumerians to other unnamed peoples from the eastern and lower regions of Africa as well as Asia.

Alphabets

In Egypt, we find both writing and architecture that surpasses anything produced by any other civilization. The hieroglyphics as they are presented are quite sophisticated and shown in comparison to cuneiform, the writing system of the Sumerians, the civilization that directly precedes it. What we do not see, though, is the evolution of hieroglyphics, which undoubtedly would have been developed in either Upper or Lower Egypt before its unification in 3100 BC, or by some other ancient civilization that immigrated to Egypt. In his book *Afrikan Alphabets: The Story of Writing in Afrika*, Professor Saki Mafundikwa writes that "pictographs and symbols—used in pictographic rock art, scarification, knotted strings, tally sticks, and symbol writing—are considered together as forerunners of writing in Afrika. They form the roots, both directly and indirectly, of Afrikan writing systems."[35]

Protowriting and petroglyphs can also be seen as the precursors to pictographic writing styles like hieroglyphics. While the word *hieroglyphics* is most often associated with Egypt, hieroglyphs as a style of writing are not exclusive to Egypt. The Mayans have their own hieroglyphics that postdate the ones found in Egypt. But the Dogon in Mali have a system of hieroglyphics that are quite like the ones found in Egypt. While the two styles differ in execution, with the Egyptians offering more sophistication in the color and depth of their

carved reliefs, they are similar in that they both utilize a system of imagery to represent all things in the universe. The most interesting of these is math and science. Studies of the Dogon culture reveal close relationships between Dogon words and Egyptian words, and many Dogon drawings appear as glyphs in Egyptian words.

> Laird Scranton's radical reinterpretation of Egyptian Hieroglyphs came directly from his studies of Dogon cosmological symbols. Their priests use cosmological drawings, symbols they have used for thousands of years. While it is impossible to ask the ancient Egyptians to explain their beliefs, Dogon priests can explain their cosmology, how their symbols are written and pronounced.[36]

Scranton asserts that the link between the Dogon and Egyptians exists because the Dogon are said to have come out of a class of ancient Egyptian priests who had specialized knowledge and, in his opinion, left Egypt. While there is no evidence to back up his claim, I would argue that the style of the Dogon hieroglyphs seems closer to rock painting, and had they been taken out of Egypt, the technology for creating the reliefs and so on, would have come along with it. There is no doubt, however, that the Dogon come from an ancient priesthood, and it is no surprise that many of the rock paintings found across the African continent can be associated with shamanistic rituals, with many of the sites still being used for spiritual purposes today. I believe that the Dogon may be one of the unnamed civilizations of sub-Saharan Africa that immigrated into and influenced ancient Egypt.

Looking forward to the present day, Africa now has over two thousand living languages and possibly an equal number of alphabets that are yet to be included in the design canons.

Illuminated Manuscripts

The word *illuminated* as it pertains to manuscripts used to refer only to gilded manuscripts, but "today this name is used for all decorated and illustrated handwritten books."[37] Their study in graphic design history begins with the Vatican Vergil created in the early fourth or fifth century, and concludes in 1450 when typography and printed books start to replace manuscripts. Once movable type was invented, the Gutenberg Bible became and still is one of the world's most valuable books. Ethiopian bibles, specifically the Garima gospels, are argued to be the world's oldest-surviving illuminated manuscript. To date they are not mentioned in most major design canons.

The Golden Section

A great deal has been learned from Egyptian and Dogon hieroglyphics about our cosmology and belief systems. Hidden in those systems are ancient math and science. The earliest example of math found on the African continent is the Lebombo bone. Discovered in Swaziland, the Lebombo bone is a thirty-seven-thousand-year-old fibula of a baboon that "was found marked with 29 notches similar to the Calendar sticks, and Tally sticks used by the Bushmen of Namibia today."[38] The most common example of African math, though, can be found in the pyramids of Egypt.

The pyramids of Giza are the pièce de résistance of ancient African architecture. Built during the Old Kingdom to house the pharaohs, these pyramids are works of art that tell the story of religious beliefs at the scale of political power, unmatched by anything else in its time. They are also a representation of the extremely technological and mathematical skills of the Egyptians, as evidenced by their ability to stand the test of time and their use of the golden section in the building of the Great Pyramid. As explained in the *Britannica*, the golden ratio is

> Also known as the golden section, golden mean, or divine proportion, in mathematics, the irrational number $(1 + \text{Square root of} \sqrt{5})/2$, often denoted by the Greek letter ϕ or τ, which is approximately equal to 1.618. It is the ratio of a line segment cut into two pieces of different lengths such that the ratio of the whole segment to that of the longer segment is equal to the ratio of the longer segment to the shorter segment.[39]

Originally credited to the mathematician Euclid, there has been much debate surrounding the golden ratio's application to the pyramids. Some scientists believe that the math is close but not exact. "The height of an isosceles triangular face is approximately phi (ϕ). The height of the pyramid is approximately the square root of phi. The height can then be found as $\sqrt{\phi} = 4 \div \pi$. And the slope of the pyramid is very close to the golden pyramid inclination of 51°50′."[40]

While the erosion of the pyramid itself can account for the approximation of the math, scientists further argue that there is no written evidence of the golden section in any of the Egyptian texts.

While the golden section can be said to be an anomaly on the Giza Plateau, the sight of the Great Pyramids, it can be found across a number of African artifacts that also predate Euclid.

Logone-Birni

Logone-Birni is a city in Cameroon founded by the Kotoko people. The Kokoto create massive compounds by a process called "architecture by accretion," where the builders add walls onto existing ones to expand the footprint of the compound. It's hard to discern in the photograph here, but when the outlines of the compound are drawn, we see the self-similar scaling (making the same pattern at different scales). The Kotoko men describe their architecture in terms of "a combination of patrilocal household expansion and the historic need for defense. A man would like his sons to live next to him, they said, and so we build by adding walls to the father's house."[41] The sons using pathways and architecture to form a barrier of protection around their father is a beautiful notion that results in a spiral effect around the compound that resembles a golden section. As Dr. Audrey G. Bennett puts it in *The Golden Ratio and Ancient African Roots of Swiss Design,*

> The recursive construction of the palace—from tiny rectangles to larger and larger rectangles—naturally lends itself to the golden rectangle construction for the overall form, even though the match along any one wall is far from perfect. This method of organically growing architecture is typical of building layouts in Africa; indeed, many of its design patterns include this organic scaling, probably because it links to concepts of fecundity, fertility and generational kinship that are commonplace in African art and culture.[42]

—— APPROXIMATE PALACE BLUEPRINT	- - - WALKING PATH TO THE CHIEF	—— GOLDEN SECTION SQUARES	—— GOLDEN SECTION SPIRAL

The Palace of the Chief in Logone-Birni, Cameroon. Illustration by the author, 2022.

There is a behavioral pattern also associated with the movement through the spiral. As the person enters and draws closer to the chief's quarters, it is customary that their behavior becomes more reserved until finally the visitor enters the chief's quarters shoeless and speaking in hushed tones.

Like the pyramids of Giza, the golden ration scaling shown here is an approximation, although the viewer can see the spiral from the aerial photo. And while the inhabitants of such structures may not speak of the building in mathematical terms, the repetition of such structures in different communities is what in my opinion makes these ancient traditions that have been taught to the citizens of Cameroon for over hundreds, if not thousands, of years.

Design Principles

Graphic design is taught as a series of principles—hierarchy, repetition, balance, pattern, white space, color, and proportion, to name a few. Architectural design shares many of the same principles too, with buildings like the Taj Mahal and Saint Basil's Cathedral topping the list of the world's most notable structures. The pyramids of Giza also appear on these lists, yet as I mentioned previously, an examination of this kind rarely looks below North Africa for examples of excellence in the field.

The Ba-ila settlements of southern Zambia are designed as an enormous ring of rings. Each ring is made up of a series of smaller ones. The rings are ordered or sized according to one's social standing in the community (a status gradient). The straight lines to the front are fencing. Next, there are small rings, and those rings are used for livestock or things of a lower status. The rings after that are used for storage. As the rings become larger and larger, they begin to be used as the family's living quarters, with the largest rings in any set being used for the most important person in that settlement. The settlement next to that is ordered the same; since the size of the ring is larger, the occupants of that ring are of higher standing in the community. Their animal quarters are larger because they have more livestock, and their living quarters are larger because they are more important. The settlements continue to get bigger and bigger as you move up the curve of the circular village. Finally, the rings at the back or center are occupied by the chief's extended family. The largest ring is situated at the center of the village, and that ring is reserved for the chief and his family. As you will note in the drawings below, each ring has an altar at the back. And the chief's quarters are placed in the position of the village's altar. Eglash and Bennett note,

> As a logician would put it, the chief's family ring is to the whole settlement as the altar is to the house. They view this as a recurring functional role between different scales within the settlement. The chief's relation to his people is described by the word kulela, a word we would translate as "to rule." However, it has this only as a secondary

meaning—kulela is primarily to nurse and to cherish. The same word [is] applied to a mother caring for her child, making the chief the father of the community. This relationship is echoed throughout family and spiritual ties at all scales and is structurally mapped through self-similar architecture.[43]

The three core elements of each settlement are the ring structure, use of size gradients in the architecture, and placement of the altar. From the smallest animal corral to the chief's quarters, every settlement within the village mimics this identical structure. In the figure below, the first iteration shows a single house. Note that the single line of the sacred altar is situated at the back of the house. In the second iteration, the altar has become a house, with other circular dwellings surrounding it. In the third iteration, you will see that the main house becomes the chief's family village and sits inside the village as a whole.

The Village, The Fractal Elements of Ba-ila. Illustration by the author, 2022.

This Ba-ila village is a perfect example of self-similarity. The status gradient is applied to both architecture and community. The social scaling is mapped onto the architectural geometric scaling, and the nested architecture seems to provide a fortress for the chief's quarters.

Mathematically speaking, Ba-ila is an ancient fractal. Although Ba-ila is not credited with the invention, fractals have been used in African culture as a design tool in sculpture, architecture, pattern making, and divination for centuries.

Mathematics is not the only lens through which we can view Ba-ila. From a design perspective, Ba-ila is a stunning representation of modern-day architectural principles like form follows function—a principle of design that states that the shape of a structure should be determined by its use or function. The village is also symmetrical in its construction with an excellent use of both positive and negative space (white space). Moreover, we see pattern, hierarchy, and balance exhibited harmoniously within this single composition.

The Ancient African Aesthetic

Africans have made contributions to design since the beginning of civilization, and these examples represent only a handful of the information that exists. These instances prove that ancient African aesthetics represent a much too often overlooked sophistication of the continent that I would love to see incorporated into designs and design textbooks today. The position that African art is the output of mathematicians, intellectuals, and thinkers has never been suggested, and it begs exploration. The goal here is not to compete with or delete any of design's past but rather to begin to add a more inclusive perspective of the field.

Biography

Jillian M. Harris is a creative director based in New York City and has been a graphic designer for twenty-five years. Her research focuses on the ancient African contributions to design.

#BlackHistoryMatters. Digital drawing by Stacey Robinson, 2020.

#BlackHistoryMatters

Stacey Robinson

During summer 2020, the world was literally on fire with global protests surrounding the murder of George Floyd, Breonna Taylor, and others. #BlackHistoryMatters, a twelve-part billboard series commissioned from artist Black Kirby (John Jennings and myself) by the CEPA Gallery in Buffalo, New York, was created in response to the outrage in a way that the gallery could immediately exhibit in support. The twelve billboards juxtaposed images and text with hashtags that prompted the viewer to stand, view, ponder, and respond, in hopes of being inspired to act. The works were created with confidence that viewers would continue the conversation in part by adding to it—to reflect on what is not included within the twelve hashtags.

#BlackHistoryMatters mimics a carved wood print relief and is collaged from an earlier existing drawing that I created circa 2018–2019 celebrating the fifty-year anniversary of Project 500, where a poorly executed heighted effort to enroll Black students in the University of Illinois at Urbana-Champaign campus led to several protests and the arrests of Black students.

This work illustrates an older woman and younger man in an infinity loop placed in front of a sankofa bird. *Sankofa* is a Ghanaian term from the Akan people meaning to "go back and fetch it." More specifically, as Black people proceed into the future (the Black liberated future), we must go back and retrieve the past that has been stolen, hidden, commandeered, and erased from Black people's lives. This infinity loop of the woman and man represent that past and future of the University of Illinois at Urbana-Champaign's Black student representation. The school colors are the specific blue and orange pictured here. Yet I wanted to represent the global unification of Pan-African colors—red, black, and green—within the sankofa bird. I took the opportunity to utilize them by replacing the black with the university's blue color to represent the blue-blackness of dark-hued Black skin often seen in certain light. The woman facing left is looking to the past, reflective of her fight and contribution to the future generation represented by the man, facing right or forward-looking at the audience as if to ask, "Will we take up the continued fight or equities for all people?" Or maybe the question is as the rapper Common's father, Lonnie "Pops" Lynn, asked us when closing out Common's album and title track *Finding Forever*, where he pondered, to paraphrase, What is my "I/self" going to leave as my one and only grain of spiritual sand?

The bird walking is representative of the direction needed to pursue the future while retrieving the past, or the claiming of the past in full focus of the future. With feet always placed forward, the bird (here also circular shaped) is placing an egg on its back. This egg has several interpreted meanings including our Black youths and the goodness of our Black history that must be brought into the future with us. I added to this commentary that the egg in #BlackHistoryMatters represents the unreconciled trauma from our colonial and imperialist oppression of our present hindrance to our Black liberated futures that must be brought into the future with us in order to excavate, unpack, and therefore heal them. We are metaphorically fleeing to safety from the burning house before checking the quantity of our scars.

Stacey Robinson, associate professor of graphic design at the University of Illinois at Urbana-Champaign, was a 2019–2020 Nasir Jones Hip-Hop Fellow at Harvard University's Hutchins Center for African and African American Research and completed his MFA at the University at Buffalo in 2015. His work discusses decolonized Black futures. Robinson's illustrated books include *I Am Alfonso Jones* (Lee and Low Books, 2017), written by Tony Medina, and *Across the Tracks: Remembering Greenwood, Black Wall Street* (Abrams Books, 2021), written by Alverne Ball. His exhibitions include *Ascension of Black Stillness* (CEPA Gallery, 2021) and *The Black Angel of History* (Carnegie Hall, 2022).

The Movement Imprinted

Terresa Moses

In my years as an educator in higher education, I have always found creative ways to incorporate the topics of race, gender, sexuality, and other categorizations of social identity into course projects. For me, there is absolutely no way that I would consider a course to be successful unless students completed it understanding their positionality within the broader culture, their communities, and the industry they will soon enter. This intentional subject matter is important to the future of design as more emphasis is being placed on human-centered design approaches. Dismantling the ideology and practice of design saviorism means that intentional efforts to understand our impact over our well-meaning intentions is necessary as we strive to create liberatory design approaches.[44] The stress must be placed on how our design outputs and deliverables are directly related to our social identity and cultural lens. Not only that, but that understanding must be linked to action—actively working to disrupt the status quo and create opportunities to dissect colonialism and privileged identity in the context of our designs, with and for communities.

Identity Matters

As an educator who holds intersectional identities that are socially marginalized, my cultural and experiential lens assists me in the ways I use design for social change and positive cultural impact. Because of my community organizing background, I understand the ways those who hold positions of power have a responsibility to advocate for those without, and uplift voices that are often silenced by tradition, colonialism, and the Eurocentric educational canon. One of the ways I use my power in the classroom to achieve positive impact is by designing course projects that not only emphasize good design practices but also open the door to cultural exploration and advocacy.[45]

Centering Blackness Takes Effort

Class projects can center on Blackness and the Black experience all while leaving students of all races feeling empowered.[46] Privileged professors simply choose not to, leaving the work of bringing awareness to racial and social oppression in the classroom up to the professors who are themselves oppressed under the reign of white supremacy, patriarchy, heteronormativity, and the like. It is a choice to actively ignore the oppression in the United States and perpetuate your chosen ignorance onto the students you have a responsibility to educate. How dare we refer to our colleges and universities as institutions of *higher* learning when many professors choose not to learn about issues like racism simply because they feel uncomfortable. We should be ashamed that students can enter our colleges and universities with racist ideologies and graduate without being challenged in those oppressive ways of thinking. Just because a course is not specifically labeled as a diversity course does not mean that issues of equity and oppression cannot be explored. I would argue that as design professors, our courses can more easily delve into these issues compared to other disciplines. We have the ability to teach design all while creating justice-focused design outcomes.

The Movement Imprinted

An example of how this might be done is through a multilayered, community-engaged undergraduate project that I titled "The Movement Imprinted." Each year of running this project, the theme changed, with subtitles such as "Faces of Change," "Moments in the Movement," "Music of the Revolution," and "The Life, the Work, the Fight." This project specifically and intentionally centered on the nuance of the Black experience. It created an opportunity for students to explore not only Black-led narratives but Black design inspiration and Black advocacy too. The project outcome for students was to design an original poster design along with a correlated eight-page booklet, and participate in a Black-centered poster exhibition as well as an auction, with the proceeds benefiting the Duluth Branch of the National Association for the Advancement of Colored People (NAACP).

To begin the project, students were assigned a piece of Black cultural representation to research, analyze, and study. The assignments always related to the exhibition theme. For instance, in "Faces of Change," students were assigned historical and modern-day Black activists to illustrate in their piece, while in "Music of the Revolution" they were assigned a song about the Black experience by a Black musical artist to represent in their final piece. Along with the Black cultural piece, the students were given a set of questions to help in the exploration and discovery. They would also use these questions as they wrote about the piece of Black culture in their booklets. A few of the questions for "Faces of Change" included:

- What started their interest in activism?
- What are they best known for as it relates to social justice?
- What social norms or systems of oppression did this person challenge?

A few of the questions for "Music of the Revolution" included:

- Who wrote this song, and why did they write the song?
- What are three major points in the lyrics, and how do they help explain systemic oppression and/or Black empowerment?
- What social norms or systems of oppression did the musical artist challenge in their work?

After the research phase was completed using the supplied guided questions, students were instructed to create an original poster design using imagery and text to evoke the likeness of their assigned Black activist, Black song, or Black event. In addition to their own ideas of what their assigned piece of Black culture meant, they were assigned a Black designer who they were meant to be inspired by. So alongside learning the nuances of Black culture, students engaged with work that they would typically not be exposed to. Students did not have the liberty to choose which Black designer they were assigned, which was meant to imitate a client who either had their solidified brand or a style request. Some of the Black designers included Charles Dawson, Aaron Douglas, Leroy Winbush, Eugene Winslow, Georg Olden, Thomas Miller, Emmett McBain, Archie Boston, Emory Douglas, Art Sims, Gail Anderson, Maurice Woods, Cheryl D. Miller, Ed Towles, Eddie Opara, Andrea Pippins, Bill Howell, Alex Walker, Dorothy Hayes, William Wacasey, Dorothy Akubuiro, and Michael "Freestylee" Thompson.

Introducing these designers allowed for conversation around the lack of representation of Black designers in the design industry and how this issue stems from systemic racism. This set the foundation for how students not only studied their Black cultural element but also the Black designers themselves— annotating three major visual works they contributed to history. Students not only pulled the top three works the designers would use as inspiration in their own piece for this project but critiqued the work too, describing the use of

the principles of design, and how it was evoked and used to communicate certain instances in the designers' work. Furthermore, students gained an understanding of the Black designers' childhood and upbringing, how they began their career, what changes they brought to the field of design, and what design movement their design style most emulated. It was important to center Blackness in this project by having the students not only look at the lives of the activists, revolutionary songs, or particular moment in history but the lives of the Black designers—often forgotten—who contributed to society in major ways as well.

Project Poster Examples. Mock-up by the author, spring 2017–spring 2020.

In conjunction with the poster design, a major feat in itself, students designed a complementary eight-page booklet that held the information they had gathered. The cover of the booklet was meant to be branded similarly to that of the poster (however, not the poster design itself). The first spread held information about the Black activist, song, or moment as well as an important Black event they identified that had significant meaning in their subject matter. They also created a time line that correlated to their Black subject matter. The second spread included the information they had gained about the Black designer along with a photo and biography. Some students were even able to speak with their assigned designer to gain more information about their life and inspiration in their work. In addition, the students took the three pieces they were most inspired by, laid them out, and included the date, medium, and critique write-up. The students created a time line of the designer's life and

major works as well. The third spread included information about the student, their biography, and life goals in the design field. They included three process photos of their poster—a sketch, black-and-white illustration, and the final version. Students included a write-up on the event they participated in (with the language supplied by me) and their references. The back cover included a statement of copyright. The design of the booklet honed the student's skills in typographic combination and grid, color theory, hierarchy, and data visualization. All of this was created in a Graphic Design 1 course during the first six weeks.

Project Poster Booklet. Mock-up by the author, spring 2019.

The project was intentionally facilitated during January and February, purposefully ending in Black History Month. This is when the exhibition would take place, supporting a Black-led organization, the Duluth Branch of the NAACP. It was due to the unintended added pressure of having the students' name attached to their work that I believe class critiques were such a huge deal to the class, and the meticulousness and consideration in their work was noteworthy. In keeping with an equitable class environment, the exhibition was of no cost to the students as I ensured that they could print their design for free at the university's print shop.[47] (This also ensured that all the posters were the same size and printed on the same paper weight.) I then had a group of student volunteers help with the exhibition setup, which was completely optional, however I always had enough student help given the nature and connection they all had to their work. The exhibition took place one hour

before and during the NAACP's Annual Freedom Fund Dinner. Students were elated about this opportunity, and many of them invited their parents, families, friends, and other classmates to come and bid on their work. The pieces were sold via silent auction. Students were asked to donate at least half of their proceeds to the NAACP, although many opted to donate all of their proceeds. Each and every year, four in all, every single piece sold from $10 to $400. Each year, the class had at least $1,000 to happily give in support of the NAACP.

Looking back on the facilitation of this project, it is my relationship to the NAACP that added to the ease of integrating this exhibition with its annual fundraising dinner. Attendees from all over the city thanked students for their work, and many Black residents did so with tears in their eyes at the representation of significant Black moments in the city. This project not only taught Black history but also pushed students to more deeply explore how Blackness is erased from media and the field of design. Moreover, it opened them up to designers who many had never heard of despite having already taken design history courses. Of the 164 students who have participated in this project, I have had 2 students who have had serious negative reactions to having to look at Blackness in the design process. But even in those negative situations, I was able to give students room to reflect on why they were having these emotions and why Black history was important to gaining an understanding of their cultural worldview. In four years, I would say that was a success, and by now, plenty of the anti-racist seeds that were planted would have sprouted.

The Movement Imprinted 2017 Exhibition: Faces of Change. Photograph by the author, spring 2017. Zeitgeist Arts Atrium, Duluth, Minnesota.

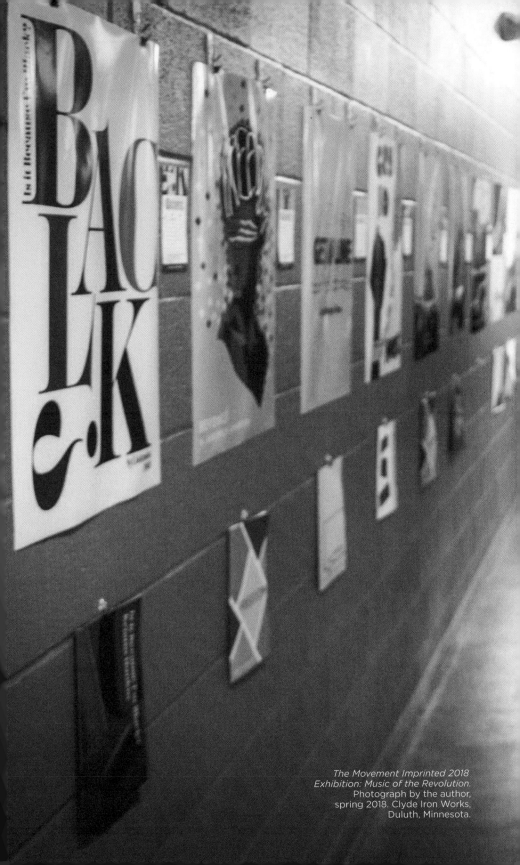

*The Movement Imprinted 2018
Exhibition: Music of the Revolution.*
Photograph by the author,
spring 2018. Clyde Iron Works,
Duluth, Minnesota.

Using Exhibition Design to Support Political Engagement, Active Learning, and Civic Participation

Anne H. Berry and Kelly Walters

A form of creative practice that also serves as an arbiter of communication and information across media, design has the ability—for better or worse—to wield undue influence within US culture. Proof of the extent of design's strength is easily recognizable; the spectrum of negative Black caricature references, whether from bygone eras or present in contemporary culture, have been created, promoted, and perpetuated by design over the course of centuries. The Aunt Jemima brand, introduced in the late 1880s and retired in 2020 after decades of backlash, is a testament to the longevity and pervasiveness of stereotypes within US society.[48]

Compounding the existing tensions embedded in design's racist history is the increase in political and racial polarization across the United States.[49] In a country that has traditionally prided itself on free speech, books by Black and/or LGBTQ+ authors are being banned and challenged at an "unprecedented" rate, efforts to curb teaching about Black history are under threat, and the spread of misinformation/disinformation has put US democracy in jeopardy.[50] Now more than ever, consequently, designers have a responsibility to address these issues—issues related to media, race and representation, and misinformation/disinformation that are rooted in design and communication. The veneer of design as a neutral presence has been pierced by the rise of white supremacy, and promoting political engagement, active learning, and civic participation are necessary in order to cultivate a design workforce prepared to confront the communication obstacles that society faces.[51]

Black creatives are keenly aware of the power of mediated representations in shaping culture—representations that have primarily been controlled by white moderators—and have been working against the harm caused by racist caricatures by building cultural awareness through decades of contributions.[52] For marginalized groups, design never has been and never will be a neutral medium devoid of cultural influence and context. Rather, design is an unabashed expression of and response to politics, design history, culture, socialization, and civic participation.

Two exhibitions, *Ongoing Matter: Democracy, Design, and the Mueller Report* and *With a Cast of Colored Stars*, demonstrate the efficacy of exhibitions and exhibition spaces as arenas where conversations about politics, civic responsibilities, and creative contributions can foster healthy discussions on difficult topics.

A note on positionality: As Black, female, design practitioners and educators, the authors acknowledge our respective identities and the cultural influences that inform our perspectives on the topics addressed. We believe our voices, severely underrepresented in academia, play an important role in helping to shape the future of the design profession accordingly.

Mobilizing Political Engagement through Poster Design

> The Russian government interfered in the 2016 presidential election in sweeping and systematic fashion.
> —US Department of Justice, *Report on the Investigation into Russian Interference in the 2016 Presidential Election*

> The most prolific [the Russian state-supported Internet Research Agency] efforts on Facebook and Instagram

specifically targeted Black American communities and appear to have been focused on developing Black audiences and recruiting Black Americans as assets.

—New Knowledge, *The Tactics and Tropes of the Internet Research Agency*

The US presidential election of 2016 was one of the most consequential political moments in modern history. As the *Report on the Investigation into Russian Interference in the 2016 Presidential Election*, colloquially known as the Mueller Report, documents within its 448 pages, the Russian government and government-supported entities made concerted efforts to "provoke and amplify political and social discord in the United States."[53] Despite public interest in the report and dissemination of its content via books, news reporting, and podcasts, the length and verbiage made the document difficult to read.

The *Ongoing Matter* traveling exhibition, cocreated by Cleveland State University associate professor Anne H. Berry and University of Notre Dame assistant professor Sarah Edmands Martin, has become a means of bridging the gap between public interest and public understanding, communicating the text of the Mueller Report to the general public via the medium of poster designs. From its inception, the *Ongoing Matter* project has served as an invitation to any designer wanting to participate in the process of breaking down text from a notoriously dense government document and presenting the information in a visually approachable way. The original group of design contributors, a team of ten friends and creative connections, met over the course of several months, reading through the content of the report together, developing the *Ongoing Matter* visual guidelines/standards, and sharing poster design concepts. Technology helped facilitate a collaborative process that crossed time zones and continents, and increased collective insights into political systems and government processes via the process of creative making. The standing call for design contributors is an intentional effort to continue promoting interest in the *Ongoing Matter* project as well as civic engagement more broadly.[54]

Though the collection of works in the *Ongoing Matter* exhibition span the two volumes of the Mueller Report, a recurring theme represented in many of the posters is the use of social media to create divisions among the voting electorate. Key findings in the Mueller Report as well as a report commissioned by the US Senate Select Committee on Intelligence, for example, note the disproportionately concerted effort to target Black Americans through Facebook and Instagram.[55] The *Report on the Investigation into Russian Interference* emphasizes the threats against democracy via misinformation/disinformation and the actions of the Trump administration. At the same time, this government document is a painful reminder of the systematic harm inflicted on communities of color within technological spaces

where the moderation and mediation of images and information are primarily in the hands of powerful—and indifferent—tech companies.

Importantly, however, *Ongoing Matter* provides a foundation for educating audiences about events surrounding the 2016 presidential election, and driving conversation about the roles of race and social media platforms in fueling Russian interference in US elections. The bold text and images represented in the body of work, which continues to expand and now integrates augmented reality, immediately invites audience response and interaction, regardless of backgrounds or racial/ethnic identities. In spring 2022, Assistant Professor of Graphic Design Misty Thomas-Trout brought *Ongoing Matter* to the University of Dayton's Index Gallery and Radial Gallery, using the exhibition as a way to engage students specifically about the formal design components along with the meaning and interpretations of the work through the following prompts:

1. Walk by the work and when your attention is grabbed, stop. Think only about how it looks and not what it means.
2. Discuss the imagery. What and how was it made? What media do you think the designer used? How do those decisions stress meaning?
3. Enter the piece. What did you read first? Or see first? What established a visual hierarchy. Then, read it all. What is the message? The meaning? The connotations of imagery?
4. Now look at the full body of work. What is keeping it as a strong visual system. The type palette? Underlying grid? Logo?

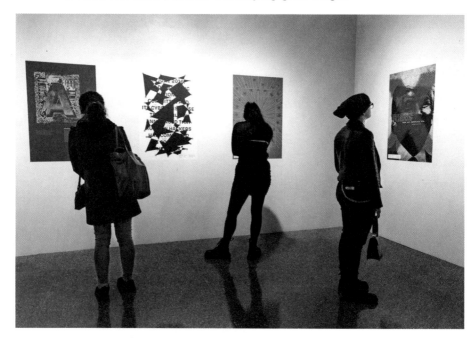

Grunwald Gallery of Art Exhibition. Photograph by Sarah Edmands Martin, 2021.

Black Design Pedagogy

Edmands Martin and I later gave an in-person presentation and spoke informally with University of Dayton students about the poster collection. This is but one example of how we have used *Ongoing Matter* to facilitate discussions of greater depth and interest than the seemingly stilted, tedious pages of the Mueller Report pdf.

In response to questions about the continued value of the Mueller Report, and by extension, *Ongoing Matter*, Edmands Martin states, "We need to pay attention to how information is coming to us, including the ways in which this information has been used, and continues to be used, to disparage people and create conflict." She adds, "For the sake of democracy, designers must step up and fight back against misinformation and disinformation, which can cause real harm."

Since fall 2019, *Ongoing Matter* has exhibited at seven venues including, most recently, the University of Notre Dame in Notre Dame, Indiana, and the University of La Verne in La Verne, California. In addition to the *Ongoing Matter* traveling show, the project cocreators and Andre Mūrnieks, a project contributor and senior lecturer at the Ngā Pae Māhutonga Wellington School of Design in New Zealand, have presented at international design conferences using *Ongoing Matter* as a case study for broader conversations about designing government documents for the public good. Beyond its value as a communication tool, *Ongoing Matter* is a means of activating exhibition

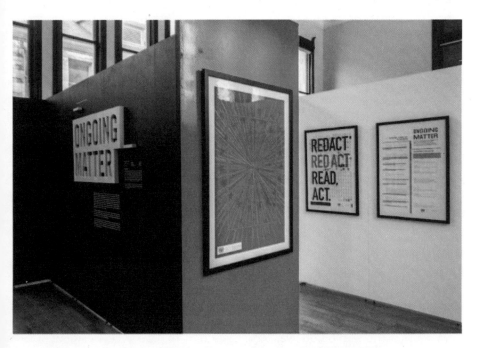

Maxwell Hall Exhibition. Photograph by James Nakagawa, 2021.

spaces, promoting discussions about politics and civic engagement, and motivating audiences to learn more about the US political system, whether through viewing the posters or creating work for the collection.

Interrogating Black Representations in US Popular Entertainment

> Spaces of agency exist for black people, wherein we can both interrogate the gaze of the Other but also look back, and at one another, naming what we see. The "gaze" has been and is a site of resistance for colonized black people globally. Subordinates in relations of power learn experientially that there is a critical gaze, one that "looks" to document, one that is oppositional. In resistance struggle, the power of the dominated to assert agency by claiming and cultivating "awareness" politicizes "looking" relations—one learns to look a certain way in order to resist.
>
> —bell hooks, *Black Looks: Race and Representation*

In mainstream US media and popular entertainment, white bias has influenced how Black people have historically been defined, visualized, and culturally understood. At the beginning of the twentieth century, with the emergence of new technologies such as sound recordings, moving pictures, and photography—promotional graphics pivoted to disseminate these new forms of entertainment to the US public. The "white gaze," however, directly shaped how Black people and their cultural traditions *could* and *would* be seen. We see this most clearly today in countless archives, books, and collections across the United States that are filled with dehumanizing Black caricatures and racist language used in connection to the Black body. As more Black media creators (performers, musicians, and filmmakers) began to reshape these perspectives (and gained access to these technologies), they started to deploy the "oppositional gaze" that hooks references above. The "gaze," as she notes, can be both a "site of resistance" and site that "cultivates awareness." Henry Louis Gates Jr. describes this thinking as well in the foreword to *Separate Cinema: The First 100 Years of Black Poster Art*: "At times film has served as a weapon of propaganda to maintain blacks' marginalized position; at other times, it has promoted, quite powerfully, a counter-narrative challenging the status quo."[56] Together, hooks and Gates echo Toni Morrison's understanding that "definitions belonged to the definers—not the defined."[57]

With a Cast of Colored Stars is an exhibition curated by Parsons School of Design assistant professor Kelly Walter's that explores these visual tensions in the evolution of Black racialized iconography found in US film, theater, and music. The exhibition was codesigned with freelance designer Joelle Riffle (Parsons BFA, communication design, 2013), with design assistance

from design student Staicy Ngongu (Parsons BFA, communication design, 2022). From January 24 to March 1, 2022, the exhibition was on view in the Aronson Gallery at Parsons School of Design at the New School in New York City. The concept direction for *With a Cast of Colored Stars* emerged through the exploratory research Walters was conducting related to images of Black culture in US media. Within her research, she learned of Black independent filmmaker Oscar Micheaux. Micheaux's film posters became symbolic because they repeatedly used phrases such as "an all-colored cast" or "with a cast of colored stars," reflecting the Jim Crow era segregation present in the United States during the post-Reconstruction period.

Featuring original sheet music covers, theater advertisements, reproductions of vinyl album covers, and film posters spanning from 1856 to 1979, *With a Cast of Colored Stars* sought to link together disparate Black representations from across more than a hundred years. The archival works selected for the show are a mixture of artifacts from the following collections: the Globe Collection and Press at Maryland Institute College of Art, National Museum of African American History and Culture, New School Archives and Special Collections, New York Public Library Digital Collections, Separate Cinema Archive, and Walters Collection. The inclusion of these printed works was significant to the exhibition because they provided a historical time line for the show, and drew relationships between various entertainment genres (jazz, soul, and rhythm and blues) and the performance of themes such as Black femininity/masculinity, sexuality, colorism, social class, and fashion. These works also demonstrated the kinds of print materials that have been preserved and are now accessible in archives to the general public.

Alongside the historical works, artists and designers were commissioned to create original artwork as a counterpoint. *With a Cast of Colored Stars* contains the work of over twenty-five living artists, designers, and students who reinterpreted, reenvisioned andremixed from historical examples of Black visual vernacular. Their artwork was transformed into printed zines, posters, videos, patterns, and photographic collages. These newly formed works confront the viewer while simultaneously magnifying particular language and imagery used in support of Black performance. It is through this confrontation and response that we begin to identify what cultural symbols have "defined Blackness" as we know it today.

One of the last and most essential components of *With a Cast of Colored Stars* is that it could be used as an educational platform for cross-cultural and interdisciplinary dialogue on Black representation. By interrogating physical and digital archives, we have the capacity to build a better understanding of cultural histories that have been hidden from view. So often, there is a difficulty in discussing larger themes of race as it connects to the history of mainstream print media. Yet having this exhibition situated and installed in an academic environment allowed for student groups to hold critical discussions

Gallery Installation View. Photograph by Luis Manuel Diaz, 2021.

in the gallery, making it a site of active dialogue. Historical exhibitions like *With a Cast of Colored Stars* help us to construct new ways of reading history that challenge the "white gaze" and provide us with the tools to be more "oppositional" in our thinking.

Conclusion

While *Ongoing Matter* and *With a Cast of Colored Stars* both engage in varied subject matter, they are linked through their shared connection to political engagement, active learning, and civic participation. From misinformation to highly constructed mediated images, it is imperative that we be informed about and aware of how our worldview can be manipulated by false representations. Both exhibitions demand that we understand the power of media and who has the ability to shape it. They are also active sites that require designers and nondesigners alike to broaden their awareness in cultural and media literacy. Each exhibition brings to light historical print media and governmental documents as facilitated aids to illicit awareness. The major takeaways from *Ongoing Matter* and *With a Cast of Colored Stars* ultimately invite us to be informed citizens in order to possess agency and the capacity to decipher when we are encountering inaccurate media.

Parsons School of Design Sophomore Communication Design Students Responding to the Exhibition. Photograph by Kelly Walters, 2021.

Anne H. Berry is a writer, designer, president of AIGA Cleveland, and associate professor in the Department of Art and Design at Cleveland State University. She has been featured in *Communication Arts* magazine, Letterform Archive, *Black, Brown + Latinx Design Educators: Conversations on Design and Race* by Kelly Walters, and "The Black Designer's Identity" for the inaugural issue of the *Recognize* anthology featuring commentary from Indigenous people and people of color. She is also cocreator of the award-winning project *Ongoing Matter: Democracy, Design, and the Mueller Report* and managing editor of *The Black Experience in Design: Identity, Expression, and Reflection*.

Kelly Walters is an artist, designer, and founder of the multidisciplinary design studio Bright Polka Dot. In her ongoing design research, she interrogates the complexities of identity formation, systems of value, and the shared vernacular in and around Black visual culture. In 2021, Walters was a Graham Foundation award recipient for her curated exhibition *With a Cast of Colored Stars*. She is also the author of *Black, Brown + Latinx Design Educators: Conversations on Design and Race* (2021), and the creative director and coeditor of *The Black Experience in Design: Identity, Expression, and Reflection* (2022). Kelly is currently an assistant professor of communication design in Parsons School of Design at the New School.

3

BLACK DESIGN

ACTIVISM

An Introduction to
Black Design Activism

Terresa Moses and Omari Souza

The Black community is no stranger to activism and the fight for our very existence. We know all too well the resilience required to actively build community during times of unrest while organizing our narrative in order to craft effective and *palatable* policies. While the fight for our Blackness has existed since the days we were forced onto these shores due to chattel slavery, the most recent uprising surrounding the murder of George Floyd during summer 2020 brought on an exhaustion that called for radical self-care and attentiveness. We have come to realize that our fists in the air on the front line of protests and a full night's rest are both radical acts of revolution.

The Black community has a long history of making a way out of no way, fighting the good fight, and sustaining through the struggle. Our sacrifices in this work include life-altering decisions and denied opportunities, such as giving up the idea of raising a family or working nonconventional jobs that can support our political arrests. In addition to our sacrifices, our work is met with respectability politics and talks of civility that muddy our attempts at freedom and control our communities' possibilities. Our very existence fights against the system of white supremacy, so it is easy to grow weary and burn out while engaging in work toward Black liberation. We have histories of work that suggest that we have the ability to overcome. How might we strategically use design in our fight for Black liberation and self-advocacy while maintaining healthy boundaries and radical self-care?

The collection of written and visual works in "Black Design Activism" are focused on how design is used to further antiracism, racial justice, abolition, community interdependency, and Black liberation. The authors and creators reflect the importance of the Black voice and Black creativity in the realm of advocacy and community organizing. Each of them touches on substantial issues that affect the quality of life for Black communities across the globe.

We begin with a visual advocacy project by Jazmine Beatty. She uses design to tackle the ideas of "good hair" and how its stereotypical nature impacts Black communities. Much like policies and practices that benefit whiteness, so does that of society's white standard of beauty and discrimination against naturally curly hair textures. Her exhibition catalog aims to enhance the self-worth of Black children and adults, change the negative social and cultural perceptions, and celebrate artwork that illustrates the beauty of Black women and their natural hair.

In a follow-up to this, Nichole Burroughs recounts the impact of Black designers in the nineteenth century, and how they basically shaped the perception of the civil rights movement and the future of Black designers. Her study suggests that Black designers were essential in showcasing Black culture and cultural figures. With that historical context, Terresa Moses explores modern-day design influence within the Minneapolis abolitionist organizing community and surrounding cities. Through typographic narratives, she highlights the importance of community protest as a tool for racial justice, and how design can provide an opportunity to support and uplift the voices of Black people. This frontline protest approach is intentionally followed up in "Peace of Mind" by Kprecia Ambers as a reminder for those engaging in activism and protest to find peace and take care of themselves.

Tracey L. Moore uses the issue of voter suppression in her community as a topic in a classroom design project that became an awareness campaign. She used this project as a means for students to identify the patterns of systemic disenfranchisement and visually respond to advocate for equitable voting

practices. Along the same lines, Asher Kolieboi examines the role of service and information design in the disenfranchisement of Black voters who utilize vote-by-mail options. In both contributions, we find that a culmination of preexisting public rhetoric of election security, the COVID-19 pandemic, and misinformation contribute to measurable information and service gaps for Black voters.

We end with another issue in access and inclusion. Jennifer White-Johnson uses this opportunity to better understand and discover what being a Black neurodivergent person means to her as well as to the culture of Black design. Within her writings, she challenges the definition of *normal*, holding space for self-acceptance.

"Black Design Activism" is an essential part of historical and present-day cultural shifts. Because of the inseparable connection that Blackness has to the foundational systems of oppression in our nation, this also means that Black liberation must be a part of our collective liberation to create sustainable Black futures.

Getting to the Root: An Exhibition Catalog on Natural Hair

Jazmine Beatty

The idea of "good hair" has been perpetuated throughout time, directly affecting people's quality of life. Black women specifically have been targeted because their naturally curly hair textures do not fit society's white standard of beauty. So often, women's self-esteem in US society is connected to their hair. Therefore society must redefine self-worth to be all-inclusive, allowing people to be true to themselves regardless of their hair's texture.

The song "I Am Not My Hair" by Black singer-songwriter India Arie tackles the subject of self-acceptance in a world that is constantly segregating people by their appearance and frequently their hair. As the lyrics assert, "I am not my hair, I am not this skin, I am not your expectations, I am not my hair, I am not this skin, I am the soul that lives within. Good hair means curls and waves. Bad hair means you look like a slave. At the turn of the century, it's time for us to redefine who we be."[1]

The desire to achieve this standard has been conditioned in the psyches of Black women, and as a result, enforces hair texture discrimination both within and outside the Black community. In order to eradicate this detrimental mindset, society must redefine self-worth to be all-inclusive.

Lack of Positive Representation

Since the beginning of slavery in the United States, Black people were put in a position of inferiority because of their physical appearances and Eurocentric cultural values were forced onto them. White European colonial settlers who purchased Africans for the purposes of enslavement and unpaid manual labor without regard for their well-being would shave the heads of the enslaved as a power-establishing practice to devalue and dehumanize the African captives.[2] In the decades that followed the abolishment of slavery, longer, straighter hair was not only desired but also expected. Like race, the notion of good hair is a social construct that has, through centuries of reinforcement, "become naturalized."[3] This limited view of acceptable hairstyling has made it difficult for Black people to develop positive self-images, particularly young Black girls.

How Might We Showcase Black Beauty

Based on my preliminary research about the impact of hair standards on the racial identities of Black women, I explored how to develop a project that showcases Black beauty as a way of thwarting the dominant white narratives of acceptable and beautiful. The following questions guided my research:

1. How can we utilize art and design to provide positive representation for young Black girls?
2. How has art and design been utilized to discuss hair, and how can those visual conversations be brought to the forefront?
3. How can art and design be utilized to give those outside the Black community a glance into Black hair culture?

Change the Narrative

On further research, I discovered a plethora of Black creatives who intentionally spotlight Black beauty in their work and looked at how their combined efforts could be amplified to inspire Black women while simultaneously educating others. I concluded that the development of an exhibition catalog could elevate Black artistic voice, thus decentering the dominant artistic voices in US society, which tend to be white, and instead centering Black voices to tell stories about Black art and culture.[4]

Breaking Barriers

Engaging in conversation is the first step to removing obstacles that hold people back from loving themselves or understanding one another. By utilizing catalog design, this project can incorporate varying Black voices from across artistic fields (i.e., multimedia, painting, sculpture, design, and photography) to visually communicate the tangible concept of Black hair. This catalog increases understanding about Black hair, highlighting its significance within people's psyches and society at large through the use of storytelling

to confront misunderstanding and shame while also addressing how natural hair is embraced today. In addition, this exhibition catalog aims to enhance not only the self-worth of Black children and adults; it strives to change the negative social and cultural perceptions other people have about Black people. By showcasing Black artists and their celebratory artwork that illustrates the beauty of Black women and their natural hairstyles, this catalog begins to untangle the social construction of "good hair" that continues to suppress people. No one should have to change themselves, especially their hair, for the sake of prosperity.[5]

The Exhibition Catalog

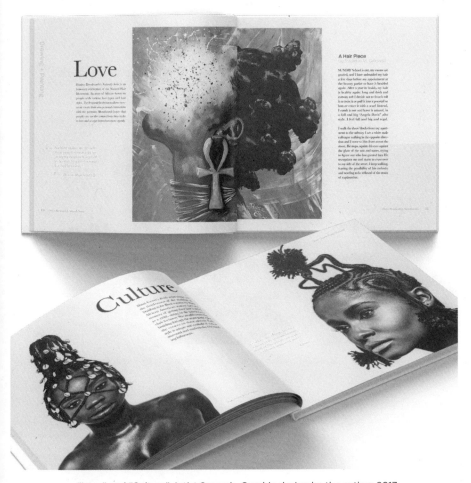

"Love" and "Culture" Artist Spreads. Graphic design by the author, 2017.

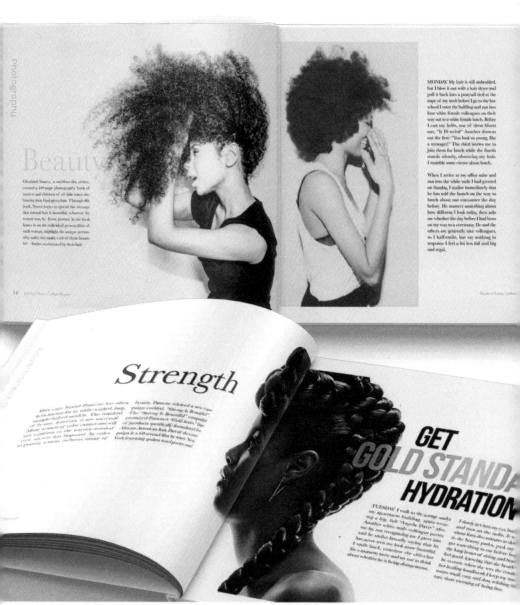

"Beauty" and "Strength" Artist Spreads. Graphic design by the author, 2017.

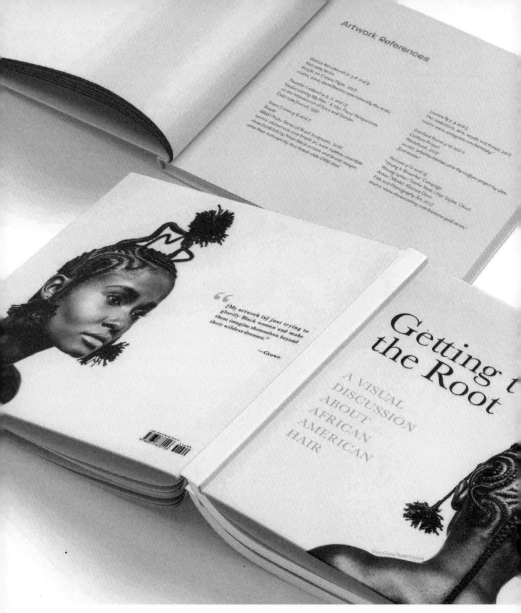

Artwork References and Front/Back Cover. Graphic design by the author, 2017.

Jazmine Beatty receives her BFA in communication design from Texas State University in 2020. As a human-centered designer and artist, passion, commitment, and empathy for others guide Beatty's work. Through her experiences as an African American student and artist, Beatty realized that she wanted to help young people, particularly from marginalized groups, utilize their creative talents to explore and expand possibilities for their futures. Now, as an art education master's student at Virginia Commonwealth University, Beatty has presented curricular ideas at Virginia Art Education Association and National Art Education Association conferences centered around cultivating the well-being of Black children and other underinvested groups.

Paving the Way: Black Designers Then and Now

Nichole Burroughs

Throughout history, society has failed to represent Black people in the broader cultural narrative. Positive representation of cultures and identities in media can have positive effects on oneself and others. Representation is defined as how the media portrays an ethnicity or identity to an audience. To demonstrate the impact of representation, an online survey was distributed to student designers of different cultures and other underrepresented identities. The respondents were asked to explain how representation in design has impacted their lives. This study's main purpose is to explore the impact that Black designers in the 1920s through the 1960s working in Chicago and Southern California had on the perception of the civil rights movement as well as future Black designers. Literature was reviewed to gain a better understanding of representations of Black Americans throughout the 1920s–1960s and how this impacted society's perception of Black Americans. The results suggest that Black designers were essential in showcasing Black culture and cultural figures, leading to a gradual acceptance of Black culture into society.

The end of the Civil War (1860–1865) gave most Black Americans new freedoms. All Black Americans were not free until June 19, 1865, two years after the Emancipation Proclamation was issued. Despite this feeling of empowerment, Black Americans quickly learned that the fight was far from over. They began to flock to northern cities such as Chicago, Detroit, and New York that offered better opportunities, thereby leading to the Great Migration. This gave way to the New Negro movement, also known as the Harlem Renaissance, which empowered Black Americans to continue to pursue equality. As the National Museum of African American History documents,

> The Harlem section of Manhattan, which covers just three-square miles, drew nearly 175,000 Black Americans, giving the neighborhood the largest concentration of Black people in the world. Harlem became a destination for African Americans of all backgrounds. From unskilled laborers to an educated middle-class, they shared common experiences of slavery, emancipation, and racial oppression, as well as a determination to forge a new identity as free people.[6]

After the Civil War and the abolition of slavery, the US civil rights movement lasted from 1954 to 1968, protesting for the constitutional rights of Black Americans. The goals of this movement were to gain legal rights that were already enjoyed by white Americans such as sufficient education and voting. Even after these goals were met, Black Americans still struggled to gain equality. Black designers in Chicago and Southern California, crowded by racial intolerance, paved the way for integration of the design world through protest and representation that greatly impacted Black designers to come.

In light of the civil rights movement, Black designers were leaders in protesting, which allowed the movement's message to spread quickly and effectively through various types of communication. Forms of protest can take many shapes, but multiple designers during this period used newspapers, magazines, and posters to express their views and the message of the civil rights movement. They were also used to make Black Americans aware of the decisions being made in courts. Protesting, in and of itself, has its own aesthetic. A designer activist must think of a design that explains their desires and grabs the audience's attention.

Black Designers

Charles Dawson
Protesting allowed for the civil rights movement to spread and educate people on what activists wanted to change while positively representing Black Americans in the minds of the people in power—white people. Black Americans were able to get jobs at white-owned design firms because of their newly found political freedom, which allowed them to become a larger

percentage of the economy. Dawson is one designer well-known for paving the way. Having been born on a Georgia plantation, Dawson achieved the unthinkable by becoming the first African American admitted to the Arts Students League in New York City.[7] "Dawson played a role in both the cultural and economic rise of blacks in the 1920s," explains Daniel Schulman. "From 1919 to 1922 he worked as a salesman and account manager for a downtown firm called Chicago Engravers, where he served black and white clients."[8]

Black designers not only can help other Black Americans with gaining newfound freedoms but also provide opportunities for white clients to change their perspective on racism. Dawson was hired to create illustrations for a variety of advertisements. This was influential because Black people were rarely hired by whites, and actions like these helped other Black people enter the predominantly white workforce.

Dawson's musical poster titled "O, Sing a New Song" exhibits Dawson's illustration style during the New Negro movement. Featuring bright yellows, greens, and oranges, this poster advertised an African American pageant taking place in Chicago during the Century of Progress Fair in 1934.[9] While his illustration style is more detailed than Emory Douglas's work, which I'll look at below, it still has a strong central focus and advocates Black excellence. Dawson's style mixed "African heritage with modern progress."[10] This mixture of African heritage with African American design has become less prevalent in designs today as Black Americans have formed their own unique identity.

In 1933, Dawson designed and published his own children's book called *ABCs of Great Negroes*.[11] In this book, Dawson illustrated, in black and white, twenty-six influential Black people whose names corresponded with a letter of the alphabet. This book helped educate Black children about their history and show them leaders they could look up to. Before Black designers were able to create their own narratives, Black people were being depicted as less intelligent and savage while being referred to in derogatory slang. Minstrel shows became the epicenter of creating stereotypes of Black people. These shows are a form of racist entertainment that mocked Black Americans through portraying blackface and instilling harmful stereotypes. They perpetuated the false notion that enslaved Africans were "lazy" and "incompetent." Dawson became the first of many to break new ground in Black design, overcoming the negative stereotypes set by normative culture.

The Black Panther Party and Emory Douglas

Douglas is another prominent Black designer and activist. He worked with the Black Panther Party and at the time was considered the Minister of Culture. Douglas was "introduced to graphic design at a young age at a print shop in juvenile detention ... [and] honed his skills in the reputable commercial art program at San Francisco City College."[12] He quickly became known for his abrasive aesthetic in design and fine arts. According to Colette Gaiter's

"Visualizing a Revolution," "Douglas was the most prolific and persistent graphic agitator in the American Black Power movements," especially for the Black Panther Party. The Black Panther Party for Self-Defense was established in Oakland, California, by Huey P. Newton and Bobby Seale as a way to combat all forms of oppression, but mainly police brutality.[13]

Police brutality occurred in poorer Black neighborhoods where police were stationed to monitor the Black community and "maintain peace," which often involved harming Black people. The Black Panther Party was used to combat this, helping to organize an armed resistance in these communities and quickly becoming a symbol of Black Power. To help reach its audience, the Black Panther Party created a publication titled the *Black Panther: Black Community News Service* that would be circled throughout California and many other major cities in the United States. "At its height, from 1968 to 1971, the *Black Panther* was the most widely read Black newspaper in the United States."[14] The Black Panther Party can mean a variety of different things to different people. While it empowered the Black community, it also unsettled white Americans, who believed the organization was violent. FBI director J. Edgar Hoover stated, "The Black Panther party, without question, represents the greatest threat to the internal security of the country."[15]

After the first publication, created by Newton and Eldridge Cleaver with only a typewriter and copy machine, and showing an image of Denzil Dowell, who was killed by police earlier that month, Douglas began working on the second publication of the *Black Panther*. While the initial publication design seems simplistic based on the lack of resources, it was both intentional and effective. Douglas typically used nonrepro blue markers, an IBM Selectric typewriter, and prefabricated instant type along with Elmer's glue and rubber cement to create these layouts. As a designer activist, his use of imagery and type to stun the reader helped make the issue at hand self-evident. According to an interview with Douglas by Stephen Coles of Letterform Archive, "He confirmed that the tools and materials of paste-up layout and photographic reproduction empowered their shoestring operation to get maximum impact with minimal expense." This cut-and-paste style quickly became the traditional look of the *Black Panther* magazine, and as the publication grew, "the team was able to acquire their own phototypesetting gear: first an early paper-tape system purchased from Carlton B. Goodlett at the Sun-Reporter Publishing Company, and later a disk-based CRT machine from Compugraphic."[16] Even with the new technology, Douglas still preferred a simpler style.

The newspaper's message started to evolve the longer that it was in production. In an article about Douglas and the *Black Panther*, Coles iterates how the Black Panther Party's message had changed:

> In the spring of 1971 the Black Panther Party's message shifted from armed self-defense to community organizing. Some of Douglas's

more brutal graphics gave way to images of information, and even celebration. Douglas's covers and posters promoted the Panthers' political activities and social programs, like health clinics, schools, arts events, and the highly successful Free Breakfasts for Children which soon spread across the US, feeding over 10,000 kids every morning and serving as a model for lunch programs in public schools."[17]

Throughout the years, the Black Panther Party was able to adapt its goals into what would best serve its community. The Black Panther Party promoted programs and events within its community while also informing both the white and Black communities about how Black Americans were being treated by police. These elements empowered Black Americans from all walks of life wherever they were in the United States. The Black Panther Party showed all Black Americans what can be done when they stick together.

Lisa Lyons was another essential designer for the Black Panther Party. While the Black Panther Party's logo has a long history and has been in the hands of three designers in total, Lyons is credited with making the official logo. Stokely Carmichael, an influential developer of the Black Power movement, spoke as to why the Black Panther Party picked a black panther: "We chose for the emblem a black panther, a beautiful black animal which symbolizes the strength and dignity of black people, an animal that never strikes back until he's back so far into the wall, he's got nothing to do but spring out. Yeah. And when he springs he does not stop."[18]

Douglas was known more for his illustration style. One illustration, published in 1969, features a young Black boy distributing two issues of the *Black Panther* while carrying what looks to be a rifle attached to his back.[19] Douglas's illustration style typically featured a limited color palette and bold black outlines. This style emboldened the characters, giving them power and courage. This imagery can be empowering, especially in bullied and impoverished neighborhoods, but it may be alarming to people who were systematically trained to be afraid of Black Americans regardless of whether they were armed. Following their work for the Black Panther Party, Douglas and Lyons became influential designers for the Black Power movement. Douglas continues to create art for racial and social justice movements.

Emmett McBain

McBain was a Black designer who represented his culture by starting his own design agency. He began his career at the first Black-owned advertising firm, called Vince Cullers Advertising.[20] In 1959, he launched an advertisement agency called Burrell McBain Incorporated with Black designer Tom Burrell.[21] Throughout his career, he helped advertise to Black Americans, normally an untargeted audience, because "advertisers began to actively recruit African Americans in the hope that they would help clients speak more meaningfully

to a sect of consumers who now spent almost $30 billion annually."[22] McBain succeeded in this by creating the Black Marlboro man.

The Black Marlboro man was the antithesis of the white version, who represented a classic lone cowboy. The Black version was more forward-thinking and modern, creating a more positive image in the minds of other people. In McBain, Avinash Rajagopal credits the Black Marlboro man as being warm and relatable.[23] This advertisement showed a different side to the Black man that was not being represented by white designers or the broader culture. The Black Marlboro man showed society that Black men were not violent like they were being portrayed in the mass media. This highlights the power of positive representation in the media and gives those who are racially intolerant a chance to rethink their beliefs. McBain chose to reinvent the purpose of a graphic designer in an advertising agency, and is credited for helping advertise a multitude of products such as Marlboro, the 1964 Ford Mustang, and SkinFood.

McBain's designs were progressive, even by today's standards. His layout sketch created for SkinFood shows the naked body, albeit as an illustration, of a Black woman.[24] This would turn heads today and was completely unheard of at the time. While it may seem like a simple act, this kind of representation leads to the acceptance of the Black community in society. While some may think that advertisements should purely entice the viewer to buy something or support an organization, McBain advocated for the Black community through advertisements. He used them to tap into an otherwise neglected community. In doing so, McBain showed that Black people are just people. Black people are striving for the same economic and societal luxuries that white Americans are. This notion begins to give these communities a common ground.

In Lilly Smith's article "Emmett McBain: Art Direction as Social Equity," McBain is credited with "uplifting the community by reflecting the true identity of a people."[25] Throughout his career, McBain advocated for the Black community more and more. After leaving Burrell McBain, he continued a career in fine arts, where he obtained more freedom in expressing his love for the Black community.

Their Impact

The impact of Black designers went beyond desegregation, helping to unlock doors for Black designers today. Previous designer's struggles helped provide opportunities for today's designers such as being able to work at any agency they choose as well as freely express themselves and their culture. Some prominent Black designers of today include Adé Hogue and Adrian Franks. These designers were inspired by those like the ones aforementioned. Previous designers' struggles helped them advance to an even greater standard. For example, Hogue is an art director, designer, and typographer

based in Chicago. Having worked with brands like Nike, the *Atlantic*, and the Obama Foundation, Hogue was named one of the fifteen best creatives under thirty in 2017 by *PRINT* magazine.[26] Much of his work is reminiscent of Douglas. Hogue focuses on dynamic layouts with bold and expressive lines. Similar to Douglas's technique, Hogue frequently uses hand-cut type and photographic reproduction. One of Hogue's designs includes a set of pins with rap lyrics that have influenced and inspired him. Although it only features typography, this design is just as bold as Douglas's illustrations.

As for Franks, his design skills have won him two ADDY awards, and he was named one of the forty under forty to watch by *Advertising Age*. Similar to Dawson, Franks's works typically feature illustrations. His *Fearless* campaign depicts people, mainly Black Americans, who were fearless in pursuing their dreams.[27] This campaign is like Dawson's *ABCs of Great Negroes* in that it highlights individuals and their accomplishments.

Dawson and Frank's campaigns show that representation can lead to great things and influence a younger generation. Both designers are passionate about teaching children about the greatness of those who came before them. Even years later, Black designers are advocating for similar acceptance that their historical counterparts were. Without the struggles of Dawson, Douglas, and McBain, modern Black designers like Hogue and Franks would not have had the inspiration to achieve at such a high level of excellence.

Representation

Representation is how popular media portrays an ethnicity, identity, or social issue to an audience. Typically when there is representation in an industry, it is based on negative stereotypes that misrepresent a culture or ethnicity. According to the Perception Institute, "Both entertainment and new media are powerful forces in creating and perpetuating negative cultural stereotypes, especially about racial and ethnic groups."[28] For example, Black women are often oversexualized in entertainment media. Additionally, Black men are commonly depicted as criminals, or as being overly aggressive and violent. Stereotypes like these are found in all forms of media from news to advertisement. These frequent depictions build up negative tropes and are harmful because they do not show the nuances of human experiences. Stereotypes categorize an entire culture into a simplistic narrative. Not only are these untrue, but they put the blame on minorities for being in a particular situation. According to Chimamanda Ngozi Adichie's TED talk called "The Danger of a Single Story," a single story leaves "no possibility of feelings more complex than pity, no possibility of a connection as human equals."[29]

Anti-Black stereotypes do not account for the systemic violence and poverty that Black communities are forced into. They don't account for the daily oppression that Black communities face. Advertising firms and news outlets

play a significant role in how we act politically. We will not be properly equipped with the tools to garner political support if stereotypes are perpetuated. A study by Dr. Travis L. Dixon of the University of Illinois at Urbana-Champaign notes that media consumers are shaped by a televised world and thus will begin to see Black families in the same way they are portrayed in media.[30] What we see in the media eventually becomes what we see in reality. This flaw in media takes away the agency of individuals with marginalized identities by filtering their voice through an uneducated and ignorant lens. Because we are constantly being fed stereotypes, no one is entirely free from stereotypes influencing our perception of others. Everyone has an implicit bias. This bias is unconscious and unintentional, meaning that only a person from a specific culture will be able to accurately represent someone from that same culture. Another important aspect of representation is the lack of it. According to a response from a survey I conducted to better understand how representation impacts designers, the negative impacts caused by a lack of representation for one individual included "the feeling of being undermined and overlooked as a minority. It can add up to one's own insecurities as a designer and can make one feel like there's no room out there for them to succeed."

Barriers

A career in the design industry can be especially difficult for underrepresented and communities who hold identities that have been historically racialized communities. According to Dorothy Jackson's article "The Black Experience in Graphic Design," "The problem—for everyone—is to get more black people into positions where they can make their own unique contribution as designers."[31] Along with financial constraints, "to many black parents ... studying art is a luxury. The average black parent is not aware of 'art' as being a field in which one can make a living."[32] Like all parents, Black parents, Indigenous parents, and parents of colors are constantly seeking a more prosperous life for their children. The fear of their children not being able to succeed in a competitive world stems from the struggles that they and previous generations have faced. What parents fail to understand is how the design industry has the potential to bring a person's culture to the forefront, which is extremely important and just as valuable as any other service-centered career. More representation of successful Black designers would allow parents to see the potential within the design industry.

Black designers can and have been fighting for their chance to succeed, but the greatest barrier to entering the field is feeling like you are doing it alone. Starting out on a path uncharted can be immensely daunting, especially when one is constantly told they can never do it, creating a self-fulfilling prophecy. Obtaining a successful career shows other Black Americans that they can achieve the same things. This is particularly true during the impressionable years of childhood. What children watch and read becomes the foundation for how they treat themselves and those around them. To help break down these

barriers, society needs a push toward advocating for positive representation and hiring underrepresented racial groups in influential roles.

Impact of Positive Representation

Positive representation has a bigger impact than most people realize. Many designers worked for advertising agencies that sold Black American products such as dolls, magazines, and hair products, allowing Black Americans to stake their claim in US media. Instead of being told who they are, Black Americans were able to claim their own identity. This act was crucial in furthering the Black Power movement and encouraging others to become designers. Before Black designers had an impact on advertisements, Black Americans had trouble disputing the false claims and negativity presented to the rest of the United States. Advertisements that included positive representation helped humanize Black Americans by showing them doing mundane tasks, thereby making them more "relatable" to white Americans. Positive exposure in the media leads to acceptance.

Cheryl Miller in "Black Designers: Missing in Action (1987)" further explains the impact of positive representation:

> The success of Asian designers—who, interestingly, have been more readily integrated into the mainstream of graphic design in the U.S. than black designers—proves that minority design and a minority perspective can be accepted, respected, even sought after. This is not to say that the black perspective should be accepted simply because the Asian perspective has been, but because it is valuable in its own right.[33]

Positive representation has the most profound impact on those of the same culture. Another response from the online survey noted that "it gives someone a sense of belonging. It makes you feel seen, heard, and understood." All cultures and identities are important to form a cohesive narrative of our own history. This history should be dictated by the ones who are experiencing it instead of those people in the most control. Minority designers have the ability to share this history.

In brief, Black designers may be left out or glossed over in design history books, but they were essential in representing Black culture to the United States. Many designers, from Chicago to Southern California, were pivotal to the success of future designers. Dawson, Douglas, and McBain broke ground in the uncharted territory of community activism and advertising. These designers were trailblazers in advocating for positive representation. Their efforts gave Black designers more opportunity to be seen as a valuable contributor in the world of design and beyond. While there is still a fight for racial justice and equity to be had, past Black designers have taught us that the struggle is worth it.

Nichole Burroughs is a graphic designer passionate about creative design rooted in inquiry and compassion. With experience across a variety of industries, her designs are founded in research and discovery. Her interest in graphic design stemmed from a desire to design for and improve her community. Her curious nature allows her to explore innovative yet authentic ideas in all of her work. A strong believer in representation, Burroughs strives to create an inclusive environment in all of her endeavors. Outside design, she enjoys relaxing on the couch with her husband and their two dogs.

Amplifying the Black Voice through Design

Terresa Moses

The murder of Black people at the hands of the police is not new to the Minneapolis and surrounding communities. The 2020 uprisings pushed this systemically violent issue to the forefront of media outlets after the murder of George Floyd.[34] And though the protests lasted for months on end, each year since, a Black life in Minneapolis has to be forcibly taken away by those meant to protect and serve—Winston Smith, Amir Locke, Daunte Wright, and most recently Tekle Sundberg. All while our people, Black people, continue to be retraumatized by institutionalized oppression and harm, we fight. In our exhaustion and hopelessness, we fight. I do not believe it is because of our resilience, although this plays a role, but rather our duty and responsibility to the generations that will come after us. We have shouted from the rooftops, and continue to do so, that Black lives matter, hoping that one day we will truly see collective liberation. While this dream remains to be seen, we as designers have been called to action.

It is important that in grounding this autoethnographic experience and qualitative recount of events, I reveal my own positionality to this work. I am a Black queer woman who organizes for abolition and Black liberation in a predominately white region in the Midwest. I often draw on my own lived experiences and those of my communities to influence the movements and organizing efforts I choose to engage in. I am frequently stuck in the middle of grief and rage, which I overcome by lifting my fists in community protests and creating work that centers the messages of Black people in my community.

Design Tactics in Activism

Each individual has their place in the movement for liberation and justice. I implore each of us to seek out how we might use our influence for good, challenging the social constructs that keep our communities oppressed. We can indeed solve issues of oppression if we can come to the collective understanding that each of us are designers. Designers are problem solvers crafting intentional artifacts, systems, and experiences that we use every day. The research that informs what design approaches we take may draw on historical literature or our own lived experiences. That is the beauty of design. And we use that information to guide us in design approaches that shape how we move about the world.

As such, designers have the unique opportunity to use their problem-solving skill set and design aesthetic to advocate for the humanity and rights of their fellow community members. Throughout the twentieth and twenty-first centuries, there have been numerous instances that reflect the power of design as a tool of amplification and support for the movement for Black lives. In 1936, the National Association for the Advancement of Colored People's began to fly a flag with the phrase "A Black Man Was Lynched Yesterday" after reoccurring lynchings across the United States. In 1968, the Poor People's Campaign led the march on Washington, DC, holding protest signs that read "I AM A MAN" to emphasize the humanity of lower-class individuals.[35] Those same, effective tactics continue today with the hashtag #BlackLivesMatter, the 2020 Minneapolis community murals created after the murder of George Floyd, and community-created slogans like "Stop Killing Black People." The use of art and design as a means to unify messaging to support and further the rights of Black people in the United States continues as we move into even more uncertain times with the overturning of *Roe v. Wade*. With good reason, however, I use some of the same tactics as the aforementioned designs to support the outcries of the communities I exist within. As an active community member and community-engaged scholar, I have found the work I have created for the Black liberation and abolitionist movements to be at the intersection of research and community. It is my intention to explore the importance of community protests, and how my participation in said protests inspired a typographic response that can be seen throughout activist-led events that call for solidarity, justice, and liberation for the Black communities

that experience the widely known violence by the police state. While the ultimate goal of my work is to perpetuate the idea that abolition is the only means to liberation, I use design as a tool to hold space for the voice of the community while we work toward a collective future free from violence.

The Importance of Community Protest

On April 11, 2021, police officer Amy Potter murdered Daunte Wright during a traffic stop to which they admitted was due to air fresheners hanging from his rearview mirror. The Minneapolis community—still mourning the murder of Floyd and protesting for his justice during the national trial of police officer Derek Chauvin—poured into the streets of Brooklyn Center to protest the murder of Wright by the Brooklyn Center Police Department.

Protesters, including myself, lined up in front of the city's police station shouting chants, singing songs, and listening to evocative and moving speeches from those leading the charge. With no justice in sight, we proceeded to the streets to further a never-ending movement for our lives—Black humanity. Emotions were high, and the community was activated. At various points during the rallies, there would be a rush of tears in conjunction with the expression of anger in the crowds. In the *Art of Protest*, T. V. Reed states that the movement uses "a variety of tactics, including marches, direct action, protest art, and lobbying for specific policy changes at local, state, and federal levels."[36] The Minneapolis community knows all too well how these marches and protests work, even down to the very moment we knew that the police would begin to use chemical warfare. With the variety of ways to show support and protest for yet another life lost at the hands of police, community members mobilized to protect each other against the police state. There were community actions like marches that stopped traffic for hours, protests that demonstrated our community power, and die-ins that emphasized the amount of lives lost due to state-enacted violence by laying on the ground. These community actions happened at the site of murders, police stations, and government buildings. As a community, we used our bodies to send a message to the police, city, state, and nation that Black lives matter.

Whose Streets? Our Streets!

Protest is used as a means of institutional disruption supporting social movements. Reed defines movements as "the unauthorized, unofficial, anti-institutional, sustained collective actions of ordinary citizens trying to change their world."[37] And with all eyes still on Minneapolis due to the 2020 uprisings, community members used every opportunity, through action and otherwise, to express their disdain for the institution of police. Along with the community at large, I joined in to stand in front of the police station, uniting with one voice as we shouted the names of the Black victims. As I looked around, attendees held handmade cardboard signs and flags with messages that spoke louder

than words with constant visibility in the photographs and B-roll taken by the press.

Protests are a unique and strategic way to gain media attention. They do this because they disrupt our nation's connection to capitalism, stopping everyone's work to focus on one issue. This tactic—disruption—used in conjunction with community protests and the visuals of protest signage, adds a megaphone to the message. It amplifies the shouts and demands of the community to have a national platform, thus adding pressure onto the state, and sets in place the earnest need for acknowledgment and justice.

These types of *dramatics* were a common practice used by the Black Panther Party for Self-Defense, which often used the press as an opportunity for theatrical messaging. In her article "Visualizing a Black Future: Emory Douglas and the Black Panther Party," Colette Gaiter describes how the Panthers used the idea of the Western avenger and reimagined it with collective Black futures in mind to create a new image of the Black man—"intelligent, handsome, strong, coolly irreverent, well-read and well-dressed men with guns." The Panthers' imagery "visualized a shift from the Civil Rights movement's restraint to the empowerment of threatened armed resistance."[38] This new idea or *rebrand* of the Black man no doubt made the "inherently dangerous and violent" Black man stereotype real in order to protect the Black communities the Panthers were defending. Media attention highlighted these theatrics, which in turn heightened the group's notoriety and influenced similar groups for other Black communities across the nation. This notoriety also made the group a target of the state, which we have seen take control of the narrative so as to make the murder of Black people legal.

Nowadays, while press is still an important tactic, social media outlets like Facebook, Instagram, Twitter, Snapchat, and TikTok allow for the self-publishing of political messaging and propaganda. The #BlackLivesMatter movement started as a "love letter to Black people" on a Facebook post by cofounder Alicia Garza in 2013. Garza expressed her message of pain, sadness, and anger about the way Black life is seen as disposable in this country. And that message sparked a chain of events—movement—that continue to this very day. With the control of movement messaging now in the hands of everyday people, media attention does not have to wait for someone with a press pass. Black people now have the opportunity to go viral, advocating and publicizing the issues of their communities in their own way, no filter.

The Black Aesthetic

Protest, specifically for Black liberation, is used as a means of Black expression, Black healing, and Black communing. The "Black aesthetic"—often culturally appropriated—represents the heart, spirit, and energy of the Black community. It ranges in its representation because of the nuances present in the Black community and the expression of the spectrum of emotions—joy,

pain, sadness, and rage. For example, the joy experienced at the conviction of police officers who need to be held accountable for their crimes of violence against the Black community. But with that, the pain in the loss of those Black lives that a conviction cannot revive, and the fact that the punitive systems of justice do not actually heal or restore our communities. Nuance.

In the words of Tef Poe, activist and cofounder of Hands Up United, "This ain't yo mama's Civil Rights movement."[39] This phrase, noted in the same *Washington Post* article, was made popular by activist and organizer Rahiel Tesfamariam when she wore a shirt with the words imprinted on it as she was arrested in August 2016 protesting for justice for Michael Brown, another Black man murdered by police, this time in Ferguson, Missouri. It is more than just a trendy Black-made saying that makes this an exemplary instance of the Black aesthetic. It is a rejection of the past tactics of silent sit-ins, turning the other cheek, going high while they go low, and honoring patriarchy in organizing the movement. It is a new way forward, of a new generation of people who boldly speaks their mind and unapologetically shows up in spaces as their true selves—femme, queer, disabled, and the like. The Black aesthetic is a mirror of the Black culture. And in activism, the Black aesthetic is a mirror of the passion and struggle found in the issues we are fighting for. It is in this struggle that we are brought together, bonded, in communion with one another.

Protest is a means of community connection. It is inescapable as you stand together united with emotion. Much like the Black aesthetic that mirrors Black culture and Black ways of being, so does the communal nature of Black communities. This connection is in opposition to that of white supremacy, which supports (and boasts) an individualistic and capitalist nature. Relationships are constantly credited as the means to change—the change in our character, bias, and support, unknowingly or not, of the systems of oppression, white supremacy, and anti-Blackness that plague our communities today. Community connection is a means of collective protection, starting mutual aid networks that support an interdependent community.

This unification of our values does not happen overnight. In fact, it is just as important to intentionally create these connections along with our fight for humanity. In an interview titled "Creating the Future" in *Deem* journal, activist adrienne maree brown states, "We have to design structures; we have to design relationships; we have to design justice."[40] It is in this intentionally designed connection with the community that the message of the movement shows up in conversation, community action, chants, and song.

This community connection, for me, ended up being a qualitative and ethnographic research process. As a participant in community protests, I was on the ground listening and hearing firsthand what community members and leaders were fighting for. This is where the defining of the message began for me, and where I saw my role in the movement. As a fiery designer and

illustrator, I could do my part in protest while at the same time unifying our message. Through design, I could put a megaphone up to the cries of the community to amplify the hard work of Black Minneapolis organizers and activists. Because the movement needed a uniform, and I wanted to see to it that it was Black as fuck and loud as hell.

Designing the Typographic Messaging

As the founder and creative director of an openly abolitionist design studio, I was already accustomed to using design as propaganda that supports an abolitionist and liberatory collective future. I am well aware that propaganda—the spreading of ideas for the purposes of furthering or promoting a person, cause, or institution—"has a bad reputation." There are a variety of examples in which art has been used as propaganda to spread negative, harmful, and violent dis/information to support destructive institutions. In *The Art of Protest: Political Art and Activism*, political artist Tania Bruguera is quoted saying, "Art can also be used for political purposes, but that is not political art, that is art propaganda."[41] Regardless of whether art propaganda is used for uplifting or oppressing the society in which we live, that propaganda sets movements in motion. Artists and designers alike have a responsibility to use their skills to frame and tell stories for the good of humanity, regardless of the art's outright political leaning. A quote that continually inspires the work that I do is from W. E. B. Du Bois:

> Thus all Art is propaganda and ever must be, despite the wailing of the purists. I stand in utter shamelessness and say that whatever art I have for writing has been used always for propaganda for gaining the right of black folk to love and enjoy. I do not care a damn for any art that is not used for propaganda. But I do care when propaganda is confined to one side while the other is stripped and silent.[42]

This critique of artistic and creative forms is a call to action and critical thought in the outcomes we produce. We have the power to influence the masses not only in the stories we tell but also how we tell them. Leslie Xia asserts that "graphic design has the power to create passionate, action-oriented imagery to engage with communities and to influence, empower, and spark change through visual messaging."[43]

As a designer who advocates for the liberation of Black people, I appreciate the ability to use my talents and skill sets for movement work. I am inspired by the quickness, flexibility, and tightly woven strategy of the movement for Black lives. The actions I take as a designer are similar to that of the iconic "vote" etched into the foreheads of young Black protesters with zinc oxide—used to protect their skin from the sun—as they fought for voting rights in 1965. I wanted to evoke this same urgency and call back to the feelings of my ancestors as they began and held the line for me as well as the generations after

me. This inspiration birthed a loud, gritty, and high-contrast illustrative type that shouted specific messages that have been cried out over generations of activists and organizers. This expressive typography was an intentional design choice meant to display particular phrases while also leaving room for a full stop while the reader sat with the meaning behind what was being stated.

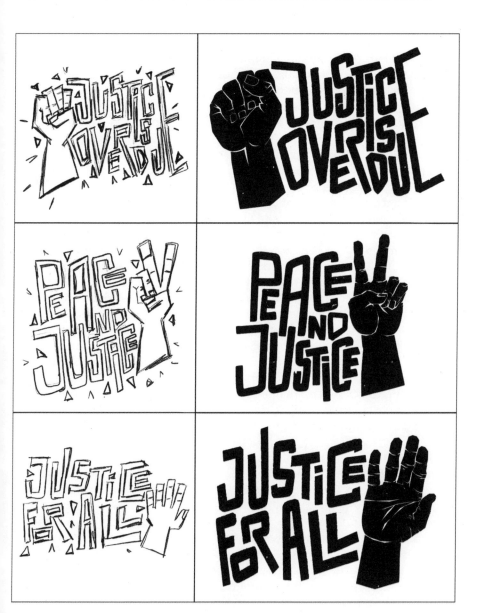

Justice Is Overdue, Peace and Justice, and Justice for All. Sketches and digital illustrations by Terresa Moses. Blackbird Revolt, 2019.

I first used the lettering to express three phrases I wanted to convey on a new T-shirt line that I was working on: "Justice Is Overdue," "Peace and Justice," and "Justice for All." Each phrase included the word *justice*, making it quite easy to name the series as such. It is a value that I hold, and one that I believe is well overdue. With this series, I hoped to convey a sense of urgency and antitradition as a means to peace and justice—the absence of systemic violence, and presence of accountability based in compassion and healing. Having previously created the fist as a piece of iconography used in the Blackbird Revolt brand, I created the other two hands and correlating letterforms. *Gritty*, *nontraditional*, *loud*, and *urgent* were the adjectives I used to describe the design direction. In the figure below, you will see this displayed clearly in the early versions of my typographic development, before 2020, when I had a bit more time to piece together messaging and imagery.

"Unusual, illustrative, or otherwise hard-to-read letters often convey a highly specific visual or intellectual tone and are meant to be looked at rather than through," observe Bruce Willen and Nolen Strails in *Lettering and Type*.[44] Combining my love of illustration with typography meant telling a story that was much more than the words themselves. The letterforms, once combined, become containers of expression. "When letters become imagery, they function on two levels: as a container for textual content and as an expression of a visual idea." I was also adamant that the letterforms fit together, much like a puzzle, while keeping the rapid feel. I found this to be similar to the work of organizers and activists in the community. Many people, ideas, and actions combining rapidly in an organic puzzle for change. This led me to using the type as a means to communicate quickly because as Willen and Strails state, "Writing emphasizes quick communication and execution above appearance." My type was meant to highlight the message over the appearance. So I kept the organic style through the use of texture with an stress on speed (although the lettering took much more time to create than what I meant to evoke). This look of casual lettering was "meant to give the impression that the letterforms were rapidly thrown together."[45]

Typography as an Emotional Outlet

Once the letterforms were crafted through sketches, and then traced and vectored in Adobe Illustrator, I began to craft messages that expressed mine and many of my fellow organizers' feelings, demands, and calls for justice. Even the very act of putting together the typographic puzzle was a means of emotional relief during times when often there were no words. My work not only told a story as a narrative but also one that evoked passionate emotions. In Ellen Lupton's *Design Is Storytelling*, she notes that "a great story does more than represent emotion from a distance. It makes us feel an emotional charge."[46] This explains exactly what I meant to do: tell the stories of the community to evoke emotional outrage and set the movement in motion.

The slogans and chants of the movement came from the community and are included in my illustrated typographic work. It's similar to how Emory Douglas, the Minister of Culture for the Black Panther Party, boldly displayed "All Power to the People" in his illustrative print *Newspaper Boy* (1969).[47] This slogan is still used today, frequently cited by those in the racial justice movement as a claim to the right to our collective power and humanity that has been stolen by the state. Another phrase that rings out in the fight for the abolition of police is "I Can't Breathe," which was on the mouths of protesters in remembrance of the last words spoken by Eric Garner, murdered by police on Staten Island on July 17, 2014, and then again in 2020 during the uprisings after the murder of Floyd, who shouted the same phrase before his death.[48] These phrases, oftentimes hard to sit with, are meant to remind the community, nation, and world of the struggles facing Black people, and our continuous and exhausting fight to exist. This discomfort hopefully incites change and a new awareness for the movement to inspire action. "Action drives stories, and it also drives the design process. Design makes things happen in the world," remarks Lupton.[49]

The Revolution Needs a Uniform

As the word spread about the ways that my fellow organizers and I chose to engage in the protests, I was asked by a friend why I decided to use design in this way. I stated that "the movement needs a uniform." I explained that while one person can easily be ignored, we cannot all be ignored with a united front. While we stood in solidarity looking into the barbed wire fences that surrounded the precinct, our message would not go unheard. Not only would this "uniform" be a message to those in opposition to us, but it would inspire more to join our cause and fight with us because they'd know they were a part of something much bigger than them. It required all of us in the fight. Radical Black feminist filmmaker and activist Toni Cade Bambara observes, "The role of the artist is to make the revolution irresistible." I do not have the luxury of making art for art's sake. No, my art is propaganda for the side of racial justice and Black liberation.

The phrases I chose to develop are not my own but rather a reflection of the words of activists and organizers who have come before me and continue fighting today. The phrases that have been designed using my typographic illustrations so far include the following (in alphabetic order), as you'll also see in the figures below: Abolish the Police, ACAB, All Power to the People, Black Lives Matter, Defund the Police, Fuck 12, Justice for Amir Locke, Justice for Ma'Khia, Justice for Floyd, Justice for Wright, No Justice No Peace, No Justice No Streets, People over Property, and Stop Killing Black People. Leslie Xia is cited in the book *Extra Bold* arguing that "activist design is often open source."[50] Each design as well as the letterforms themselves are open access on my studio's website at www.blackbirdrevolt.com/stopkillingblackpeople. These sayings and slogans were and continue to be distributed in a similar way by many friends and volunteers at protests, rallies, political actions, and marches.

Abolish the Police. Digital typographic illustration by the author, 2020.

ACAB. Digital typographic illustration by the author, 2020.

All Power to the People. Digital typographic illustration by the author, 2020.

Black Lives Matter. Digital typographic illustration by the author, 2020.

Fuck 12. Digital typographic illustration by the author, 2020.

No Justice No Streets. Digital typographic illustration by the author, 2020.

People Over Property. Digital typographic illustration by the author, 2020.

Stop Killing Black People Digital typographic illustration by the author, 2020.

Community Distribution

The idea to have free community distributions, which I have since renamed *distro*, came about as my close friends and I were organizing protest supplies. Using a digital grassroots approach, we raised funds on our social media platforms for gas masks, umbrellas, hand warmers, gloves, hats, socks, water, snacks, flashlights, antibacterial lotion, and any other requests from frontline protesters. Everyday we made trips to big-box stores, filling up multiple carts with supplies for protesters (including ourselves). After we dropped off the supplies to a safe base for protesters, we geared up and stood on the front lines with the other protesters at Brooklyn Center, Minnesota. In view were the normal cardboard signs that were being soaked by the rain and snow. There was also a distinct instruction to wear all black so as to not stand out in a crowd that was being heavily surveilled by the police. This instruction was imperative to avoid drawing attention and bringing unintended harm to you and those in your circle through this surveillance.

All of these *field* observations sparked an idea in me. I saw that we needed waterproof signs to keep the messages clear for the press. We also needed more layers to stay warm as some protesters failed to realize how cold it would get the longer they stood on the streets. With that, I made my first order from a local printer for waterproof signs that included the messaging that I had designed. I got them in just a few days, and when we did our next drop off of protest supplies, we were there with signs and buttons to hand out to the protesters in the crowd. Similar to our fundraising efforts, we were now announcing "FREE DISTRO" for the next protest. After weeks of protesting, community members came to expect our presence, and arrived in droves to pick up their gear and stand on the front lines for justice for Wright. Other folks from our networks reached out to help volunteer, increasing how much *distro* we could give out to the protesters.

Throughout the protests and rallies in April and May, we raised over $27,000 to pay for printed signs, buttons, and apparel. The following is an account of the dates we distributed items and how much we were able to distribute while engaging with community members:

On April 16, 2021, at the Brooklyn Center Police Station, we distributed 300 "Stop Killing Black People" hoodies, 200 buttons of assorted designs, and 100 waterproof signs of assorted designs.

On April 23, 2021, at the governor's residence, we passed out 1,000 buttons of assorted designs, 250 waterproof signs of assorted designs, 500 "Black Lives Matter" T-shirts, and 300 "Stop Killing Black People" hoodies.

On May 1, 2021, at the labor rally, we passed out 500 "Abolish the Police" T-shirts, 250 waterproof signs of assorted designs, and 1,400 buttons of assorted designs.

And on May 25 at George Floyd Square, we passed out 500 "All Power to the People" T-shirts and 100 waterproof signs of assorted designs.

We have since handed out almost double of what's accounted for above. Unfortunately, the culture of anti-Blackness in policing continues to thrive here in Minneapolis.

Community Appreciation

During the distributions, we experienced an intentional togetherness at a time when we were all in shock and enraged at the recent events of yet another murder of an unarmed Black man. We met many people who we have since connected and engaged in more community projects. At George Floyd Square, we had the opportunity to meet the rapper Common, who grabbed one of our "All Power to the People" T-shirts and wore it onstage during his performance at the commemoration event for Floyd. Other designers and community members also adopted the designs to use in their particular outlet of design. Sharp Design Co. adopted a few designs, and hand-painted large banners and signs for protests as well as to hang outside other police stations. Another community member used the designs on her custom jacket during Black fashion week. My typographic illustrations have been featured by many photographers including Mel D. Cole in his recent book *American Protest*.[51] The "Black Lives Matter" protest sign photographed by Uche Iroegbu ended up on the front cover of *Insight News* for the announcement of Chauvin's guilty sentence.[52] During the inaugural Juneteenth celebration hosted by the University of Minnesota, my lettering was used in the branding of the theme centered on Black past, present, and future: *Was. Is. Will Be.*

Community members have shown up for one another in amazing ways, unified by using this typography in their messaging. And although everything is available open access on my studio's website, there are conditions that I hope users of the files follow to keep aligned to the mission and vision of the now-named "Stop Killing Black People" font. On the downloadable files, I state,

> This type is available for folks to freely use under the condition that the use aligns with the type's genesis and purpose. We created this type to add our voice and creative work to the vision of, and the movement for, Black liberation. It should be used to call attention to the need for abolition, justice, and liberation. It should not be used to call attention to things unrelated or in opposition to abolition. Unacceptable uses include: Calls for reform that are not directly related or supportive of the path to abolition, advertising a product or service, or monetization for personal gain. Acceptable uses include: Calls for justice, abolition, and liberation, raising funds or gathering resources for mutual aid funds, networks, or cooperative economic models to support Black and Indigenous peoples, and art related to abolition.

A Call to Action

I end in a similar fashion to how I began, declaring that *everyone* has a place in movement work—whether it be standing on the front line of a protest or signing policy in place that provides opportunity and access. All actions in the name of the Black liberation movement are part of a bigger story. Artists and designers get the unique opportunity to help tell that story in ways that invoke change and inspire action. In a 1961 conversation between Studs Terkel and James Baldwin, Baldwin observes that "[artists] are here to disturb the peace."[53] For me, this is a call to action, a pull on my responsibility as an artist, illustrator, and freedom fighter. Even as I type this, there are continued actions happening here in Minneapolis, and I plan to show up—using my creativity, networks, and resources to support a collective future where Black people are freed from state violence and can live holistically liberated lives. Where you at?

Peace of Mind. Digital illustration by
Kprecia Ambers, 2020.

Peace of Mind
Kprecia Ambers

In response to the pandemic lockdown and 2020 uprisings, I created a mini self-care series as a way to show support. Little did I know that the series would have me question how I care for myself. I thought that because I was an introvert who works at home and enjoys being alone that the pandemic would be OK, but mentally I was breaking down. My brain was yelling for a break, and my place of comfort became the place I wanted to escape. My workload was heavy, my city was burning in pain, I lost three close family members, and life just kept happening. Being limited on where I could go throughout my community felt different. It forced me to question what self-care really meant to me, what I can control, and the boundaries I needed to create. I started to put myself first.

Although 2020 was a hectic year, it ironically helped me find peace within myself. Not only did it change my perspective of mental health, but it shed light on how systemic racism truly affects every part of the Black experience. Throughout my lifetime, I have felt misplaced in white spaces. These experiences are enough to remind me of my Blackness. The more I learn, the more I realize the same system that my ancestors were fighting against still stands strong today. Seeing George Floyd murdered on camera by the police overwhelmed my heart. I am still navigating emotions linked to this moment in racial injustice, and it often makes me think about how we are not really taught what self-care is or what it means. Most of our lives are spent surviving in a system set up against us and it leaves little space to focus on mental health or care. What I find upsetting is how the same neighborhoods that white people call dangerous and filled with "thugs" are a result of the white supremacist cages they built. We may never experience real change, but we can make choices to find our own peace of mind.

With this illustration, I encourage Black bodies to make time for themselves to think about what self-care means to them and how it looks. Look at what you can control in your life and start adding in things that bring you happiness. To me, this is success, because love and happiness are things that money cannot buy. We learn to create our own happiness, and when we do that, we learn to show up for ourselves and others.

Biography

Kprecia Ambers is a digital illustrator from Minneapolis and the owner of Kp Inspires, a digital art studio creating artworks for products, projects, and spaces that seek to inspire their audience. In 2015, Ambers graduated with a BFA in graphic design, and her creativity blossomed into an interest in surface design and a career in illustration. She is known for her vibrant figurative art, and has partnered to create for local Minneapolis businesses such as Wise Ink and Pollen to well-known brands such as Adidas and Alina. Amber's hope is to build Kp Inspires into a brand that shares love.

PANTHERS VOTE! A Studio Project Exposing Past Voter Suppression Methods to a Collegiate Population That Has Been Historically Disenfranchised

Tracey L. Moore

The students at Prairie View A&M University (PVAMU) are no strangers to voter suppression. In recent history, they have marched, protested, and sued local government officials in hopes of having voter registrations validated, reestablishing an on-campus polling place, receiving equitable early voting hours, and more since the inception of the university. Oftentimes, that history gets lost in the commotion of the current political landscape and a need exists to be reminded of past struggles to identify the patterns of disenfranchisement that continue to plague college communities. In the Digital Media Arts Program, third-year students explored the history of voter suppression in a poster campaign series titled *PANTHERS VOTE!* The project, inspired by Antionette D. Carroll's poster submission—*Vote for Your Ancestors. Vote for Yourself. It's Your Right*—to the AIGA Get Out the Vote 2016 civic engagement campaign, sought to spread awareness to the student body through traditional and digital means.

Historical Context

PVAMU is the quintessential symbol of political activism for college students facing voter suppression. The primary source of contention has been whether or not students living on and off campus are "bona fide" residents of Waller County, Texas.[54] This dispute found its way into numerous court cases involving voter suppression and accusations of voter fraud throughout the history of the college. In the 1944 case *Smith v. Allright*, PVAMU alumnus Lonnie Smith won the right to vote in Texas Democratic primaries.[55] The 1972 case *Ballas v. Symm*, which ultimately landed in the US Supreme Court in 1979 as *Symm v. US*, saw PVAMU student tCharles R. Ballas challenge the legitimacy of a questionnaire required by Leroy, Symm, the tax assessor-collector of Waller County, for all college students to complete to show that they are bona fide residents and thus eligible to vote.[56] The Supreme Court decided that students have the right to vote in local elections held where they attend college. Since 1979, though, PVAMU students have continued to face political and legal challenges regarding the validity of their right to vote in Waller County.[57]

Project Development

My own engagement with the development of the African American studies program and the Ruth J. Simmons Center for Race and Justice prompted me to increase the political activism of the students. With the election season in full swing, I was reminded of Carroll's aforementioned poster submission.[58] Carroll's design highlighted how a jar of jelly beans was used to disenfranchise Black voters. I viewed the campaign exhibition at the 2016 AIGA Design Conference and it struck a chord with me. Seeing a physical representation of the voter suppression method changes one's perspective on history. In the ongoing case *Allen v. Waller*, PVAMU students were gearing up to testify regarding similar voter suppression issues that they faced in the 2018 elections.[59]

The studio project *PANTHERS VOTE!* served as an opportunity for the students to compare historical acts of voter suppression and the fight for civil rights to what is happening now while informing the student body of the proper addresses to use on the voter registration applications. Students could also better understand the plight of their elders, and the responsibility students have to continue the legacy of political and civic engagement.

Students designed a series of posters that had two goals: highlight a voter suppression method used against minorities and economically disadvantaged in the past, and inform PVAMU students living on campus on how to properly complete the mailing and residence address portions on the voter registration card. The posters were hung in strategic locations around the PVAMU campus in the week before the official deadline for voter registration, and the information was adapted to showcase on the official Instagram page for upper-division majors, @studiothree17.

We often began the project development with a robust discussion, which led to the research phase where each student was encouraged to delve into the abyss of voter suppression and then narrow that down to the one method that unsettled them the most. Several chose the university, a historically Black college and university (HBCU), as a starting point. Students unearthed the *Ballas v. Symm* case that included a copy of the "Questionnaire Pertaining to Residence," the "PV19" case from the 1990s, and the various marches during each presidential and midterm elections throughout the 2000s and 2010s. Students also located copies of literacy and language tests, random registrar questions, and poll tax forms. They learned about groups including the Red Shirts, a late nineteenth-century white supremacist paramilitary group, voter caging, felony voter rights, civil rights martyrs like Jimmie Lee Jackson, and so much more.

As they narrowed the focus, several students specifically centered their imagery either directly or indirectly on how Black people were particularly affected by voter suppression. For aesthetics, students were influenced by past styles such as war propaganda posters as well as artists and designers like Elizabeth Catlett, Faith Ringgold, and Aaron Douglas. For this exercise, I am highlighting work where students specifically referenced Blackness.

The Work

Inspired by the cartoon *Patty-Jo 'n' Ginger* published in the *Pittsburgh Courier* from 1945 to 1956 by Jackie Ormes, considered to be the first Black woman cartoonist, Littlejohn reimagined the characters as herself and her brother, titling the piece *Caitlin-Rai 'n' Seth*. The message of the poster plays on the legitimacy of Symm's designation of bona fide Waller County residents. Each poster features either the Waller County Courthouse or Willie A. Tempton Sr. Memorial Student Center—both epicenters of voting and voter suppression.

The central theme in Harper's work encompasses the dangers and consequences of voting. While researching voter suppression in Alabama, Harper found that as Black people registered to vote, local authorities would supply the information on the voter registrations to the sheriffs and members of the Ku Klux Klan. These groups targeted and harassed those who dared to register. Harper opted to move away from the traditional color palette often associated with the United States and propaganda posters to the use of various shades of brown. Harper desired that the target audience had no question regarding who was affected by voter suppression.

Focusing on the Red Shirts, Guilarte highlighted the inherent terrorism that was directed at Black people exercising their right to vote. Initially intrigued by the color schemes of World War II propaganda posters and Afrocentricity, specifically red, yellow, and black, Guilarte combined this aesthetic with the style of Catlett's prints and the word placement of Ringgold's story quilts.

CAITLIN-RAI 'n' SETH

BONE-A-FIDE PANTHERS VOTE!

SCAN THE
QR CODE
FOR MORE
INFORMATION

"Imagine havin' to take a quiz to prove you're a bone-a-fide resident so you can vote— s'pecially since mama an' daddy say they pay good money for you to stay there. Your buddy Charles R. Ballas sure knows his constitutional an' statutory civil rights mostly on account of him taking that LeRoy Symm to court and makin' it all the way to the Supreme Court. That LeRoy Symm really has some nerve."

PRAIRIE VIEW A&M UNIVERSITY
SCHOOL OF ARCHITECTURE
DIGITAL MEDIA ARTS PROGRAM

PANTHERS VOTE!

Design for Activism Initiative by
the PVAMU Digital Media Arts Studio Bone17
instagram.com/studiobone17
Poster design By Caitlin R. Littlejohn

The Cost of Voting. Graphic design
by Natasha Guilarte, fall 2020.

LIVE ON CAMPUS

AND NEED TO REGISTER TO VOTE?

VISIT VOTETEXAS.GOV

**USE THESE ADDRESSES
FOR SECTION 3 & 4**

UNIVERSITY COLLEGE

University College
Bldg # Rm #
Prairie View, TX 77446

UNIVERSITY SQUARE PHASE VIII

University Square
Bldg # Rm #
Prairie View, TX 77446

UNIVERSITY VIEW PHASE VII

University View
Bldg # Rm #
Prairie View, TX 77446

UNIVERSITY VILLAGE PHASE I

University Village I
Bldg # Rm #
Prairie View, TX 77446

UNIVERSITY VILLAGE PHASE II

University Village II
Bldg # Rm #
Prairie View, TX 77446

UNIVERSITY VILLAGE NORTH - PHASE III

University Village III
Bldg # Rm #
Prairie View, TX 77446

UNIVERSITY VILLAGE NORTH - PHASE IV

University Village IV
Bldg # Rm #
Prairie View, TX 77446

MAILING ADDRESS

PO Box 519
Bldg # - Rm#
Prairie View, TX 77446

**SCAN
TO GET
REGISTERED
TO VOTE**

THE DEADLINE TO REGISTER
IS OCTOBER 5TH

 PRAIRIE VIEW A&M UNIVERSITY SCHOOL OF ARCHITECTURE

PANTHERS VOTE!

Design by Archiiecs Serving by the PVAMU Digital Media Arts Studio Panel C

Poster design by Jack Hagen

Caitlin-Rai 'n' Seth. Graphic design
by Caitlin Littlejohn, fall 2020.

They would prevent civil rights and voting by freedmen.

The Red Shirts were a white supremacist paramilitary group that were active in the late 19th century.

Thee Red shirts were adopted in order to make themselves more visible and threatening.

They intimidated or assassinated black leaders, and discouraged black voting.

PANTHERS VOTE!

Voter Registration Card Address Directions.
Graphic design by Jade Harper, fall 2020.

Results, Discussion, and Conclusion

Examining the effectiveness of the campaign was quite difficult. Due to university-wide requirement to physically distance, the campus was a virtual ghost town—a sentiment widely felt across the nation.[60] In addition, community-wide efforts were ramped up this past election season to get every eligible student on campus registered to vote through daily registration drives, social media campaigns, virtual town halls, and more. Designated locations for the posters centered around where a higher frequency of students was likely to occur: the library, Memorial Student Center, rec center, and University College Computer Lab, to name a few.[61] The Instagram posts clocked a total of 207 engagements.

The qualitative feedback let us know that we were on the right track. The director of libraries showcased digital versions on all library information monitors in addition to the physical posters that dotted each floor of the building. The deputy voter registrars camped out in front of the Memorial Student Center were generally excited about the posters and information presented. *PANTHERS VOTE!* helped influence the creation of the PVAMU HBCU Voting Rights Lab, a project of the Ruth J. Simmons Center for Race and Justice. This lab has provided a space for students to display their political work in a digital exhibition.

Tracey L. Moore is an assistant professor in and coordinator for the Digital Media Arts Program at Prairie View A&M University. As a part-time freelance designer, her most notable work includes logos for the Texas Institute for the Preservation of History and Culture, Charles Gilpin Players, and PVAMU iREAD program as well as the annual marketing materials for the PVAMU African American History Month Lecture and Culture Series. Her research interests include the merging of ethnographic principles and graphic design for the preservation of African American history and culture, and creating mixed-media artwork that captures personal historical narratives.

Acknowledgments

I would like to thank my third-year Digital Media Arts Program students who went above and beyond in their research and design production to make this project become a reality in the face of mandatory quarantines and reduced face-to-face instruction during fall 2020.

Corrections, Cures, and Spoils: How Vote by Mail Information and Service Design Disenfranchised Black Voters in the 2020 US Election Cycle

Asher Kolieboi

I entered the field of design because of my desire to shift political structures toward equitable and justice-centered outcomes. The adage "design is political" is an understatement when designing for disenfranchised communities in the election's space. As a service designer working in the civic space, I am surrounded by reminders of how culture, context, history, and politics shape how people use and experience government and civic services. I came to the design field after working as a community organizer and even serving as the deputy director of a youth-focused progressive voting registration campaign in 2018. My experience on the ground, problem-solving with voters and community organizations, has given me a unique perspective on the role of design and its power to improve civic participation.

Design and the Voting Process

Service design is focused on organizing communications, processes, and artifacts surrounding a single or multiple experiences. It is ephemeral and "helps to innovate (create new) or improve (existing) services to make them more useful, usable, desirable for clients and efficient as well as effective for organizations. It is a new holistic, multi-disciplinary, integrative field."[62] Unlike product design, service design often revolves around the intangible. As a service designer in the civic design space, I design artifacts and informational materials that are integral to the elections process. I work with state or local election offices and advocates to help make the voting process easier and more equitable. This can include the design and research of voter-focused websites, ballots, ballot request forms, paper voter guides, training materials, and signage used in polling places.

In tandem, *information design* is the field of design tasked with presenting information. It incorporates analysis, planning, presentation, and understanding of messages. Information design's focus is clarity and understanding. According to information designer Rune Pettersson, the task of the sender or source is actually not complete until the receiver or interpreters have received and understood messages.[63] Information design considers context, history, typography, and mediums of communication to ensure the receiver understands the message.

Every state grants eligible voters the ability to cast a ballot without being present at a polling place on Election Day. The legal and colloquial phrases used to describe this process vary. I use the phrases *vote by mail* or *absentee voting* interchangeably. While qualifications and processes differ by state, a simplified flow of the vote by mail process includes the following steps:

1. A qualified voter receives or requests an application to vote by mail[64]
2. The voter applies to vote by mail
3. Approved voters are sent a ballot and security envelope
4. The ballot is returned using a security envelope (via mail, Dropbox, or third parties, like a friend, family member, or organization if legally permitted)
5. The voter is informed that their ballot was received
6. The ballot is checked using a verification system
7. If the ballot or envelope has an error, the voter is contacted to remediate the issue
8. The ballot is processed and counted

The process of remediating or correcting errors related to a ballot or security envelope is called a *cure*, or the *curing process*. Some states have a process that allows voters to correct errors, like a missing signature or party affiliation. In theory, voters in these states are notified of the problem and provided time to correct the mistake so the vote can be counted. It is important to note that

while curing a ballot is shown to increase access to voting, it is not an option in most states.[65] In fact, at the time that this contribution was written, thirty states did not allow voters to resolve questions about voter information like an address or redo stained ballots that cannot be read by a counting machine. If a voter's materials cannot be cured in time, or the state does not allow cures, the vote is spoiled, meaning it is voided and will not be included in the final count.

Though it is not a perfect solution, voting by mail increases voter participation, especially for communities that have historically experienced, and currently still do, barriers to voting.[66] This includes communities of color, people with disabilities, new voters, voters with low or limited English literacy, and renters.

No One Should Be Surprised

Election Design, Security Theater, and the Ramp-up to 2020

For the last decade, there has been an increased focus on election security and the integrity of the vote in US politics. But behind the modern, sophisticated rhetoric of election protection is centuries-old voter disenfranchisement. Using election protection as a red herring, a wave of laws and public posturing have created a solution to a fake bugbear. Despite there being little evidence of voter fraud, there has been an avalanche of laws aimed at curtailing this supposed threat. Introduced and supported by mostly conservative politicians, these laws severely restrict who can vote and how voters cast their ballots. This cascade of laws included strict limitations on voter identification requirements, consolidation of polling places, and limits on community voter registration drives throughout the United States.

The results of pre-2020 voting rights laws and the public discourse on election fraud were undeniable, creating significant barriers to voting for communities that have historically had difficulty voting. The Center for American Progress's 2018 report "Voter Suppression during the 2018 Midterm" outlined several concerns including voter registration problems, voter confusion, voter roll purges, voter intimidation, gerrymandering, strict voter identification, and ballot requirements. Stating, "during the 2018 midterms, eligible voters across the country were dissuaded or actively prevented from casting ballots that would have counted."[67]

While widespread voter suppression is a myth, election fraud through voter suppression prospered. The preexisting rhetoric of election policing, restrictive policies, the growing visibility of antipolice violence protests like Black Lives Matter, and voting rights barriers made the election culture of 2020 predictably tense. But the coronavirus pandemic created unforeseen challenges to Black communities, civics included.

COVID-19, Voting by Mail, and Black Voter Suppression

Due to COVID-related health concerns, the number of vote by mail ballots cast across the United States increased significantly during the 2020 election cycle regardless of race. While voters across the board experienced errors throughout the process, Black voters were disproportionately impacted by these errors, which included the application request, ballot submission, and correction process.

The COVID-19 pandemic shaped every aspect of US life in 2020, but the health and social impacts of the virus were not equitable. Black Americans were disproportionately impacted, facing higher mortality, unemployment, and eviction or houselessness rates than other racial demographics.[68] These inequalities were also present in the election service and information design, or lack thereof, to many Black voters. Barriers to voting are not new to Black voters, but the COVID-19 pandemic created unique obstacles. For example, social networks that normally facilitate voter education and outreach were disrupted. Traditional get out the vote efforts were hamstrung by the pandemic.[69] Places of worship and other community organizations that normally educated and mobilized voters were unable to meet.

With traditional modes of voter information being hampered by changes in social networks, Black voters were forced to grapple with an election season in a hostile political climate with changing laws, and little information that spoke to their priorities and concerns. With vote by mail as the safest option, Black voters navigated new terrain. Forecasting the impact of the pandemic and voter suppression laws on democracy, voting rights advocates and think tanks like Black Future Labs and the Brennan Center outlined the information needs as well as concerns of Black voters. They called for more education, better tracking of applications and ballots, and timely communication if a ballot can be remediated. The reports suggested instruction and education due to a lack of familiarity with the process, while focusing on trust and transparency due to an absence of faith in governance influenced by social unrest and COVID fatigue. Research about vote by mail and Black communities show a lack of experience with the process. Prior to the 2020 election, voting by mail was the least common form of voting for Black voters. In addition to a lack of experience, there was a well-researched information drought about voting by mail. In fact, the Tufts University Center for Information and Research on Civic Learning and Engagement's 2020 report "Black Youth Have Less Experience with and Information about Voting by Mail" noted that only 10 percent of the 473 Black students who replied to its survey had voted by mail, with even fewer saying they had even encountered information about the vote by mail process. Despite the research and suggestions, there did not appear to be special efforts made to ensure the integrity of the vote and informed participation in the election process for Black Americans.

In addition to a lack of familiarity and information about the vote by mail process, Black voters were faced with rapidly changing laws, some aimed at further restricting their right to vote. Elections are often administered at the state or county level, thus there are no standard laws for vote by mail processes. Rightfully so, a community in Richmond, Virginia, may have different concerns than one in Richmond, California. This autonomy allows people in those areas to administer elections, including the vote by mail process, and set their own criteria for voter eligibility, deadlines, and the identification needed to authenticate a voter. While all states allow voters to use the vote by mail option, laws vary widely on who can vote by mail and the criteria for acceptable ballots. For example, Alaska is a no excuse state, meaning a voter can vote by mail without providing a reason. Absentee ballot return envelopes must be signed by the voter and a witness or other authorized official. Ballots are not counted if the voter or the official or witness authorized by law fails to sign an oath swearing to the ballot's authenticity. In contrast, Illinois and at least a dozen other states rely on signature verification as proof of authentication and do not require a witness signature.

If casting a ballot by mail was restrictive before the pandemic, now Black voters had to contend with changing laws that impacted whether their vote would be counted or spoiled. Legislation aimed at reducing voter fraud created designs that confused, taxed, or discouraged voters from participating in the election. Requiring voters to provide multiple signatures, navigating confusing security sleeve or envelope mailing instructions, or large blocks of legalese or oaths that distract readers from key information created negative results. This multistep process, depending on the state, changed or went through lengthy legal contestations throughout 2020. The product was an error-prone, time-consuming, and frustrating voter experience.

Inefficient Application Correction and Cure Process

Many studies, both historic and current, have shown that the ballots of Black voters are rejected at higher rates than those of white voters. The 2020 election was no different. Nationwide, voters were bombarded with information about shifting vote by mail eligibility, how to request and cast a ballot, and how to verify that their vote had been counted—all integral steps to the vote by mail process. A culmination of poor voter information design and shifting legal requirements resulted in a significant number of errors with voter materials. Due to a lack of information about who qualified to vote by mail, what information is needed, or even when to return their ballot, Black voters faced higher ballot rejection nationwide.

Regardless of the state, the majority of ballot rejections are due to signature issues, even in states like Nevada and Washington, both *all mail* election states. Meaning when all voting is conducted by mail, Black voters had their ballots rejected at a higher rate. These high rates of rejection are largely due

to deficient signatures. When voters complete a voter registration application, their signature is included as part of their voter record. This signature is matched against the voter's signature on the ballot. If the signature does not match, the ballot is flagged for potential rejection. Research from organizations like the American Civil Liberties Union affirms that signature verification laws negatively impact disabled, minority, and transgender voters, and ultimately fail to prevent vote tampering.[70]

Restrictive laws create a low barrier for rejection, while faulty service and information design ensure voters remain confused and guessing whether their application for a ballot or the ballot itself will be returned, or worse, not counted altogether. By creating better instructions for voters, information design could have better informed voters about what information was needed, what could cause their ballot to be rejected, and how to return their ballot if rejected.

In addition to poor service and information design about vote by mail applications and ballots, Black voters were negatively impacted by insufficient cure processes. In the fifteen states that did allow ballot curing in 2020, Black voters faced confusion, hurdles, and rejection. Overall, Black voters in states that allowed ballot curing were negatively impacted by the process's design. While researching cures during the 2020 election, I learned more about how inadequate information and service design contributed to disenfranchisement.

Laws that outline voter communication related to the cure process are often vague and lack clear directions for how voters should be informed. For example, the Georgia Election Code reads, "If the ballot is rejected, the voter is promptly notified of the rejection." Florida Code statute 101.68 states that "county election supervisors shall notify any voter whose signature is missing or doesn't match records." Neither statute outlined the manner and method of voter communication. Thus it is frequently up to each election official to design and execute their cure notification process. These processes varied, and depended on time and resources. Local election clerks used one or multiple methods to contact voters, each with its limitations. These methods include letters, postcards, SMS text, news outlets, email, and phone calls. This list seems exhaustive, but in reality, Black voters were underinformed about their right to a cure and the cure process.

A well-designed cure process should attempt to reach voters using multiple modes of communication. This can include voice mails, emails, letters, and text messages. Several of the offices I have worked with allowed voters to cure missing addresses or identification numbers by sending a picture of their identification via text or email. Furthermore, well-designed cure information must include dates for when the correspondence was sent and when the issue must be corrected. Especially during times when the postal service was slow, voters found information about deadlines and dates particularly important.

Finally, the communication must inform voters why their ballot was rejected and what they need to do to correct the error. Many of the cure messages I have reviewed do not give voters enough information. They may require a voter to visit an election clerk's office, but give vague reasons for why their vote was rejected. Some letters were missing key information, failing to inform voters of a limited window to cure their ballot. In many cases, it was not until after the election that some voters were informed that their ballot went uncounted.

Well-Designed Disinformation

A culmination of changing laws, COVID fatigue, anger over the death of Black people at the hands of police, and a lack of voter engagement by election offices created a culture of fear, mistrust, and an information vacuum. With no clear protocols and design-focused educational outreach or engagement for Black voters, voter suppression in the form of misinformation flourished.

The use of misinformation to discourage Black voters is not a new practice. Throughout the 2016 and 2018 election cycles, Black voters were targets of disinformation campaigns.[71] Intending to discourage Black voter participation, the campaigns are increasingly accurate and reflect a level of research. Relying on base stereotypes along with legitimate economic and social concerns, the disinformation was well scripted. Using Black voters' well-founded concern about the integrity of their votes as well as fatigue over COVID and the extrajudicial killing of Black people, political disinformation seemed designed to speak to the concerns of Black voters.[72]

Notable examples of this were robocalls initiated by right-wing disinformation content creators Jacob Wohl and Jack Burkman. They used prerecorded calls from a fictional Black organization to discourage Black voter participation and encourage suspicion of voting by mail. The two were found guilty of voter intimidation in multiple states and fined by the Federal Communication Commission. A press release from the Office of the New York State Attorney General accused the two of "orchestrating robocalls to threaten and harass Black communities through disinformation."[73] Wohl and Burkman's robocalls consisted of the following message:

> Hi, this is Tamika Taylor from Project 1599, the civil rights organization founded by Jack Burkman and Jacob Wohl. Mail-in voting sounds great, but did you know that if you vote by mail, your personal information will be part of a public database that will be used by police departments to track down old warrants and be used by credit card companies to collect outstanding debts? The CDC [Centers for Disease Control] is even pushing to use records for mail-in voting to track people for mandatory vaccines. Don't be finessed into giving

your private information to the man, stay safe, and beware of vote by mail.[74]

The type of messaging used in Wohl and Burkman's robocalls reflected the concerns of many Black Americans, making myth busting and voter education a challenge. Election officials and some campaigns were taxed with communicating accurate information promptly with limited resources. Constrained by budgets, time, mistrust, knowledge gaps about how to communicate such a complex process, and general social upheaval related to the pandemic, voting rights advocates and many election officials alike fought to educate voters as well as restore their faith in the integrity of the vote throughout the 2020 primary and general elections. Opponents of democracy, however, bombarded Black voters with disinformation at an unparalleled rate. With seemingly unlimited resources, campaigns aimed at dissuading Black voters from using vote by mail options utilized robocall, digital, mail, and print advertisements.

Working to Fill the Information and Service Design Gap

Advocates and creatives have worked tirelessly to educate the public while pushing for policies that promote better, more responsive services and information. Using best practices in information and service design, national and local voting rights and community-focused organizations combated voter suppression and continued the fight to make voting more convenient. Notable instances of this include Wide Eye's 2020 Digital March on Washington and Black Girls Vote's Party at the Mailbox.

Black Girls Vote partnered with designers at the Maryland Institute College of Art to create Party at the Mailbox. Launched in April 2020, Party at the Mailbox made the vote by mail experience interactive and relevant. Residents of Atlanta, Baltimore, Philadelphia, and Detroit received a brightly colored box with stickers, voter guides, and instructions on how to successfully request and submit their ballot. The participants were encouraged to share pictures and videos of their Party at the Mailbox with friends, families, and neighbors.

Black Girls Vote's approach to service and information design is community, centered. First, the campaign recognizes the ritual of in-person voting as a communal act in many Black communities. In fact, many Black voters' steadfast belief in voting in person hampered voter turnout during the 2020 election cycle. Fears of election fraud, including mistrust of voting by mail, resulted in many Black voters choosing to forgo the election altogether. Moreover, Black voters liked voting in person, seeing it as "a powerful act, both symbolic and substantive."[75] Party at the Mailbox and the Digital March on Washington draw on the idea of voting as a communal act, and provided much-needed information and a context familiar to some Black voters. These campaigns are aimed at assisting voters and educating them about the process.

Some community organizations and election offices have understood the importance of increasing information and service design in the election process. Even incremental changes in this area to better communicate to voters would expand voter access in states with restrictive laws. I firmly believe that electoral politics alone cannot bring about the larger changes needed to create a more equitable and just country. Yet I also believe that those who choose to exercise their franchise should be able to do so easily, without misinformation, intimidation, or confusion. Bad laws and policies that focus on security were upheld by bad design, creating a dangerous precedent for future elections. Through increased service and information design revolving around community information needs, election offices can increase Black voter trust and turnout.

Biography

Asher Kolieboi is an organizer and community-centered design researcher focused on identity, trust, and safety. He currently works as a design researcher at the Center for Civic Design. Kolieboi leverages his almost twenty years of experience as an LGBTQ rights and racial justice organizer to bring a unique lens to service design and design research. He holds a bachelor of arts in sociology and women's studies from the University of Missouri, master of divinity from Vanderbilt University, and master of science in interaction design and information architecture from the University of Baltimore.

Amplifying Accessibility and Abolishing Ableism: Designing to Embolden Black Disability Visual Culture

Jennifer White-Johnson

This work is dedicated to all the Black disabled, crip, neurodivergent, chronically ill, mad humans out there.

While writing, I had the pleasure of being asked to be a part of *Deem* journal's "Envisioning Equity Panel on Neurodiversity." It was beautiful to share space with other neurodivergent Black, Indigenous, and creatives of color who are combating their own internalized ableism as well as the ableism that continues to exist in creative and corporate spaces. How we use our own unique strategies and methodologies amplifying disability and access was at the heart of the conversation.

As a Black creative, I continue to grapple with my own understanding and discovery of what being neurodivergent means to me and for the culture of Black design. I keep a copy of my attention deficit hyperactivity disorder (ADHD) trait flash cards next to me created by Rachel Idowu, who runs the amazing ADHD advocacy collective AdultingADHD. Rachel is a Black woman who also lives with ADHD and was diagnosed in her late twenties. The flash cards list ADHD traits and tips that can help me manage what I live with on a daily basis, such as hyperfocusing, hypermobility, procrastination, getting easily distracted, dealing with rejection sensitive dysphoria, difficulty sustaining attention, and more. I procrastinated heavily when attempting to write this, constantly thinking about how I could make this contribution different from others I had written before about this same topic.

During the *Deem* panel, our moderator, Dr. Yewande Pearse, who's written extensively on the practice of equitable science and the neurodiversity paradigm, asked us to reflect on the following: "Language can be limiting but when challenged, can free us. I've found the concept of neurodiversity and the term 'neurodivergent' liberating, but only after really struggling to grasp what it means because in many ways, neurodiversity is a departure from definition. What does neurodiversity mean to you?"[76]

For me, neurodiversity means embracing that your bodymind can be a radical space of softness and resistance at the same time. In the traits I listed above that define my ADHD, I have to remember that as Audre Lorde said, "We don't live single-issue lives."[77] To me this means that we can accept the authenticity of pain and pleasure as power. I believe we can build, create, and exist in our own worlds that have been deemed inaccessible to us. We can be unapologetically disabled and demand that the world be made accessible to us.

As I continue to understand my needs, I can continue to challenge the definition of *normal*, knowing that there is no such thing as a normal brain. I believe *normal* is an ableist social construct. The concept of neurodivergence should push back against the idea of "the broken and disordered brain," holding space for self-acceptance instead of fear.

Our *Deem* conversation continued with talking about the concept of neurodiversity, and its implications in shaping conditions for equity, why we think it is important to make the distinction between equity and equality as it pertains to neurodiversity, and what equity looks like to us. Equality does not end with gender and race; equality needs to embody an equitable space for access as we exist as folks with different disabilities, especially for those of us who live with invisible disabilities, and often diagnoses like ADHD and autism come later in life for many Black women.[78] A recent study by the Center for American Progress revealed that Black disabled women and girls experience economic insecurity at higher rates frequently due to job loss and subminimum wages—as low as $2.13 per hour.[79] Aside from living as disabled in creative,

corporate, and academic spaces with invisible disabilities, Black women and disabled bodies are frequently demonized or coddled. We are often spoken over or subject to erasure, with our work uncredited and appropriated.

We also know the educational system is not always fair, accepting, or equitable when a ten-year-old autistic girl like Isabel Trichenor can be bullied day after day by her teacher and classmates just because she is autistic. Isabel, also known as "Izzy," died by suicide as a result of alienation and the racist, ableist behaviors of others. Her environment should have been a safe space for her to thrive in. These oppressive spaces should make us want to advocate for resources that are built by Black and brown disabled communities that are already putting in the work to uplift our most vulnerable and oppressed people. We really need to commit to asking ourselves, Whose Black/brown futures are we really saving? Do their lives hold less value than able-bodied folks? We do not hear these stories until it is too late. Imagine what our world would look like if we centered and celebrated Black disabled joy in design spaces and communities that often view our body, mind, and talent as disposable. Equity means not investing solely in capitalist and ableist notions of productivity but in collective care, access, and leadership opportunities for those most impacted by these oppressive systems too.

Being open with myself and acknowledging the strength in communal care has allowed my creative practice to thrive. Holding space for accessible teaching and choosing to disclose my neurodivergence to my students has also opened up levels of transparency as well as care between us that I frequently haven't experienced in academic spaces. Validating self-diagnosing and not being afraid to be vulnerable has permitted me to find strength in those vulnerabilities. Seeing and accepting similarities between myself and my child, while I was often viewed as "too much" when I was an expressive young Afro-Latina kid, has allowed my son to be free in a way that I was was not confident growing up.

My creative practice continues to draw inspiration from my own autistic son's creativity and playfulness. This paved the way for me to create my first photo zine, which served as a love letter to Black autistic and neurodivergent families like my own. I felt showcasing my own family's journey and the perspective of my son's diagnosis could serve as a catalyst for change.

I continue to see so much of myself in him, thereby allowing me to understand my disability even more. Reclaiming visual narratives and breaking the stigma of my son's autistic joy using photography and design has allowed me to highlight what I typically don't see depicted in the media. The importance of portraying his joy increases visibility in the lives of Black autistic kids. It is beautiful and luminous to show the world that being autistic isn't something to be ashamed of, demonstrating that being your true authentic self is a form of resistance. This design process has allowed me to continue creating dialogue

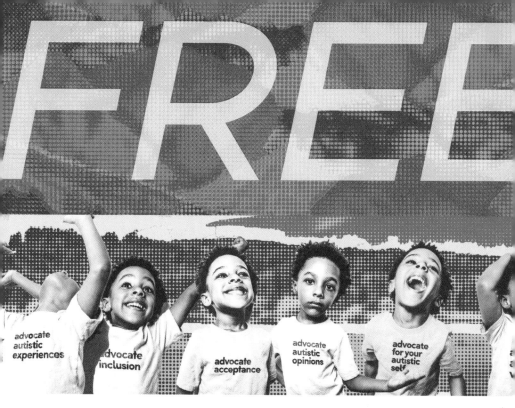

KnoxRoxs Freedom. Risograph print by Jennifer White-Johnson, 2022.

between myself and other neurodivergent families by highlighting my son's ability to experience disability joy. Creating art to combat ableism and racism is my family's ultimate liberatory practice.

For instance, in the image here—a riso print colored with hues of blue, purple, and pink halftones—a five-year-old Black autistic boy is smiling. There are six different collaged photographs of Knox wearing T-shirts that say "advocate for autistic voices," "advocate for autistic opinions," "advocate acceptance," "advocate inclusion," and "advocate autistic experiences."

Often the neurodiverse community is excluded from artistic narratives and creative spaces, and thus we gladly create our own, taking ownership of our stories and telling them how we choose to tell them—unfiltered and honest. I also run an online disability advocacy shop that includes antiableist poster designs, zines, access to protest art resources, and more. The designs have become essential conversation starters that help to shift and disrupt justice stigmas while encouraging helpful dialogue for educators, parents, and families. In my zine-making workshops, all ages can engage in accessible, authentic storytelling and mess making.

Whether or not we choose to disclose our disabilities in the workplace, masking them in design spaces is never the answer. When we cannot thrive in creative spaces that are not built or made for us, we need to challenge those ableist systems and construct our own. As I continue to be active within the neurodiversity community and disability design justice space, I want to leave you with perspectives that have helped me on my own personal neurodivergent journey.

Combating Anti-Blackness and Antiableism in the Design Community

Follow the Work and Wisdom of Black Disabled Creators, Scholars, and Ancestors

Following the work of the most impacted and those who share their lived experience stories are the best folks to learn from. Honoring our radical Black and disabled revolutionary ancestors like Harriet Tubman, Fannie Lou Hamer, Audre Lorde, and Brad Lomax can illuminate how our past continues to inform our present and future.

Share Information

Share your vision for what kind of design future you want to see and help facilitate it if you can. By info dumping or sharing resources, your ideas don't have to exist in a vacuum.

When Feeling Excluded, Aim to Create and Cocreate Your Own Spaces of Creative Resistance

The charity model of disability is not always the best place to find a community that will uplift you. Pay attention to the spaces that nondisabled communities promote and what or who they fund; this will reveal if they are true accomplices.

Validate Self Diagnosing

Not all folks have access to equitable health care and the funds it takes to receive a medical diagnosis. Please do not invalidate or rank anyone else's disability over another's.

Follow and Incorporate the Ten Principles of Disability Justice in Your Design Spaces When Working with the Disability Community

These principles, as developed by Patty Berne of Sins Invalid, are intersectionality, leadership of the most impacted, anticapitalist politics, commitment to cross-movement organizing, recognizing wholeness, sustainability, commitment to cross-disability solidarity, interdependence, collective access, and collective liberation.[80]

Look for Disability Solidarity Statements from So-called Allied Spaces

In the words of disability justice consultant Christiana Obeysumner, "If your statement isn't backed with a Black-led and designed plan, strategy, or history of acting and doing the anti-racist systems work—starting in the organization itself—it is a barrier to inclusion and progress and an even larger part of the problem."[81] How is disability talked about in your organization or community?

Make Sure Your Organization Does an Internal Audit to Uplift Disability Communities That Work in Your Space

How many disabled people are working in your organization? How do you know this? How many of those folks are in leadership? Do you know how they feel about the ways that they are supported in their disabled and access needs? Is there a method for checking in about this regularly? How many of the disabled, deaf, and neurodivergent people in your organization (including you) are involved in disability organizing, culture, community, and so on?[82]

To be Proneurodiversity Is to Be Anti-Racist

How are folks in your organization impacted by ableism and anti-Blackness? Antiableist practices in our communities and the workplace must be dismantled. The barriers and structures of ableist oppression will do nothing but hold us back from survival and progress. Black disabled folks must be put in leadership and paid high enough to close the wealth gap.

Holding Space for Equitable and Accessible Design Cultural Creative Practices in the Black Design Community

If you are looking to integrate more pro-Black and antiableist ideologies into your design practices, here are a few Black, disabled, and advocate-led design cultural spaces, organizations, and people you should know about.

Lavant Consulting was founded by Black and disabled advocate Andraea Lavant. It is a social impact communications firm that offers cutting-edge corporate development and content marketing for brands and nonprofits. Lavant's firm often posts helpful Instagram stories on how to hold accessible online events by advocating for American Sign Language interpreters and Communication Access Realtime Translation captioning, and how to properly add alt text to images and more.

The Keri Gray Group founded by Keri Gray advises young professionals, businesses, and organizations on issues around disability, race, gender, and intersectionality. Gray illustrates how the framework of intersectionality is essential to true inclusion.

Ramp Your Voice! by Villisa Thompson is a disability rights and consultation and advocacy organization that promotes self-advocacy and empowerment for disabled people.

Sabeera Najee is a Black and disabled DJ doing amazing work with Accessible Festivals, which creates safe and accessible spaces as well as programs for disabled artists and creatives to enjoy the festival experience.

Jillian Mercado is a disabled model, actor, and the creator of Black Disabled Creatives. Mercado's initiative started in alliance with the Black disabled community, bridging the divide between hiring spaces and disabled folks who are tired of being underrepresented as well as underappreciated.

Regine Gilbert is a design educator whose areas of research focus are digital accessibility, inclusive design, and immersive experiences. In 2019, Gilbert's first book, *Inclusive Design for a Digital World: Designing with Accessibility in Mind*, was released through Apress publishing.

Vivianne Castillo is the founder and CEO of HmntyCntrd, an award-winning professional growth community supporting user experience and tech professionals in transforming the status quo of what it means to be human centered in their professional and personal lives through courses, community, and consulting.

Teri Henderson is the author of *Black Collagists*, which uplifts collage as an improvisational art form similar to disabled lives—existing and creating with whatever resources they have.

ChrisTiana ObeySumner is the principal social equity consultant and CEO for Epiphanies of Equity Education and Consulting.

Rachel Iduwo is an ADHD advocate and founder of Adulting with ADHD.

Crystal Preston-Watson is an accessibility engineer who believes that accessibility is a civic and human right. Preston-Watson is passionate about building accessible and inclusive applications for everyone.

Krip Hop Nation is an international Black disability art and culture collective.

Talila A. Lewis is a social justice engineer, educator, organizer, attorney, and artist.

Black Disability Collective is a Minnesota-based Black disability-led advocacy network providing support, mutual aid, and camaraderie for the Black and disabled community.

Disabled in Higher Ed is a nonprofit aiming to create a higher education where disabled people not only exist but also thrive.

Biography

Jennifer White-Johnson (she/her/they/them) is an artist and design educator whose creative practice and parent/child advocacy work is rooted in neurodiversity and autism acceptance/advocacy in Black and brown families. Reclaiming visual narratives and breaking the stigma of her son's autistic and her own ADHD/anxiety journeys, she uses photography, collage, and design as a space for visual activism, highlighting what she often doesn't see depicted in media, art, and design. You can find her on Instagram and Twitter @jtknoxroxs.

BLACKNESS IS ESSENTIAL TO DESIGN

Epilogue

Terresa Moses and Omari Souza

We hope that after reading through the contributions of these radical Black thought leaders, intellectuals, designers, creatives, entrepreneurs, and educators, you have a newfound joy and love for Blackness in design. It is gritty, unapologetic, sorrowful, bright, and filled with a (partial) spectrum of nuance and beautifully designed intersections of identity.

Blackness is an essential and foundational part of design that if intentionally explored, can create opportunities to progressively move the design industry forward. The design industry cannot expect change with minimal effort and lip service. We need a creative overhaul that opens up communal ways of being that consider those who are least considered, not only in our design outcomes, but our workplaces, educational institutions, and policies.

Blackness, race, and racism are not bad words. They should be mentioned in every classroom and critically explored in hopes of creating anti-racist solutions. Educators create the curriculum in the classroom, so it is the educator's responsibility to do their own homework if we ever hope to see pro-Black pedagogy. We cannot expect Black communities to attend institutions that are offended by the very existence of Blackness.

By now, we trust you know that anti-Blackness will not go down without a fight. And because we understand anti-Blackness to be so pervasive, designers have the opportunity to create and shift cultural narratives that center Black experiences and establish room for positive change in our communities. We have committed ourselves to the work of uplifting and finding space for Black existence without the threat of violence, harm, invalidation, and aggression. It is our hope that this contribution—among many from Black designers—to the design industry begins to open up opportunities for new and innovative ways to cultivate the value of Black lives.

Acknowledgments

Terresa Moses and Omari Souza

We joyfully thank our amazing contributors, who add untold value to the design field. Without your contribution to this anthology, we would not have been able to write and visualize the breadth of Blackness in design; thank you.

We would like to thank our peers engaged in the work of centering intersectional Blackness as well as contributing to anti-racist and Black liberatory work. In addition to our contributors, we are inspired by so many of you whose work influences our writings: Emory Douglas, Cheryl D. Miller, Maurice Cherry, and Timothy Bardlavens.

We would like to acknowledge Terresa Moses and Blackbird Revolt for their contribution to the book design and biography illustrations throughout this work. We also want to thank our editor, Victoria Hindley, and the entire team at the MIT Press for their willingness to work with us to craft something unusual, creative, and meaningful.

And to the readers of this work, thank you for engaging with us.

From Terresa: To my ancestors, the historical abolitionists and freedom fighters, it is because of your dedication to our collective liberation that I am here today. My abilities, contributions, and successes in this world are inspired and activated by what you have done for me and my community. To my mother, family, friends, fellow organizers, and mentors—thank you for your encouragement, critique, help, and the inspiration to keep going in the struggle.

From Omari: To my mother, father, siblings, cousins, and my two sons. To Ken, Larrie, Jessica, Sanda, my professors at Kent State University, Nwaka Onwusa, and Skyller Walkes. And to my dear friends Duwain Pinder, Tim Mwangi, Derrick Moore, Edward Hunter, Evan Artist, Philip and Patricia White, Babajide Falae, Nate and Kelli Williams, Pastor Jason Drayton, Lewis Burrell, and Garrett Kisner.

NOTES

1. Black Design Industry + Organizations

1 Micah Bowers and Miklos Philips, "Art vs Design: A Timeless Debate," *Toptal*, accessed May 17, 2022, https://www.toptal.com/designers/creative-direction/art-vs-design.

2 Aleksandra A. W. Dopierala and Lauren L. Emberson, "Cognitive Development: Looking for Perceptual Awareness in Human Infants," *Current Biology* 32, no. 7 (2022): R322–R324, accessed May 17, 2022, https://doi.org/10.1016/j.cub.2022.02.045; Emory Richardson and Frank C. Keil, "Thinking Takes Time: Children Use Agents' Response Times to Infer the Source, Quality, and Complexity of Their Knowledge," *Cognition* 224 (July 2022), doi:10.1016/j.cognition.2022.105073.

3 Clay Paul Greene, "The Preexistence of the Soul in the Early English Enlightenment: 1640–1740" (PhD diss., Yale Graduate School of Arts and Sciences, 2021), https://elischolar.library.yale.edu/gsas_dissertations/243.

4 Steve Olson, Kate Berg, Vence Bonham, Joy Boyer, Larry Brody, Lisa Brooks, Francis Collins, et al., "The Use of Racial, Ethnic, and Ancestral Categories in Human Genetics Research," *American Journal of Human Genetics* 77, no. 4 (2005): 519–532, https://doi.org/10.1086/491747.

5 Jesper Hoffmeyer, *Biosemiotics: An Examination into the Signs of Life and the Life of Signs* (Scranton, PA: University of Scranton Press, 2009).

6 Gilles Deleuze and Félix Guattari, *A Thousand Plateaus: Capitalism and Schizophrenia* (London: Athlone Press, 1988), 170.

7 Marshall McLuhan, *Understanding Media: The Extensions of Man* (Cambridge, MA: MIT Press, 1994), 69.

8 Derrick Bell, *Faces at the Bottom of the Well: The Permanence of Racism* (New York: Basic Books, 1992).

9 African American Graphic Designers, last modified 2022, https://aagd.co.

10 "Consent Is Accountability," YouTube, October 25, 2019, https://www.youtube.com/watch?v=ibFFQsNGK9Q.

11 R. Keith Sawyer, *Group Genius: The Creative Power of Collaboration* (New York: Basic Books, 2008).

12 W. E. B. Du Bois, "Criteria of Negro Art," *The Crisis* 32 (October 1926): 290–297, http://www.webdubois.org/dbCriteriaNArt.html.

13 Antionette D. Carroll, "Developing Our Perspectives," Creative Reaction Lab Worksheet and Educational Module, in author's possession, 2019.

14 David Carson, "Don't Mistake Legibility for Communication," TED, 2003, https://www.ted.com/talks/david_carson_design_and_discovery.

15 IBM Corporation, "IBM Design Thinking Field Guide," 2018, https://www.ibm.com/cloud/architecture/files/design-thinking-field-guide.pdf.

16 Google Design, "Be Counted: 2019 Design Census," Google.com, 2019, Designcensus.org.

17 Joanne (@leafjooce), "White Colonizers Have Looted," Twitter, 2019.

18 Kenneth Jones and Tema Okun, "Dismantling Racism Works Web Workbook," dismantlingRacism.org, 2001.

19 Ashley Lugo, "White Supremacy Culture in Professional Spaces Is Toxic—to Dismantle It, We Must First Be Willing to Name It!," Community Centric Fundraising, September 8, 2020, https://communitycentricfundraising.org/2020/09/08/white-supremacy-culture-in-professional-spaces-is-toxic-to-dismantle-it-we-must-first-be-willing-to-name-it/.

20 Jones and Okun, "Dismantling Racism."

21 Jo Szczepanska, "Design Thinking Origin Story Plus Some of the People Who Made It All Happen," Medium, January 3, 2017, https://medium.com/@szczpanks/design-thinking-where-it-came-from-and-the-type-of-people-who-made-it-all-happen-dc3a05411e53.

22 Jennifer Joy Butler, "How Accountability Will Lead You to Heal and Move On," *Worthy*, April 18, 2018, https://www.worthy.com/blog/divorce/healing/accountability/.

23 Creative Reaction Lab, "Redesigners for Justice: The Leaders We Need for an Equitable Future," Medium, September 23, 2109, https://medium.com/equal-space/redesigners-for-justice-the-leaders-we-need-for-an-equitable-future-d3a73459ba60.

24 Jacinda N. Walker, "Design Journeys: Jacinda Walker on Diversity in Design Education," AIGAdesign, June 20, 2017, https://www.youtube.com/watch?v=rjKCsyFn6DA.

25 Peter B. Levy, "George C. Wallace, 'Inaugural Address'" (1963), in *The Civil Rights Movement: A Reference Guide*, 2nd ed. (Santa Barbara, CA: ABC-CLIO, 2019), 202–206, accessed July 26, 2022, https://link.gale.com/apps/doc/CX7783200047/GVRL?u=umn_wilson&sid=bookmark-GVRL&xid=21f0be77.

26 Tinsley E. Yarbrough, "The Schoolhouse Door: Segregation's Last Stand at the University of Alabama (review)," *Southern Cultures* 2, no. 1 (1995): 122–124, https://doi.org/10.1353/scu.1995.0062.

27 Peter B. Levy, "From John F. Kennedy, 'Address on Civil Rights'" (1963), in *The Civil Rights Movement: A Reference Guide*, 2nd ed. (Santa Barbara, CA: ABC-CLIO, 2019), 206–209, accessed July 26, 2022, https://link.gale.com/apps/doc/CX7783200048/GVRL?u=umn_wilson&sid=bookmark-GVRL&xid=0e74a711.

28 Tami J. Friedman, "Young, Whitney M., Jr.," in *Encyclopedia of African-American Culture and History*, ed. Colin A. Palmer, 2nd ed. (Detroit: Macmillan Reference,2006), 2349–2351, accessed July 26, 2022, https://link.gale.com/apps/doc/CX3444701342/GVRL?u=umn_wilson&sid=bookmark-GVRL&xid=73dca5a3.

29 Whitney Young Jr., "Breaking the 'Thunderous Silence,'" 50 Years after Whitney Young Jr., accessed July 26, 2022, https://www.50yearsafterwhitneyyoung.org/introduction-aia-and-whitney-young.

30 Shirley Anne Tate, "Racial Affective Economies, Disalienation and 'Race Made Ordinary,'" *Ethnic and Racial Studies* 37, no. 13 (2014): 2475–2490, https://doi.org/10.1080/01419870.2013.821146..

31 Steve Baty, "Solving Complex Problems through Design," *Interactions* 17, no. 5 (2010): 70–73, https://doi.org/10.1145/1836216.1836235.

32 Horst W. J. Rittel and Melvin M. Webber, "Dilemmas in a General Theory of Planning," *Policy Sciences* 4, no. 2 (1973): 155–169, https://doi.org/10.1007/BF01405730.

33 Richard Buchanan, "Wicked Problems in Design Thinking," *Design Issues* 8, no. 2 (1992): 5–21, https://doi.org/10.2307/1511637.

34 Rittel and Webber, "Dilemmas in a General Theory of Planning."

35 Jacinda N. Walker, "Design Journeys: Strategies for Increasing Diversity in Design Disciplines" (master's thesis, Ohio State University, 2016), http://rave.ohiolink.edu/etdc/view?acc_num=osu1469162518.

36 Walker, "Design Journeys."

37 G. T. Doran, "There's a SMART Way to Write Management's Goals and Objectives," *Management Review* 70 (1981): 35–36.

38 Reni Eddo-Lodge and ProQuest, *Why I'm No Longer Talking to White People about Race* (London: Bloomsbury Publishing, 2018).

39 Trina C. Olson and Alfonso T. Wenker, *Hiring Revolution: A Guide to Disrupt Racism and Sexism in Hiring* (Minneapolis: Wise Ink Creative Publishing, 2021); Gina Torino, "How Racism and Microaggressions Lead to Worse Health," Center for Health Journalism, accessed May 30, 2022, https://centerforhealthjournalism.org/2017/11/08/how-racism-and-microaggressions-lead-worse-health; "The Detrimental Effects of Microaggressions," *Psychology Today*, October 5, 2020, accessed May 30, 2022, https://www.psychologytoday.com/us/blog/evidence-based-living/202110/the-detrimental-effects-microaggressions; "Physiological and Psychological Impact of Racism and Discrimination for African-Americans," American Psychological Association, accessed May 30, 2022, https://www.apa.org/pi/oema/resources/ethnicity-health/racism-stress.

40 "Jim Crow of the North," *Almanac*," episode 23, Public Broadcasting Service, 2019.

41 Sojourner Truth, "Ain't I A Woman?," speech presented at the Women's Rights Convention, Old Stone Church [since demolished], Akron, Ohio, 1851.

42 Rebecca Hodes, "The 'Hottentot Apron,'" in *Global History of Sexual Science, 1880–1960,* ed. Veronika Fuechtner, Douglas E. Haynes, and Ryan M. Jones (Oakland: University of California Press, 2017), 118–138, https://doi.org/10.1525/california/9780520293373.003.0006.

43 Hodes, "The 'Hottentot Apron.'"

44 Hodes, "The 'Hottentot Apron.'"

45 Janell Hobson, "The 'Batty' Politic: Toward an Aesthetic of the Black Female Body," in *Venus in the Dark: Blackness and Beauty in Popular Culture* (New York: Routledge, 2018), 87–112, https://doi.org/10.4324/9781315299396-4.

46 Carla Williams, Deborah Willis, and Sander Gilman, "The Hottentot and the Prostitute: Toward an Iconography of Female Sexuality," in *Black Venus 2010: They Called Her "Hottentot"* (Philadelphia: Temple University Press, 2010), 15–32.

47 Williams, Willis, and Gilman, "The Hottentot and the Prostitute."

48 Balasz Takac,"The Controversy behind Édouard 'Manet's Olympia Masterpiece," *Widewalls,* October 28, 2018, https://www.widewalls.ch/magazine/edouard-manet-olympia.

49 Takac, "The Controversy behind Édouard Manet's Olympia Masterpiece."

50 Takac, "The Controversy behind Édouard Manet's Olympia Masterpiece."

51 Lorraine O'Grady, "Olympia's Maid: Reclaiming Black Female Subjectivity," in *Art, Activism, and Oppositionality: Essays from Afterimage,* ed. Grant H. Kester (Durham, NC: Duke University Press, 1998), 268–286, at 269, https://doi.org/10.1215/9780822396109-016.

52 Jean-Paul Goude, *Jungle Fever* (London: Quartet Books, 1982).

53 Christina Montford, "Fetishism of Black Women in Mainstream Culture Continues to Rage, Helped Along by Celebrities," *Atlanta Black Star,* December 6, 2014, https://atlantablackstar.com/2014/12/06/fetishism-black-women-mainstream-culture-history-future.

54 Telusma, Blue. "Kim Kardashian Doesn't Realize She's the Butt of an Old Racial Joke," TheGrio, November 12, 2014, https://thegrio.com/2014/11/12/kim-kardashian-butt.

55 Marita Sturken and Lisa Cartwright, *Practices of Looking: An Introduction to Visual Culture* (New York: Oxford University Press, 2018).

56 Nadine Dornieden, "Leveling Up Representation: Depictions of People of Color in Video Games," Public Broadcasting Service, December 22, 2020, https://www.pbs.org/independentlens/blog/leveling-up-representation-depictions-of-people-of-color-in-video-games/#:~:text=Some%20may%20be%20surprised%20to,teens%20not%20too%20far%20behind.

57 J. Clement, "Global Game Developer Ethnicity 2021," Statista, August 19, 2021, https://www.statista.com/statistics/1127374/game-developer-ethnicity-worldwide/.

58 Josh Sanburn, "Ferguson Grand Jury Evidence: Darren Wilson Calls Michael Brown Demon," *Time,* November 25, 2014, https://time.com/3605346/darren-wilson-michael-brown-demon/.

59 Tom Wijman, "The Games Market and beyond in 2021: The Year in Numbers," Newzoo, December 22, 2021, https://newzoo.com/insights/articles/the-games-market-in-2021-the-year-in-numbers-esports-cloud-gaming/#:~:text=The%20games%20market%20in%202021,%2B1.4%25%20over%20last%202020.

60 Nestor Gilbert, "Number of Gamers Worldwide 2022/2023: Demographics, Statistics, and Predictions," Financesonline.com, January 14, 2022, https://financesonline.com/number-of-gamers-worldwide/#:~:text=Statistics%2C%20and%20Predictions-,Number%20of%20Gamers%20Worldwide%202022%2F2023%3A%20Demographics%2C%20Statistics%2C,%2Don%2Dyear%20growth%20forecast.

61 Erin Blakemore, "How Dolls Helped Win *Brown v. Board of Education*," history.com, A&E Television Networks, March 27, 2018, https://www.history.com/news/brown-v-board-of-education-doll-experiment.

62 Cheryl D. Miller, "Black Designers: Missing in Action (1987)," *Print,* June 27, 2016, https://www.printmag.com/design-culture/black-designers-missing-in-action-1987/.

63 Eugene Korsunskiy, "Dismantling White Supremacy in Design Classrooms: My Conversation with Design Guru Cheryl D. Miller," Medium, May 5, 2021, https://medium.com/future-of-design-in-higher-education/dismantling-white-supremacy-in-design-classrooms-my-conversation-with-design-guru-cheryl-d-miller-5dc9c48b15e4.

64 Quoted in Dorothy Jackson, "The Black Experience in Graphic Design: 1968 and 2020," Letterform Archive, July 8, 2020, https://letterformarchive.org/news/view/the-black-experience-in-graphic-design-1968-and-2020.

65 Google Design, "Be Counted: 2019 Design Census," Google.com, 2019, Designcensus.org.

66 Cheryl D. Miller, "Transcending the Problems of the Black Graphic Designer to Success in the Marketplace" (master's thesis, Pratt Institute, 1985), https://searchworks.stanford.edu/view /tr623tv1100.

67 Sylvia Harris, "Searching for a Black Aesthetic in American Graphic Design," accessed May 31, 2021, https://readings.design/PDF/harris-blackaesthetic.pdf.

2. Black Design Pedagogy

1 Ashley A. Smith, "Students at California's Top-Tier Universities Don't Reflect State's Racial and Ethnic Diversity, Says Urban Institute Study," EdSource, July 10, 2020, https://edsource .org/2020/students-at-californias-top-tier-universities-dont-reflect-states-racial-and-ethnic -diversity-says-urban-institute-study/635332.

2 bell hooks, *Teaching to Transgress: Education as the Practice of Freedom* (New York: Routledge, 1994).

3 Beverly Daniel Tatum, *Why Are All the Black Kids Sitting Together in the Cafeteria?: And Other Conversations about Race*, twentieth anniversary ed. (New York: Basic Books, 2017).

4 Anibal Quijano, "Coloniality of Power and Eurocentrism in Latin America," *International Sociology* 15, no. 2 (2000): 215–232.

5 Christopher Alexander, *Notes on the Synthesis of Form* (Cambridge, MA: Harvard University Press, 1964), 5:54.

6 Pierce Otlhogile-Gordon, "Designer, You Can't Control the Future," Medium, April 6, 2021, https://medium.com/thinkrubix/designer-you-cant-control-the-future-53fdb9cd485f.

7 Darin Buzon, "Design Thinking Is a Rebrand for White Supremacy," Medium, March 2, 2020, https://dabuzon.medium.com/design-thinking-is-a-rebrand-for-white-supremacy -b3d31aa55831.

8 Zeus Leonardo, "The Color of Supremacy: Beyond the Discourse of 'White Privilege,'" *Educational Philosophy and Theory* 36, no. 2 (2004): 137–152.

9 Kyoko Kishimoto, "Anti-Racist Pedagogy: From Faculty's Self-reflection to Organizing within and beyond the Classroom," *Race Ethnicity and Education* 21, no. 4 (2018): 540–554.

10 April Warren-Grice, "Show Don't Tell: Decolonize Your Classroom, Syllabus, Rules, and Practices," *Liberated Genius* (blog), September 13, 2018, https://liberatedgenius.com/2018 /decolonize-your-syllabus/; Yvette DeChavez, "It's Time to Decolonize That Syllabus," *Los Angeles Times*, October 8, 2018, https://www.latimes.com/books/la-et-jc-decolonize -syllabus-20181008-story.html; Max Liboiron, "Decolonizing Your Syllabus? You Might Have Missed Some Steps," CLEAR, August 12, 2019, https://civiclaboratory.nl/2019/08/12 /decolonizing-your-syllabus-you-might-have-missed-some-steps/.

11 Joe Truss, "When My School Started to Dismantle White Supremacy Culture," NGLC, 2020, https://www.nextgenlearning.org/articles/what-happened-when-my-school-started-to -dismantle-white-supremacy-culture; Ryan Rideau and Teaching@Tufts, "Anti-Racist Teaching Resources," Teaching@Tufts, July 21, 2020, https://sites.tufts.edu/teaching/2020/07/21/anti -racist-teaching-resources/; Anamika Twyman-Ghoshal and Danielle Carkin Lacorazza, "Strategies for Anti-Racist and Decolonized Teaching," Faculty Focus: Higher Ed Teaching and Learning, March 31, 2021, https://www.facultyfocus.com/articles/equality-inclusion-and -diversity/strategies-for-anti-racist-and-decolonized-teaching/; Pirette McKamey, "How to Be an Anti-Racist Teacher," *Atlantic*, June 17, 2020, https://www.theatlantic.com/education /archive/2020/06/how-be-anti-racist-teacher/613138/.

12 Dartmouth Center for the Advancement of Learning, "Becoming an Anti-Racist Educator," 2020, https://dcal.dartmouth.edu/resources/teaching-learning-foundations/becoming -anti-racist-educator; Amie Thurber, M. Brielle Harbin, and Joe Bandy, "Teaching Race: Pedagogy and Practice," Vanderbilt University, 2021, https://cft.vanderbilt.edu/guides-sub -pages/teaching-race/.

13 Buzon, "Design Thinking Is a Rebrand for White Supremacy."

14 Eugene Korsunskiy, "Dismantling White Supremacy in Design Classrooms: My Conversation with Design Guru Cheryl D. Miller," Medium, September 1, 2020, https://medium.com/future -of-design-in-higher-education/dismantling-white-supremacy-in-design-classrooms-my -conversation-with-design-guru-cheryl-d-miller-5dc9c48b15e4.

15 Lesley-Ann Noel, A Designer's Critical Alphabet [card deck], 2020, https://www.etsy.com /listing/725094845/a-designers-critical-alphabet.

16 Tania Anaissie, Victor Cary, David Clifford, Tom Malarkey, and Susie Wise, Liberatory Design Cards [card deck], Stanford University, 2020, https://dschool.stanford.edu /resources/liberatory-design-cards.

17 Decolonial Futures, With/Out Modernity Cards [card deck], Decolonial Futures, 2019, https://decolonialfutures.net/withoutmodernitycards/.

18 Ramon Tejada, "The Decolonizing Design Reader v.4," Google Docs—Open Source Collaborative, 2021, https://docs.google.com/document/d/1Hbymt6a3zz044xF _LCqGfTmXJip3cetj5sHlxZEjtJ4/edit; Isabelle Yisak, "An Incomplete List of Resources for the Equity-Centered Designer," Medium, October 24, 2017, https://medium.com/equal -space/an-incomplete-list-of-resources-for-the-equity-centered-designer-4f57b410e606; Pierce Otlhogile-Gordon, "A Hundred Racist Designs," Medium, August 2, 2020, https://otlhogilegordon.medium.com/a-hundred-racist-designs-ff713cd5aa42.

19 Equity Meets Design, 2021, https://equitymeetsdesign.com/.

20 Silas Munro, Pierre Bowins, and Tasheka Arceneaux-Sutton, BIPOC Design History, 2021, https://bipocdesignhistory.com/.

21 Terresa Moses and Lisa Mercer, "Racism Untaught: Revealing and Unlearning Racialized Design," Racism Untaught, 2018, https://racismuntaught.com/.

22 Dark Matter University, "Vision and Mission," 2021, https://darkmatteruniversity.org /Vision-Mission.

23 Black School, "Studio: The Black School," 2021, https://theblack.school/studio/.

24 Actipedia, "Projects: Most Effective," 2021, https://actipedia.org/projects/most-effective; KATA and Molly McCue, "Examples of Inclusive Design" [Pinterest collection], Pinterest, 2020, https://www.pinterest.com/katacompany/examples-of-inclusive-design/.

25 Creative Reaction Lab, 2021, https://www.creativereactionlab.com/.

26 Philip B. Meggs, A History of Graphic Design, 3rd ed. (New York: John Wiley and Sons, 1998).

27 Sylvia Harris, "Searching for a Black Aesthetic in American Graphic Design," in The Education of a Graphic Designer, ed. Steven Heller, 3rd ed. (New York: Allworth Press, 2015), 125.

28 Meggs, A History of Graphic Design, 7.

29 "Where Is the Oldest Rock Art?," Bradshaw Foundation, accessed July 23, 2022, https://www .bradshawfoundation.com/africa/oldest_art/index.php.

30 "Hamites," Wikipedia, accessed December 16, 2022, https://en.wikipedia.org/w/index .php?title=Hamites&oldid=1096494851.

31 George A. Barton, "The Origins of Civilization in Africa and Mesopotamia, Their Relative Antiquity and Interplay," Proceedings of the American Philosophical Society 68, no. 4 (1929): 303–312.

32 Meggs, A History of Graphic Design, 11.

33 Chancellor Williams, The Destruction of Black Civilization: Great Issues of a Race from 4500 BC to 2000 AD (Chicago: Third World Press, 1987), chapter 2.

34 Williams, The Destruction of Black Civilization, chapter 11.

35 Saki Mafundikwa, Afrikan Alphabets (West New York, NJ: Mark Batty, 2004), 11.

36 Georgegarbonzo, "The Dogon Tribe and Hieroglyphics," YouTube, February 20, 2019, https://www.youtube.com/watch?v=OTdTjfa6sSw.

37 Meggs, A History of Graphic Design.

38 African Creation Energy, Supreme Mathematic African Ma'at Magic: Nine to the Ninth Power of Nine (Lulu.com, 2010), www.africancreationenergy.com.

39 Stephan C. Carlson, "Golden Ratio," in Britannica, accessed July 23, 2022, https://www .britannica.com/science/golden-ratio.

40 Carlson, "Golden Ratio."

41 Ron Eglash, African Fractals: Modern Computing and Indigenous Design, 3rd ed. (New Brunswick, NJ: Rutgers University Press, 2005), https://csdt.org/culture/africanfractals /index.html.

42 Christa Nathe and Kate Hobgood, "The Golden Ratio in Architecture," accessed July 1, 2022, http://jwilson.coe.uga.edu/emat6680fa06/hobgood/kate_files/golden%20ratio/gr%20arch .html#:~:text=The%20largest%20of%20the%20pyramids,length%20of%20the%20square %20base.&text=The%20length%20of%20the%20base%20of%20the%20pyramid%20is %20approximately%20.

43 Eglash, *African Fractals*.

44 Simona Goldin, Addison Duane, and Debi Khasnabis, "Interrupting the Weaponization of Trauma-Informed Practice: '… Who Were You Really Doing the "Saving' For?,'" *Educational Forum* 86, no. 1 (2021): 5–25, https://doi.org/10.1080/00131725.2022.1997308.

45 Natalia Ilyin, "What Design Activism Is and Is Not: A Primer for Students," in *Developing Citizen Designers*, ed. Elizabeth Resnick (London: Bloomsbury Visual Arts, 2016), 64–65.

46 Charles P. Henry, *Black Studies and the Democratization of American Higher Education* (Cham, Switzerland: Palgrave Macmillan, 2017).

47 bell hooks, *Teaching to Transgress: Education as the Practice of Freedom* (New York: Routledge, 1994).

48 Jordan Valinsky, "The Aunt Jemima Brand, Acknowledging Its Racist Past, Will Be Retired," CNN, last modified June 17, 2020, https://www.cnn.com/2020/06/17/business/aunt-jemima -logo-change/index.html.

49 Philip Bump, "Is Political Polarization Making Racial Tensions Worse?," *Washington Post*, last modified July 8, 2016, https://www.washingtonpost.com/news/the-fix/wp/2016/07/08/is -political-polarization-making-racial-tensions-worse/.

50 American Library Association, "State of America's Libraries 2022," 2022, accessed December 17, 2022, https://www.ala.org/news/state-americas-libraries-report-2022; Joe Heim and Lori Rozsa, "African Americans Say the Teaching of Black History Is under Threat," *Washington Post*, last modified February 23, 2022, https://www.washingtonpost.com/education /2022/02/23/schools-black-history-month-crt/; "President Barack Obama and Maria Ressa on Disinformation and the Erosion of Democracy," *Atlantic*, April 6, 2022, https://www.youtube.com/watch?v=guO3_7pn7FI&list=PLDamP-pfOskPqNJ -i_33pXRxXvZM_srJ0; US Department of Justice, *Report on the Investigation into Russian Interference in the 2016 Presidential Election*, vol. 1, 2019, accessed July 23, 2019, https://www.justice.gov/storage/report_volume1.pdf.

51 Robert O'Harrow Jr., Andrew Ba Tran, and Derek Hawkins, "The Rise of Domestic Extremism in America," *Washington Post*, last modified April 12, 2021, https://www.washingtonpost.com /investigations/interactive/2021/domestic-terrorism-data/.

52 Anne H. Berry, Kareem Collie, Penina Acayo Laker, Lesley-Ann Noel, Jennifer Rittner, and Kelly Walters, eds., *The Black Experience in Design: Identity, Expression, and Reflection* (New York: Allworth Press, 2022).

53 US Department of Justice, *Report on the Investigation into Russian Interference in the 2016 Presidential Election*.

54 Anne H. Berry and Sarah Edmands Martin, "About," in *Ongoing Matter: Democracy, Design, and the Mueller Report*, accessed March 1, 2022, https://www.ongoing-matter.org/about/.

55 US Department of Justice, *Report on the Investigation into Russian Interference in the 2016 Presidential Election*; New Knowledge, *The Tactics and Tropes of the Internet Research Agency*, accessed March 8, 2022, https://disinformationreport.blob.core.windows .net/disinformation-report/NewKnowledge-Disinformation-Report-Whitepaper.pdf.

56 Henry Louis Gates Jr., foreword to *Separate Cinema: The First 100 Years of Black Poster Art*, by John Duke Kisch (London: Reel Art Press, 2014): 10.

57 Toni Morrison, *Beloved* (London: Vintage Classics, 1987): 225.

3. Black Design Activism

1 India Arie, "I Am Not My Hair," on *Testimony: Vol. 1, Life and Relationship*, Motown, 2005, https://www.songfacts.com/facts/indiaarie/i-am-not-my-hair.

2 Ayana Byrd and Lori Tharps, *Hair Story: Untangling the Roots of Black Hair in America* (New York: St. Martin's Press, 2014).

3 Camille DeBose, dir., *Good Hair and Other Dubious Distinctions*, SOC Media Films, 2011, https://web.archive.org/web/20130223201407/http://mensformosus.com/?page_id=18.

4 Joni Boyd Acuff, "Afrofuturism: Reimagining Art Curricula for Black Existence," *Art Education* 73, no. 3 (2020): 13–21.

5 For more information on the figures, see Donice Bloodworth Jr., *Naturally* series, 2017, acrylic on canvas, https://dacre8iveone.store/; Shani Crowe, *Braids*, 2016, black-and-white photo series of braid sculptures, https://www.huffpost.com/entry/shani-crowe-braids-art-video_n_578fd97ae4b 00c9876cdccd8; Glenford Nunez, Coiffure Project, 2012, Photobook, https://www.huffpost.com /entry/natural-hair-book-the-coiffure-project-by-glenford-nunez_n_3535323; Txema Yeste

[photographer], Chuck Amos [hair stylist], and Ebonee Davis [model], Pantene Gold series, "Strong Is Beautiful" campaign, 2017, www.envuecasting.com/pantene-gold-series/.

6 "A New African American Identity: The Harlem Renaissance," National Museum of African American History and Culture, Smithsonian, 2018, https://nmaahc.si.edu/blog-post/new -african-american-identity-harlem-renaissance.

7 Jon Daniel, "The Pioneering Work of Nine Black Designers," *Design Week*, February 26, 2014, https://www.designweek.co.uk/issues/february-2014/the-pioneering-work-of-nine-black -designers/.

8 Daniel Schulman, "Charles Dawson's Design Journey," AIGA, September 1, 2008, https://www .aiga.org/design-journeys-charles-dawson/.

9 Schulman, "Charles Dawson's Design Journey."

10 "Charles Dawson," University of Chicago Library, accessed December 18, 2022, https://www .lib.uchicago.edu/collex/exhibits/race-and-design-american-life/kingdom-commerce/charles -dawson/.

11 "Charles Dawson," Princeton University, July 10, 2015, https://graphicarts.princeton .edu/2015/07/10/charles-dawson/

12 Stephen Coles, "This Just In: Emory Douglas and the Black Panther," Letterform Archive, October 6, 2017, https://letterformarchive.org/news/view/emory-douglas-and-the-black -panther.

13 Colette Gaiter, "Visualizing a Revolution: Emory Douglas and the Black Panther Newspaper," *Journal of Visual Culture* 17, no. 3 (2018), https://journals.sagepub.com/doi/10.1177 /1470412918800007.

14 Coles, "This Just In."

15 Quoted in "Black Panther Greatest Threat to U.S. Security," *Desert Sun*, July 16, 1969, https:// www.upi.com/Archives/1969/07/16/J-Edgar-Hoover-Black-Panther-Greatest-Threat-to-US -Security/1571551977068/.

16 Coles, "This Just In."

17 Coles, "This Just In."

18 Lincoln Cushing, "The Women behind the Black Panther Party Logo," *Design Observer*, February 1, 2018, https://designobserver.com/feature/the-women-behind-the-black-panther -party-logo/39755.

19 "Emory Douglas," Norman Rockwell Museum, accessed May 29, 2021, https://www .illustrationhistory.org/artists/emory-douglas.

20 Avinash Rajagopal, "Emmett McBain, an American Ad Man, Graphic Designer," *Artist of the Day* (blog), July 14, 2020, https://visualdiplomacyusa.blogspot.com/2020/07/artist-of-day -july-14-2020-emmett.html.

21 "Emmett McBain," University of Chicago Library, accessed December 18, 2022, https://www .lib.uchicago.edu/collex/exhibits/race-and-design-american-life/kingdom-commerce/emmett -mcbain/.

22 Rajagopal, "Emmett McBain."

23 Rajagopal, "Emmett McBain."

24 Rajagopal, "Emmett McBain."

25 Lilly Smith, "Emmett McBain: Art Direction as Social Equity," *Design Observer*, April 20, 2017, https://designobserver.com/feature/emmett-mcbain-art-direction-as-social-equity/39565.

26 Adé Hogue, 2019, http://www.adehogue.com/.

27 Adrian Franks, accessed December 18, 2022, https://adrianfranks.com/projects.

28 "Representation: Culture and Perception," Perception Institute, accessed December 18, 2022, https://perception.org/representation/.

29 Chimamanda Ngozi Adichie, "The Danger of a Single Story," TED, July 2009, https://www.ted .com/talks/chimamanda_ngozi_adichie_the_danger_of_a_single_story/details.

30 Travis L. Dixon, "A Dangerous Distortion of Our Families," Color of Change, January 2018, https://colorofchange.org/wp-content/uploads/2019/05/COC-FS-Families-Representation -Report_Full_121217.pdf.

31 Dorothy Jackson, "The Black Experience in Graphic Design," *PRINT*, 1968, https://www .instagram.com/p/CBs6ObDhuR8/.

32 Cheryl D. Miller, "Black Designers: Missing in Action (1987)," *PRINT*, June 27, 2016, https://www.printmag.com/design-culture/black-designers-missing-in-action-1987/.

33 Miller, "Black Designers."

34 Pat Borzi, "Why Are Cops in Minnesota So Rarely Charged in Officer-Involved Deaths?," *MinnPost*, June 1, 2020, https://www.minnpost.com/metro/2020/06/why-are-cops-in -minnesota-so-rarely-charged-in-officer-involved-deaths/. Derek Chauvin was the primary police officer who was charged with the murder of George Floyd. He remains only the third police officer to be charged with killing a civilian in Minnesota.

35 Liz McQuiston, *Protest!: A History of Social and Political Protest Graphics* (Princeton, NJ: Princeton University Press, 2019), 105. The Poor People's Campaign was created to advocate and demand for the recognition and rights of the working class in the United States.

36 T. V. Reed, *Art of Protest: Culture and Activism from the Civil Rights Movement to the Present*, 2nd ed. (Minneapolis: University of Minnesota Press, 2019), 82.

37 Reed, *Art of Protest*, xii.

38 Colette Gaiter, "Visualizing a Black Future: Emory Douglas and the Black Panther Party," *Journal of Visual Culture* 17, no. 3 (2018): 300, 301.

39 Quoted in Peggy McGlone, "'This Ain't Yo Mama's Civil Rights Movement' T-shirt from Ferguson Donated to Smithsonian Museum," *Washington Post*, March 1, 2016, https://www .washingtonpost.com/news/arts-and-entertainment/wp/2016/03/01/this-aint-yo-mamas-civil -rights-movement-t-shirt-from-ferguson-donated-to-smithsonian/.

40 "Adrienne maree brown on Creating the Future," interview with Alice Grandoit, *Deem*, 2019, https://www.deemjournal.com/stories/amb.

41 Francesca Gavin and Alain Bieber, eds., *The Art of Protest: Political Art and Activism* (Berlin: Gestalten, 2021), 5.

42 W. E. B. Du Bois, "Criteria of Negro Art," *The Crisis* 32 (October 1926), http://www.webdubois .org/dbCriteriaNArt.html.

43 Quoted in Ellen Lupton, *Extra Bold: A Feminist Inclusive Anti-Racist Non-Binary Field Guide for Graphic Designers* (New York: Princeton Architectural Press, 2021), 212.

44 Bruce Willen and Nolen Strails, *Lettering and Type: Creating Letters and Designing Typefaces* (New York: Princeton Architectural Press, 2009), 1.

45 Willen and Strails, *Lettering and Type*, 87, 27, 71.

46 Ellen Lupton, *Design Is Storytelling* (New York: Cooper Hewitt, Smithsonian Design Museum, 2017), 56.

47 Emory Douglas, *Black Panther: The Revolutionary Art of Emory Douglas* (New York: Rizzoli, 2007), 8–9.

48 McQuiston, *Protest!*, 241.

49 Lupton, *Design Is Storytelling*, 21.

50 Quoted in Lupton, *Extra Bold*, 212.

51 Mel D. Cole, *American Protest: Photographs 2020–2021* (Bologna: Damiani, 2021), 143.

52 Al McFarlane, "Guilty, Guilty, Guilty," Insight News, April 26, 2021, 1, https://www.insightnews .com/news/guilty-guilty-guilty/article_b22f9b80-a70e-11eb-b693-37abe8a254e4.html.

53 James Baldwin, interview on Studs Terkel Radio Archive, Chicago History Museum, 1961.

54 "Prairie View Student Files Vote Right Suit," *Longview News-Journal*, October 13, 1972, 11.

55 Robert W. Mickey, "The Beginning of the End for Authoritarian Rule in America: Smith v. Allwright and the Abolition of the White Primary in the Deep South, 1944–1948," *Studies in American Political Development* 22 (Fall 2008): 143–182.

56 The "Questionnaire Pertaining to Residence" asked the following questions: Please print or type your name and address. Are you a college student? If so, where do you attend school? How long have you been a student at such school? Where do you live while in college? How long have you lived in Texas? In Waller County? Do you intend to reside in Waller County indefinitely? How long have you considered yourself to be a bona fide resident of Waller County? What do you plan to do when you finish your college education? Do you have a job or position in Waller County? Own any home or other property in Waller County? Have an automobile registered in Waller County? Have a telephone listing in Waller County? Belong to a church, club or some Waller County organization other than college related? If so, please name them. Where do you live when the college is not in session? What address is listed as your home address with the college? Give any other information that might be helpful.

57 Alexandra Villarreal, "Texas Is a 'Voter Suppression' State and One of the Hardest Places to Vote. Will It Help Trump Win?," *Guardian*, September 18, 2020, https://www.theguardian .com/us-news/2020/sep/18/texas-voting-restrictions-rights-coronavirus; Nina Perales, Luis Figueroa, and Criselda G. Rivas, "Voting Rights in Texas 1982–2006: A Report of Renew the VRA.org," *Southern California Review of Law and Social Justice* 17, no. 2 (Spring 2008), https://gould.usc.edu/students/journals/rlsj/issues/assets/docs/issue_17/06_Texas_Macro .pdf; "Election Records Seized by State," *Fort Worth Star-Telegram*, December 23, 2006, A4; Ronald D. Server, "Prairie View A&M Students Walk the Walk of Political Engagement," *Peer Review* 10, nos. 2–3 (Spring–Summer 2008).

58 "AIGA Get Out the Vote 2016: Google Arts and Culture," Google, accessed fall 2020, https:// artsandculture.google.com/exhibit/aiga-get-out-the-vote-2016-aiga/6QIC0UI0SaBaKQ?hl=en.

59 Alexa Ura, "Texas' Oldest Black University Was Built on a Former Plantation. Its Students Still Fight a Legacy of Voter Suppression" *Texas Tribune*, February 25, 2021, https://www .texastribune.org/2021/02/25/waller-county-texas-voter-suppression/.

60 Karen Brooks Harper, "Coronavirus Restrictions and Remote Learning May Hamper College Student Voter Turnout," *Texas Tribune*, September 25, 2021, https://www.texastribune .org/2020/09/25/texas-college-voter-turnout-coronavirus/.

61 The selected buildings included the John B. Coleman Library, Panther Lanes Bowling Center, Willie A. Tempton Sr. Memorial Student Center, Student Recreation Center, Athletics Field House, E. E. O'Banion Science Building, Nathelyne Archie Kennedy Building, Harrington Science Building, Hobart Taylor Sr. Hall, and University College Computer Lab.

62 Marc Stickdorn, Markus Edgar Hormess, Adam Lawrence, and Jakob Schneider, "This Is Service Design Doing: Applying Service Design Thinking in the Real World," O'Reilly Media, Inc., 2018.

63 Rune Pettersson, *Information Design: An Introduction*, vol. 3 (Amsterdam: John Benjamins Publishing, 2002).

64 Qualifications, the number of security envelopes, and verification of the voter vary by state.

65 Mindy Acevedo, Matthew A. Barreto, Michael Cohen, Chad W. Dunn, and Sonni Waknin, "Ensuring Equal Access to the Mail-in-Ballot Box," *UCLA Law Review Discourse* 68 (2020): 4.

66 Amanda Zoch, "Voting Outside the Polling Place: Absentee, All-Mail and Other Voting at Home Options," National Conference of State Legislatures, March 15, 2022, https://www.ncsl .org/research/elections-and-campaigns/absentee-and-early-voting.aspx.

67 Danielle Root and Aadam Barclay, "Voter Suppression during the 2018 Midterm Elections," Center for American Progress, November 20, 2018, https://www.americanprogress.org /article/voter-suppression-2018-midterm-elections/.

68 "Health Equity Considerations and Racial and Ethnic Minority Groups," Centers for Disease Control and Prevention, January 25, 2022, https://www.cdc.gov/coronavirus/2019 -ncov/community/health-equity/race-ethnicity.html.

69 Aaron Morrison, "Black Churches Mobilizing Voters Despite Virus Challenges," Associated Press, October 12, 2020, https://apnews.com/article/election-2020-virus-outbreak-race-and -ethnicity-new-york-voting-c8f6ec1b9eb46c6e49340747d781bb11.

70 Lila Carpenter, "Signature Match Laws Disproportionately Impact Voters Already on the Margins," American Civil Liberties Union, November 2, 2018, https://www.aclu.org /blog/voting-rights/signature-match-laws-disproportionately-impact-voters-already-margins.

71 M. L. Schultze, "The Real Goal of Misinformation Campaigns Focused on Black Voters," WKSU Ohio Public Radio, October 11, 2020, https://www.wksu.org/government -politics/2020-10-09/the-real-goal-of-misinformation-campaigns-focused-on-Black-voters.

72 Shannon Bond, "Black and Latino Voters Flooded with Disinformation in Election's Final Days," NPR, October 30, 2020, https://www.npr.org/2020/10/30/929248146/Black-and-latino -voters-flooded-with-disinformation-in-elections-final-days.

73 "Attorney General James Takes Legal Action against Conspiracy Theorists for Threatening Robocalls to Suppress Black Voters," Office of the New York State Attorney General, May 6, 2021, https://ag.ny.gov/press-release/2021/attorney-general-james-takes-legal-action -against-conspiracy-theorists.

74 "Attorney General James Takes Legal Action against Conspiracy Theorists."

75 John Whitesides, "Black Voters Don't Trust Mail Ballots. That's a Problem for Democrats," Reuters, May 29, 2020, https://www.reuters.com/article/us-health-coronavirus-usa-election -insig/Black-voters-dont-trust-mail-ballots-thats-a-problem-for-democrats-idUSKBN2351G0.

76 "Deem Forum Three: Envisioning Equity," *Deem*, February 22, 2022, https://www .deemjournal.com/stories/forum-three.

77 Audre Lorde, "Learning from the '60s," address presented at Malcolm X Weekend, Harvard University, February 1982.

78 Inflow Team, "ADHD in Girls and Women: Misdiagnosed and Misunderstood," Inflow ADHD, January 12, 2022, https://www.getinflow.io/post/adhd-in-girls-and-women-misunderstood -and-misdiagnosed-add.

79 Robin Bleiweis, Diana Boesch, and Alexandra Cawthorne Gaines, "The Basic Facts about Women in Poverty," Center for American Progress, December 3, 2021, https://www .americanprogress.org/article/basic-facts-women-poverty/.

80 "10 Principles of Disability Justice," Sins Invalid, September 17, 2015, https://www.sinsinvalid .org/blog/10-principles-of-disability-justice.

81 Christiana Obeysumner, "Christiana Obeysumner MPA, MNPL: A Word of Caution for Organizations with #BlackLivesMatter Statements," 2020, https://www.linkedin.com/in /christianaobeysumner.

82 Leah Lakshmi Piepzna-Samarasinha and Stacey Park Milbern, "Disability Justice Audit Tool," Northwest Health Foundation, March 17, 2022, https://www.northwesthealth.org/djaudittool.